e in

the Library

only

181A High Holborn
London WC1V 7QX

In the United States please write to:

THAMES & HUDSON INC.
500 Fifth Avenue
New York, New York 10110

Printed in Singapore

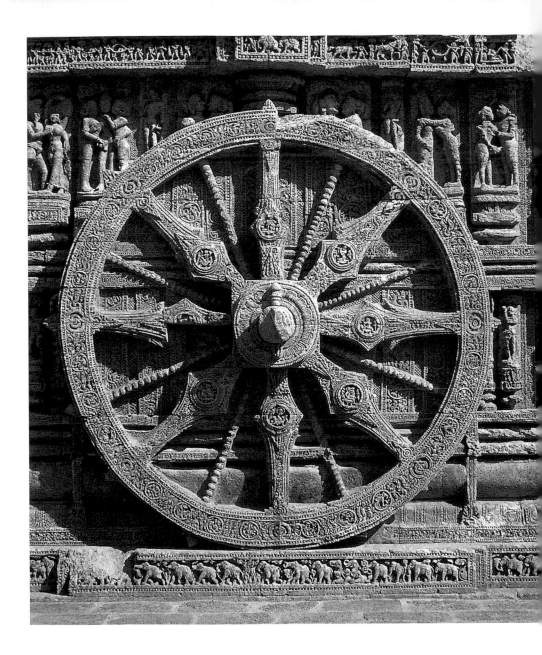

1. Sculpted wheel on the plinth of the Surya temple at Konarak in Orissa, Ganga period, mid-thirteenth century (see p. 106).

George Michell

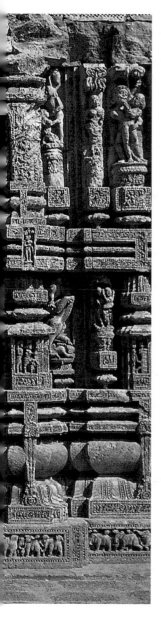

Hindu Art
and Architecture

186 illustrations, 77 in colour

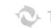 Thames & Hudson **world of art**

First published in the United Kingdom in 2000 by
Thames & Hudson Ltd, 181A High Holborn, London WC1V 7QX

www.thamesandhudson.com

British Library Cataloguing-in-Publication Data
A catalogue record for this book is available from the British Library

ISBN 0-500-20337-7

Printed and bound in Singapore by C. S. Graphics

Contents

Preface

The art of Hinduism constitutes one of the world's great traditions, as alive today as when the first images of Hindu gods were fashioned out of stone more than two thousand years ago. By no means confined to the countries of South Asia, the area of its origin and major phases of development, Hindu temples and sculpted images are found in Cambodia and Indonesia from the seventh century AD onwards, and, in more recent times, Malaysia and South Africa, and now even Europe and the United States. It is, however, with India alone that this book is concerned, with only occasional reference to the adjacent countries of Pakistan, Bangladesh and Nepal. Even so, it is impossible to do justice to the wealth of Hindu monuments and works of art that survive from the successive periods of Indian history in the different regions of the country; only the most important monuments are referred to here, and a painfully small selection has had to be made from the profusion of stone and metal sculptures, murals and miniature paintings.

Given these limitations, the book makes some claim to completeness by adopting a broad chronological sweep, tracing the evolution of Hindu art and architecture over some two millennia. The first chapter establishes the required framework for the subject by outlining the development of Hinduism and the principal iconic forms that were devised for its pantheon of gods and goddesses; the symbolic basis for Hindu religious architecture is briefly introduced, together with the system of royal patronage that led to the construction of so many temples and the commissioning of their attendant works of art. This is followed by a chapter that examines the tentative beginnings of Hindu art in the period between the second century BC and the second century AD. The next three chapters deal with consecutive phases, each of about the same time length, spanning the fifth to eighteenth centuries; they chart the principal phases of Hindu temple architecture, sculpture and painting, focusing on the most significant examples. A shorter final chapter on the nineteenth and twentieth centuries brings this survey up to date. In order to impose a broad historical and regional structure on this superabundance of

materials, subsections covering dynastic patrons are inserted into the chapters.

It may be worthwhile at the outset to comment on the traditional chronological divisions of the subject into a sequence of 'ancient', 'classical' and 'medieval' phases, the last sometimes extended as far as the nineteenth century. Such an obviously European-derived terminology is not followed here because it gives a misleading idea of the relationship between the successive stages of Hindu architecture, sculpture and painting. The titles of the first three survey chapters – Beginnings, Early Maturity and Culmination – are intended to describe in a more convincing way the major art-historical processes that determined Hindu architecture and sculpture between the second century BC and the thirteenth century AD. As for the so-called 'Muslim' era of Indian art, spanning the twelfth to eighteenth centuries, this is better understood from the Hindu point of view as a temporary break in the tradition followed by a vigorous period of revival; hence the chapter title used.

No book on Hindu art and architecture can be written without defining the boundaries of the subject; this is no easy task given the confusing amalgam of beliefs and practices embraced by the term 'Hinduism'. Only the most narrow definition is adopted here, the discussion being confined to shrines consecrated to Hindu cults, and works of art portraying specifically Hindu divinities, semi-divine personalities and mythological narratives. There is, however, some acknowledgment of the Buddhist legacy that affected early Hindu architecture and sculpture, and a brief notice of the Jain artistic tradition that coexisted and sometimes inter-acted with that of Hinduism. The disadvantages of this approach are felt most keenly in the chapter dealing with the fifteenth to eighteenth centuries, where, sadly, it has been necessary to exclude the palace architecture and secular paintings of the Hindu courts. The only justification for these omissions is that this is a book about Hindu art rather than Hindu culture, even if the two are not readily distinguished.

There already exists a wide-ranging scholarship for the subject by both Indian and Western specialists. Many of their studies focus on particular periods or regions, while others are more concerned with the iconic forms assumed by one or other deity. General surveys either tackle the religious arts, including those of Hinduism, up to the Muslim conquest in the twelfth–thirteenth centuries, or focus exclusively on the arts of later centuries, including miniature painting with Hindu themes. The

scope of the present work is more ambitious since it attempts to deal with all of these historical phases, even though the materials available vary considerably from one period to another. This approach has the advantage of demonstrating artistic continuities down to the present day in the different regions of the country; it also confirms the sustained visual potency of Hinduism, obsessed as it is by ritual and image worship. If the book communicates anything of the vibrancy of this tradition then the author will be well pleased. He craves indulgence for compressing too much information in too little space, and for succumbing to a plethora of Indian names and terms; however, a glossary is provided at the end.

Notes to readers

Rendering Indian spellings in Roman script is always a headache for any author. The approach here has to been to avoid the diacritical marks which attempt to indicate the letters used in the original but which may be unhelpful to all but the initiate; 'sh' and 'ch' are used where appropriate, to suggest the actual pronunciation – 'Shiva' and 'Chola', for instance, not 'Siva' and 'Cola'. Spellings of place names, however, conform to accepted norms in Roman script, even though this results in occasional inconsistencies; thus Srirangam, rather than Shrirangam.

Dates are given according to the Christian era, though obviously this is not the system employed in Indian calendrical records.

Cities and sites with Hindu monuments and works of art are located in the present-day states of India or the adjacent countries, while keeping in mind that these divisions do not always coincide with ancient territorial boundaries.

Chapter 1: Introduction: Hinduism and its visual expression

The development of the major Hindu cults is of central importance for any understanding of Hindu art, and a familiarity with the mythical personalities and legends that populate the Hindu pantheon is essential for unravelling the profusion of its imagery. Some appreciation of the ritual life of temples is also helpful, since this reveals the underlying purpose of the sacred monument, together with its carved and painted decor. As for the more philosophical and esoteric aspects of Hinduism, these generally lie beyond the visual realm, and do not form part of the discussion here.

Religious developments

2. Elephant-headed Ganesha, the popular Hindu god invoked at the beginning of any undertaking since he guarantees the removal of all obstacles. Panel from Khajuraho in Madhya Pradesh, eleventh century, sandstone.

3. Seal showing a seated figure in yogic posture surrounded by animals, sometimes identified as proto-Shiva. From Mohenjo Daro in Pakistan, beginning of the second millennium BC; ctono, H 3.4 cm.

The beginnings of Hinduism may be traced back to the urbanized civilization of the Indus Valley in the middle of the third millennium BC. Harappa and Mohenjo Daro in present-day Pakistan, the two most important sites associated with this civilization, were well-planned cities with an extensive architecture in brick. An abundance of terracotta and stone seals with imprinted characters have been discovered here from the 1920s onwards, but their inscriptions remain undeciphered, hindering any proper understanding of the religious beliefs of the Indus Valley people. Even so, such seals, together with associated figurines and phallic emblems, are often considered as proto-Hindu: that is, as anticipating features of later Hinduism.

Majestic bulls standing before an altar are commonly portrayed on the seals, suggesting a cult of this animal in prehistoric times. The preference for the bull, which is depicted more frequently and more naturalistically than any other animal in Indus Valley art, appears to prefigure depictions of Nandi, the bull mount of the Hindu god Shiva. Another possible connection with Shiva is suggested by a celebrated seal found at Mohenjo Daro showing a male seated in yogic posture, his phallus exposed. He wears a large horned crown and is surrounded by a tiger, rhinoceros, elephant and buffalo. While no certain identification

3

is possible, the figure seems to be an agricultural deity involved in yogic practice, not unlike Shiva himself who is also connected with animals and yoga.

That a goddess cult may have existed in Indus Valley times is implied by a number of rudimentary terracottas showing females with exaggerated child-bearing hips and elaborate headdresses. The proto-Hindu character of these figures is borne out by their striking resemblance to later images of mother goddesses. Such terracottas continued to be manufactured in India through the centuries, surviving into recent times in the art of village communities. Terracotta phallic emblems and ring stones identified with female sexual organs have also been discovered at Indus Valley sites; they recall the *linga* (phallus) and *yoni* (vulva) venerated in later centuries as emblems of Shiva and the goddess Shakti. Such iconographic continuities offer insights into the substratum of beliefs that links prehistory with evolved Hinduism.

At some point in the middle of the second millennium BC the Indus Valley cities declined, and artefacts such as those just described disappear. The following period is marked by a series of invasions of horse-riding Aryan people who sweep across northern India, leaving only the scarcest material traces of their progress. The overall lack of architectural and sculptural remains for Aryan culture is, however, fully compensated for by an abundant literary heritage. It is the Aryans who are credited with the introduction of Sanskrit, the language of later Hindu scriptures, still studied and chanted in India today. In the process of settling into their new homeland, the Aryans composed a set of works known as the *Vedas*, or Books of Knowledge, in which they describe an elaborate pantheon of gods and the devotional rites with which they honoured these deities. While Vedic divinities and practices only partly coincide with those of later times, the *Vedas* are nevertheless regarded as the ultimate literary source of Hinduism. The celestial characters of the *Vedas* are dominated by Indra, god of the skies, Varuna, god of the oceans, and Agni, god of fire. Among a host of minor figures is Rudra, a storm god who wields the thunderbolt, and whose savage aspect is akin to that of Shiva as the horrific-looking Bhairava. These and other cosmic personalities are placated by fire and animal sacrifices, as well as hymns and ritual incantations known as *mantras*. All these practices are familiar in evolved Hinduism.

In the course of the first millennium BC the *Vedas* were succeeded by the philosophically based *Upanishads* and the more practically concerned *Brahmanas*. These works define a well-

4. A proto-Hindu mother goddess from Mohenjo Daro, beginning of the second millennium BC; terracotta, H 15 cm.

5. Krishna in his cosmic form displaying all of creation on his body, as described in the *Bhagavad Gita*; from Jaipur, early nineteenth century; watercolour on paper, 36 × 22 cm. As in other depictions, the hero is shown with blue skin, in accordance with his name which literally means 'blue-black'.

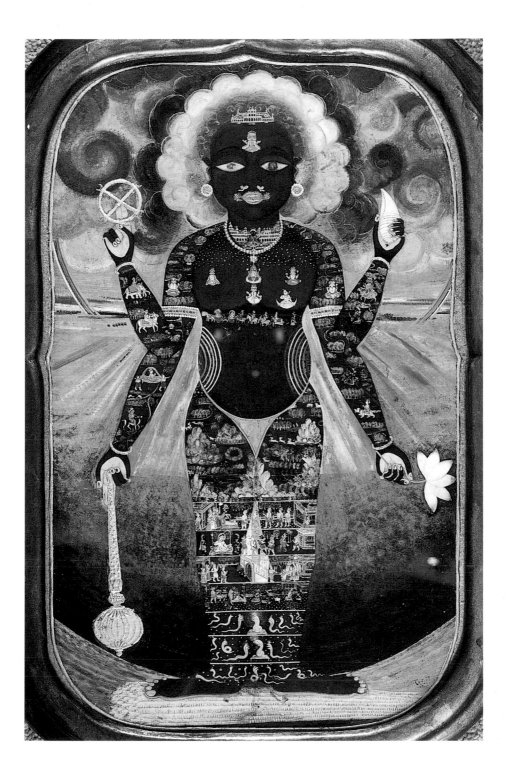

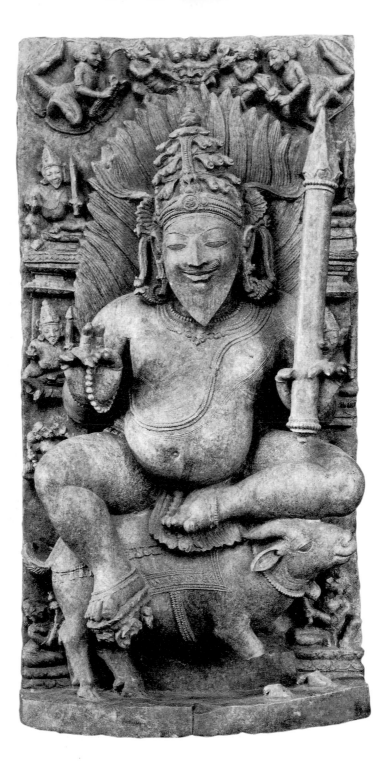

organized system of beliefs overseen by a class of priests known as *brahmanas* (brahmins). Yet there is little mention of Shiva and Vishnu or of the goddess Shakti, the principal cult divinities of Hinduism. The next significant Sanskrit texts are the *Ramayana* and *Mahabharata* epics, the earliest parts of which were composed in about the fourth–third centuries BC, but which were only committed to writing in later times. These poetic narratives assume the existence of divine figures who manifest themselves to their human worshippers. Even so, the process by which the legends pertaining to celestial and heroic figures were amalgamated into the synthetic personalities of Shiva, Vishnu and Shakti does not seem to have been completed until the first or second century AD. That period marks the true beginning of Hindu art (see Chapter 2).

The third and fourth centuries AD witnessed the rise of *bhakti*, a devotional movement that was to provide the basis for the fashioning of images intended for worship. According to bhakti doctrine, devotees enter into a personal relationship with a chosen deity who is imagined visually. The supreme expression of this devotional form of worship is that given in the *Bhagavad Gita*, the Song of the Lord, a later interpolation to the *Mahabharata*, in which the god Krishna appears in awe-inspiring cosmic form before the warrior hero Arjuna. The hymn eloquently propounds the notion of *avatara*, or divine 'descent', by which the god Vishnu assumes visual forms as an act of concern and compassion for human beings. Further evidence of the avatara concept is found in the *Ramayana* and *Mahabharata*. The composition of the *Puranas*, or Ancient Stories, may also be assigned to this period. These compilations of myths and legends were of crucial importance in shaping the complex personalities and manifold aspects of the different Hindu deities. Yet another body of texts dating from this time, the *Agamas*, specifies the appropriate mantras and hymns by which sacred images are to be worshipped. Such literary compendiums provided the essential background to the earliest temples and sculptures of the first mature phase of Hindu art in the fifth and sixth centuries (see Chapter 3).

The further development of Hinduism is partly explained by the continuing strength of the bhakti movement and the careers of philosophers such as Shankara (*c.* 788–820), whose systematic reworking of the *Vedas* and *Upanishads* provided Hinduism with a secure intellectual basis. Regional traditions also had a contribution to make. In southern India, for instance, Tamil literature in these centuries records the ecstatic songs sung by saints in praise

6. Agni, god of fire in the *Vedas*, in his later role in Hindu art as one of the Dikpalas, the eight guardians of the directions of space; he is recognized by his flaming hair and ram mount. Panel from Bhubaneshwar in Orissa, eleventh century, chloritic schist, H 67 cm.

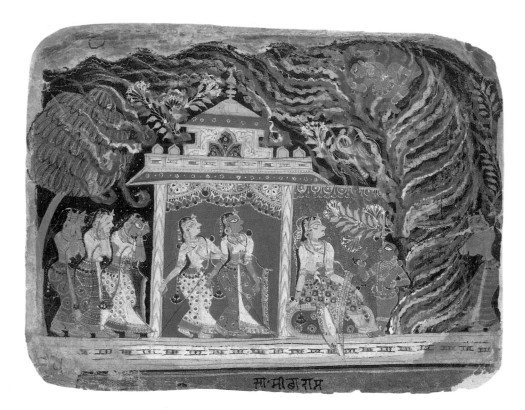

मा·मीबोराम

7. Krishna standing before Radha after defeating the whirlwind demon; from a *Bhagavata Purana*, Delhi–Agra region, mid-sixteenth century; watercolour on paper.

of Shiva and Vishnu, both of whom are meticulously described in their various aspects. An increasing focus on the cult of Vishnu is evident in the *Bhagavata Purana*, which chronicles the major incarnations of the god. Composed in about the tenth century, it includes the first complete account of the Krishna story. As for the early life of Krishna and his love for the *gopis*, the herdswomen who help him tend the cows, this part of the story formed the subject of the *Gita Govinda*, or Song of the Cowherd, written by Jayadeva in the twelfth century. Both these works were to inspire much Hindu sculpture and painting. This literary focus on particular deities served as a background to the proliferation of Hindu cults that flourished up to the Muslim invasion of India at the end of the twelfth century, an event that brought to a close the culminating phase of Hindu art and architecture (see Chapter 4).

While the religious momentum of Hinduism was profoundly interrupted by the introduction of Islam into India, it was by no means extinguished. Hinduism survived the Muslim conquest, and in the fifteenth and sixteenth centuries emerged again with

7.

182

new-found strength. Revived Hinduism in northern India concentrated on the worship of Krishna and the hero Rama, largely influenced by the teachings of the saint Chaitanya (1486–1533) and the translation of the *Ramayana* epic into the Hindi vernacular language by the poet Tulsidas in 1574. In southern India, the rise of a Hindu ruling dynasty based at Vijayanagara in Karnataka was responsible for a resuscitation of Hindu intellectual traditions as well as the construction of temples. It was these renewals that underscored the revivalist phase of Hindu art and architecture (see Chapter 5).

The vitality of these religious developments continued uninterruptedly into the nineteenth and twentieth centuries, largely unaffected by the European presence in India and the consequent introduction of Christianity. Such cultural resilience finds expression in the lesser traditions of the most recent and continuing phase of Hindu art and architecture (see Chapter 6).

Sacred images

A bewildering array of images constitutes the core of Hindu art, expressing the complex inter-relationships of divinities who assume countless aspects and emanations. Yet a survey of some fifteen hundred years or so of artistic activity uncovers an overall consistency in the representation of these manifold personalities. Such visual coherence is explained by the written canons that guided sculptors and painters. Chapters on image-making in the *Puranas* and *Agamas*, as well as in encyclopedic works such as the *Vishnudharmottara*, for instance, counselled artists to work according to strictly defined rules: only in this way could deities be persuaded to inhabit a carved sandstone block, bronze statue or painting. This distinction between a lifeless work of art and an actual divine presence is felt keenly in Hinduism; hence the emphasis on consecration rites that attend the completion of a sacred icon and its installation in the temple sanctuary.

A fundamental principle of Hindu theology is the concept of multiplicity. The major deities are worshipped in a large variety of forms that reflect their all-encompassing powers and contrasting natures, while at the same time suggesting their synthetic origins. Shiva, for instance, is the lord of destruction as well as the practitioner of more peaceful arts. Devotees of Krishna contemplate a deity who appears successively as a mischievous child, flirtatious cowherd, and wise charioteer who expounds the doctrine of the *Bhagavad Gita*. The stories of Vishnu's avataras enumerate the occasions on which the god comes down to earth to save mankind.

8. Ardhanarishvara, the androgynous deity that combines the god Shiva with Devi, his female counterpart. From Nepal, eleventh century; copper, H 83 cm. Shiva forms the right side of the figure (to the viewer's left) and Devi the left.

9. Shiva linga bearing a face of the god. From Madhya Pradesh, fifth century; sandstone, H 147 cm. Characteristic of Shiva are the long matted hair in which a crescent moon is visible, and the third eye placed vertically in his forehead.

Shakti's appearances range from goddesses of annihilation and death to those who guarantee peace and prosperity.

In order to express the super-human powers of Hindu divinities, gods and goddesses are usually represented with four, six or even more arms. Multiple heads are sometimes also employed, as for Shiva in his cosmic form as Sadashiva (Eternal Shiva), or Vishnu as Vaikuntha, the latter with boar and lion side-heads. Hybrid figures combine animal heads with human torsos, as in the first four avataras of Vishnu, or the sets of *yoginis* that embody

in female form the powers of the male gods, as well as the seven mothers, or Saptamatrikas. Elephant-headed, human-bodied Ganesha is one of the most frequently encountered characters in Hindu art. Another hybrid figure is Shiva as Ardhanarishvara, the androgyne, in which the god is joined to his female counterpart.

Identification of deities relies mostly on weapons, emblems and other items, such as the trident, spear and small drum held by Shiva, or the disc and conch of Vishnu. Animal mounts, known as *vahanas*, or 'vehicles', also help to distinguish the different celestials: thus, Nandi, the bull of Shiva; Garuda, the eagle, on which Vishnu rides; the lion of Durga. Facial expression and bodily type are of importance in disclosing varied moods: protruding eyes and tusks express Shiva's terrifying aspect; Ganesha's pot belly symbolizes the auspicious nature of a god who assures success in all human endeavours.

Shiva as Maheshvara, the Great Lord, is universally worshipped as the linga, an emblem of the universal forces of generation. But the god is also depicted in human form, sometimes as part of a celestial family group, accompanied by his wife Parvati

10. Shiva with Parvati seated on the bull Nandi. Panel from Hinglajgarh in Madhya Pradesh, tenth century; sandstone, H 69 cm.

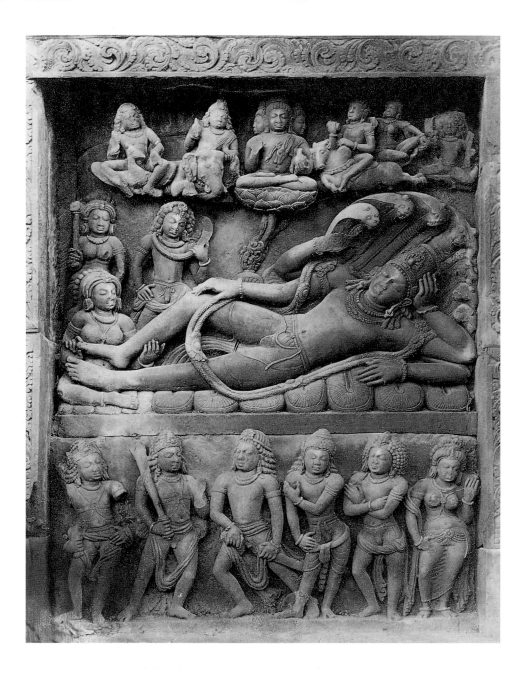

11. Vishnu on Ananta floating on the cosmic ocean, dreaming
the creation of the universe; behind rises four-headed Brahma, the
creator, seated on a lotus. Relief on the sanctuary of the Dashavatara
temple at Deogarh in Madhya Pradesh, sixth century; sandstone.

and perhaps by their sons Ganesha and Karttikeya. Shiva is
Nataraja, lord of the dance, tapping out the steps of cosmic
destruction with one foot, while the other foot is raised high
as a sign of cosmic liberation. In a more contemplative mood,
Shiva takes the form of Yogeshvara, the master of yoga, or
Dakshinamurti, exponent of the sacred scriptures seated beneath
a tree. He is also Bhikshatanamurti, the naked ascetic who wan-
ders the earth together with a dog, and Bhairava, who haunts
battlefields and cremation grounds in the company of ghosts, evil
spirits and dwarfish imps known as *ganas*.

114,
183

The forms of Vishnu are no less varied. As Anantashayana,
the god floats on the cosmic ocean dreaming the creation of the
universe, supported by the serpent Ananta, known also as Shesha.
A lotus stalk emerges from Vishnu's navel, opening into a flower
to reveal four-headed Brahma, the god actually responsible for
the act of creation. Here as elsewhere, Vishnu is attended by his
consorts Lakshmi and Bhudevi. In the first three avatars as
fish, tortoise and boar, known as Matsya, Kurma and Varaha
respectively, Vishnu rescues the earth, sometimes personified as
Bhudevi. As Narasimha, Vishnu appears as the fierce man-lion,
while in the following incarnation, as Trivikrama, he paces out the
universe in three gigantic steps. In his next three appearances, as
Parashurama, Rama and Krishna, Vishnu comes to live among
men in human form. Rama is the hero of the *Ramayana*, while
Krishna forms the principal subject of an independent set of
narratives, of which the *Bhagavata Purana* and *Gita Govinda* have
already been mentioned. The last incarnation is Kalki, a man
riding a horse, who heralds the destruction of the present era.

11,
173

27

52
66

137
15
33,
115
81

Goddesses play a central role in Hinduism, and the cult of
Shakti rivals those of Shiva and Vishnu. As the child-bearing,
nourishing and maternal divinity, Shakti is connected with life-
giving waters and lotuses: in this aspect she is Lakshmi, the
consort of Vishnu, bringer of wealth, who stands or is seated on
the lotus, bathed by elephants with upraised trunks. In an obvious
image of fertility, Shakti appears as a lotus-headed goddess,
displaying her sexual parts. The variety of names and alternative
forms that the goddess assumes demonstrate her all-embracing
nature. The idea of Shakti as the creative energy of the god causes
her to be associated with Shiva, with whom she develops her
most characteristic features. The eternal couple Shiva–Shakti is
represented by the conjunction of the male and female sexual
emblems, the linga and the yoni. As Parvati or Devi, Shakti
personifies the benign and bountiful nature of Shiva; accordingly

23

12

she is portrayed as a gracefully posed, beautiful woman with full breasts and narrow waist.

According to one particular myth, Shakti is the combined energies of all the gods, who created her and armed her with their weapons in order that she might destroy Mahisha, the powerful buffalo demon who threatened the heavens. In this determined role she is multi-armed Durga riding the lion. As the fearsome Kali, she symbolizes death: in this role she assumes the appearance of a horrifying bloodthirsty figure with protruding tongue, decked in severed human heads.

64

13,

186

Shakti is also worshipped as the ultimate principle of the universe, especially by Tantric sects, so called after the *Tantras*, a body of scriptures praising the goddess in her all-powerful form. Cosmic energy is personified by Kundalini, who is likened to the coiled serpent that activates the *chakras*, or nodes of energy located along the spine; the highest chakra, in the forehead, is represented as a thousand-petalled lotus. In another of her Tantric forms, Shakti is represented as an auspicious *yantra*, or geometric diagram, which serves as an object of contemplation.

A number of lesser deities also make an appearance in Hindu art. Surya, the solar divinity, is worshipped as the supreme soul, the creator of the universe and the source of all life. Dressed in a tunic and wearing high boots, a costume that reveals his foreign origin, the god rides across the sky in a horse-drawn chariot directed by Aruna, the personification of dawn. The Navagrahas, the nine planets of Hindu astronomy, include the sun and moon, as

40,

89

22

12. Shakti as a lotus-flower-headed fertility goddess. From Sangameshvara near Alampur in Andhra Pradesh, eighth century; stone, L 91 cm.

13. Kali, goddess of destruction. Painting produced for pilgrims to the temple at Kalighat in Calcutta, West Bengal, nineteenth century; watercolour on paper, 46 × 28 cm.

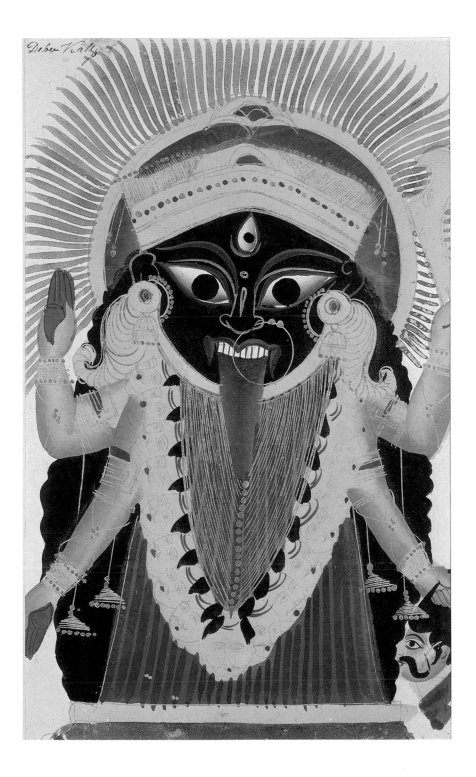

14. Scenes from the *Ramayana* (for their subjects, see p. 81) on the staircase leading to the main shrine of the Kailasanatha temple at Ellora in Maharashtra, Rashtrakuta period, eighth–ninth centuries; basalt.

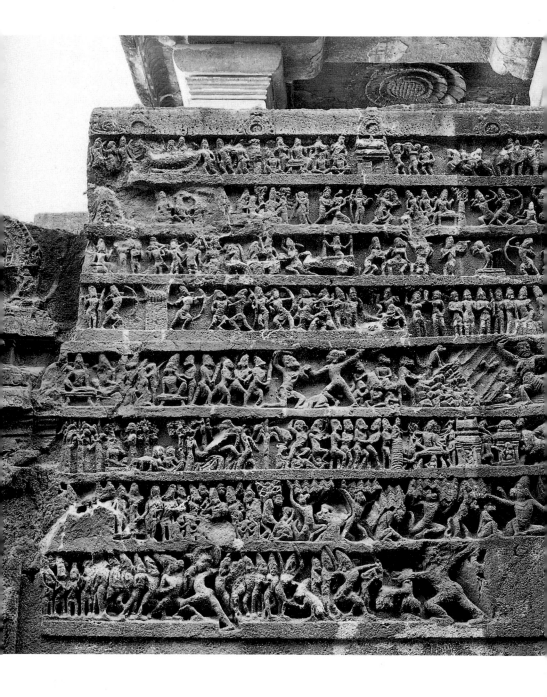

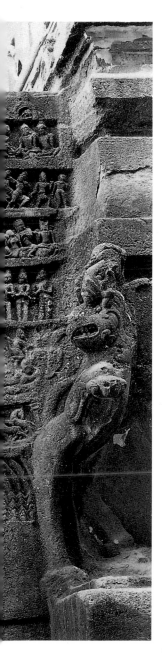

well as Rahu, the planetary eclipse. While Brahma is considered the creator god, he is generally subservient to the other deities for whom he performs sacrificial acts. He is easily recognized by his four heads and the ritual ladle and rosary that he holds. Karttikeya, who is known variously as Kumara, Skanda or Subrahmanya, is the eternally youthful and chaste battle god who rides on a peacock. According to some legends he is the offspring of Shiva, and for this reason he is sometimes shown together with Shiva, Parvati and Ganesha. The Dikpalas, the regents of the eight directions of space, incorporate deities taken from the *Vedas*, notably Indra wielding a thunderbolt and riding on an aerial elephant, Varuna accompanied by an aquatic monster, and Agni with flame-like hair, sometimes also holding a flame. Another Dikpala is Yama, the lord of death, who displays the noose with which he drags his victims into the underworld.

Narrative traditions
Hindu art is greatly enriched by sculpted and painted illustrations of mythological events. Some compositions are based on chapters in Sanskrit compilations of Hindu legends, such as the *Puranas*; others depict stories pertaining to particular shrines recorded in vernacular languages, known as *Sthalapuranas*. Narrative depictions often focus on single-action scenes: for example, the story of Vishnu as Varaha, stepping out of the cosmic ocean to nuzzle the goddess Bhudevi with his boar head, is generally compressed into a single tableau. Vishnu Trivikrama is represented both as the dwarf Vamana, who asks the wicked king Bali for a boon of territory, and as the giant who kicks up one leg in the act of pacing out the universe in three tremendous strides. Successive events drawn from the *Ramayana* and the Krishna legend are often combined in linear fashion, with the chief protagonists appearing repeatedly in successive scenes, a device well suited to long friezes on temple basements or painted panels on walls and ceilings. In miniature painting, such scenes are distributed over a number of different pages intended to be viewed in a predetermined sequence.

Certain compositions focus on dramatic moments of miraculous appearance and intervention. Vishnu riding through the air on Garuda descends to earth to free Gajendra, an elephant devotee who had been trapped in a lotus pond by a mythical water creature. Shiva leaps out of the linga to rescue Markandeya, a youthful worshipper clutching the emblem so as to avert being dragged by Yama into the underworld; he steps out of a fiery linga to settle a dispute between Vishnu and Brahma, who had presumed to

11
25

117
6

27

66

14

31

judge the linga's height; he manifests himself before the sage Bhagiratha, whose austerities induced the god to persuade the Ganges river to descend to earth so as to immerse the ashes of his ancestors; Shiva then saves the earth from destruction by receiving the mighty waters in his matted tresses.

Deities triumphing over their adversaries proliferate in Hindu art, sometimes in compositions marked by a conspicuous violence. Durga slays Mahisha by savagely plunging her spear down into the buffalo demon; in a comparable scene, Shiva impales the demon Andhaka, but here the spear is angled upwards. Scenes of triumph follow: Durga stands on the severed head of Mahisha, while Shiva dances in the elephant skin of another demon that he has just slain. No less turbulent are the episodes from the story of Vishnu Narasimha, who appears out of a pillar before his youthful devotee Prahlada, and then proceeds to disembowel Prahlada's wicked father, Hiranyakashipu, in an unparalleled act of fury. Battles provided artists with unrivalled opportunities for portraying gods and their enemies in the company of armed troops, horses and elephants, with arrows flying through the air and slain victims littering the ground. One of the most frequently depicted combats in all Hindu art is the war between Rama and Ravana, the multi-headed demon king of Lanka, taken from the *Ramayana*. Other combats are generally reduced to a pair of figures pitted against each other, such as Yudhishthira and Duryodhana, leaders of the opposing armies in the *Mahabharata*, or Arjuna grappling with Shiva disguised as a *kirata*, or forest hunter.

The *Ramayana* is the subject of countless temple reliefs and painted compositions. The story offers an enticing variety of settings: the palace in Ayodhya where King Dasharatha lives with his four sons, including Rama and Lakshmana; the forest to which these two brothers, together with Rama's wife Sita, are banished, and where they encounter their monkey allies; Ravana's stronghold on the island of Lanka where Sita is held in captivity and which the allies eventually capture and destroy. Furthermore, the *Ramayana* is packed with scenes of emotion and action: Rama and his brother Lakshmana saying farewell to their father; the combats between the heroes and the forest demons, including the ogress Taraka; Ravana's abduction of Sita in his aerial chariot, and the death of Jatayu, the valiant bird, who tries to intercept them; the struggle between the monkeys Sugriva and Vali, rival claimants to the throne of Kishkindha; the adventures of Hanuman, the monkey general, while discovering the whereabouts of Sita; the climactic battle between the armies of Rama and

15. Rama and Sita in the forest, a scene from the *Ramayana*. Mughal court at Agra or Lahore, 1590s; watercolour on paper.

26

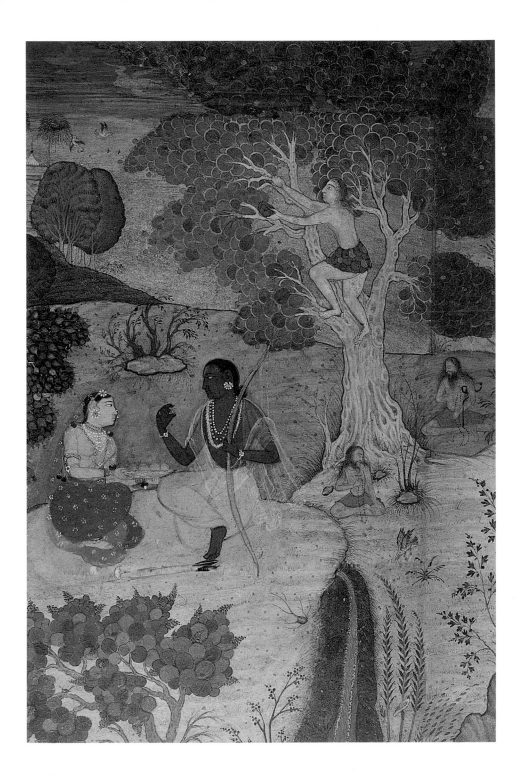

Ravana that has already been noted; Sita's ordeal by fire after her rescue, in order to demonstrate her innocence to the doubting Rama; and, bringing the epic to a triumphal conclusion, Rama's coronation in Ayodhya.

The Krishna legend is no less appealing, its various episodes providing abundant scope for animated storytelling in both sculpture and painting: the escape of the child Krishna from the murdering intent of Kamsa, the evil king of Mathura; Krishna and his brother Balarama being raised by the cowherd Nanda and his wife Yashoda; Krishna as a child mischievously stealing butter, 164 kicking the cart, and dragging a stone mortar to which he is chained; Krishna as a youth killing the ogress Putana by sucking at her breast, protecting the herds of cows from Indra's wrath by 118 lifting up Mount Govardhana, drinking in the flames of the forest 132 fire to save the flocks, and subduing the wicked serpent Kaliya by 115 dancing on its hoods. Throughout painted illustrations of these scenes, Krishna is distinguished by his blue skin, a characteristic explained by his name, which literally means 'blue-black'.

By far the most frequently depicted episode of the Krishna story is that in which the god appears as an amorous cowherd flirting with the gopis. Krishna entertains them by playing the flute or 126, dancing with them in a circle; he teases them by stealing their 145 clothes and hiding up a tree; he flirts unashamedly with Radha, his 116 favourite. When he comes of age, Krishna returns to Mathura; he wrestles with animal demons to gain admittance to the palace of Kamsa; finally, he grabs Kamsa's hair and pulls the king down from the throne and beheads him. With this last act of revenge, 130 most carved and painted cycles of the Krishna legend are brought to an end.

The number and variety of portrayals of Krishna with Radha far exceed the relevant chapters in the *Bhagavata Purana*; such scenes, in fact, are partly inspired by the verses of the *Gita Govinda* emphasizing Radha's longing for the absent Krishna, and her ultimate union with her lord. Other literary sources are also relevant here, most notably the *Ragamalas*, or Garlands of Melody. These descriptions of Indian musical modes, conceived in male and female form as *ragas* and *raginis*, are visualized as romantic-erotic situations in aristocratic settings. The courtly lovers who appear in the different phases of love-making are often 128 impersonated by Krishna and Radha.

No account of Hindu narrative art would be complete without notice of the Tamil saints. A bounty of miracles attends the tales of the deified devotees of Shiva: Sambandar cures the Pandya

ruler by applying holy ash, and restores a beautiful twelve-year-old girl who had died of a snakebite; Sundarar delivers a child from the jaws of a crocodile, and sings a hymn that causes the waters of the Kaveri river to part so that he might visit a shrine on the other bank; Chandesha cuts off his father's leg when the latter disrespectfully kicks the linga; Kannappa, the hunter, plucks out his own eyes to offer them to the blind linga of Shiva.

Magical protection
Other than the icons of deities and representations of their mythical exploits, there exists in Hindu art a wealth of accessory themes that have a crucial role to play in the magical protection of religious monuments. As the settings for the major cults of Hinduism and attendant rites of worship, temples require shielding from negative forces; hence the need for an effectively auspicious imagery. Such themes express the opposite but complementary tendencies of naturalism and fantasy that are such a feature of Hindu art.

The ritually protective purpose of temple sculpture and painting is taken literally. The *dvarapalas*, or guardian figures, placed on 48 either side of shrine doorways have fierce expressions and are invariably armed with clubs; they also bear the same emblems as those of the god or goddess whom they are defending. Dvarapalas are sometimes accompanied by dwarfish ganas, the custodians of 30 the treasures of the earth. Human warriors also contribute to the ritual protection of the temple, and martial themes commonly adorn basements and column shafts. Such compositions offer a 97 valuable insight into contemporary military life, complete with elephants, infantry, cavalry, musicians, standard-bearers and war-chariots. Warriors on leaping horses or fantastic beasts are singled out for special attention in many of these compositions.

Nor is the symbolic protection of the temple restricted to male figures. Hindu art is also celebrated for its female figures, especially the maidens known as *surasundaris*, or 'heavenly beauties'. 73 They appear as young women with generous hips, small waists and full breasts, and bewitching smiling countenances. They are shown in alluring postures that express the guises of female sexuality: attending to their toilette, holding a bird, recoiling from a scorpion, fending off a mischievous monkey. Surasundaris accompany dvarapalas at shrine doorways where, as Yamuna 30 and Ganga, the personifications of the sacred Jumna and Ganges rivers, they stand respectively on a tortoise and a *makara*, a type of 51 aquatic beast; as *shalabhanjikas*, clutching a branch or a creeper, 93

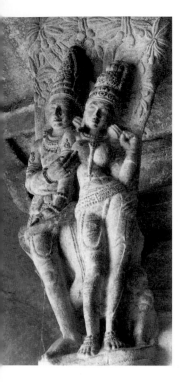

16. Mithuna couple beneath a fruiting tree. Bracket at the entrance to the Vishnu cave-temple at Badami in Karnataka, 578; sandstone.

they grace temple gateways, porches and balconies. Maidens adopt dance postures and play the *vina*, a stringed instrument, as well as cymbals and drums, thereby illustrating of the importance of music in temple worship.

Maidens appear together with male companions as embracing couples known as *mithunas*, a felicitous and ubiquitous motif in Hindu art. Standing couples adorn shrine doorways and porch brackets, while flying couples appear on temple ceilings, their draperies billowing outwards. The mithuna topic is sometimes developed into an overtly sexual theme, with couples engaged in copulating acts, even orgiastic groups. The facial expression of these figures is generally human and tender, imbuing such scenes with a lyrical erotic flavour far removed from pornography. Though sexual compositions are sometimes interpreted as portrayals of esoteric rites associated with Tantric cults, their presence in Hindu art is better understood as part of a widespread belief in the magical efficacy of sex to protect a sacred monument, hence their placing at the ritually vulnerable parts of temples.

Animals and flowers are a constant presence in Hindu art, attesting to the beneficial powers of nature. Animals provide a symbolic support for the temple, and for this reason plinths are often sculpted with processions of mighty elephants. Horses appear in leaping postures in conjunction with spoked wheels, transforming the temple into a chariot, the most celebrated example being the thirteenth-century sanctuary of the god Surya at Konarak in Orissa. The innate vitality of animals is evident in the fantastic beasts with terrifying eyes, tusks and horns, known in various parts of India as *vyalas* or *yalis*. These imaginary creatures guard the gateways to temples or line the approaches leading to the sanctuary; reduced to *kirttimukhas*, or 'monster heads', they animate towers and parapets.

Such fantastic visions contrast with the more obvious naturalism of bulls, which in Hindu art appear as placid agricultural animals. Nandi is seated comfortably, the bulk of the body displaced to one side, ceremonially decked in bells and clappers. Cobras, known in India as *nagas*, are much favoured for their magical powers connected with the underworld. Multi-headed nagas rear up protectively over the linga; Ananta or Shesha, the cosmic serpent supporting Vishnu, has already been noticed. Hybrid cobras appear with male (naga) or female (*nagini*) torsos and serpent hoods, sometimes paired in male-female groups. Aquatic creatures also populate this sacred bestiary, especially geese and crocodile-like makaras, both with fanciful tails.

100

109

1

17

42

101

18

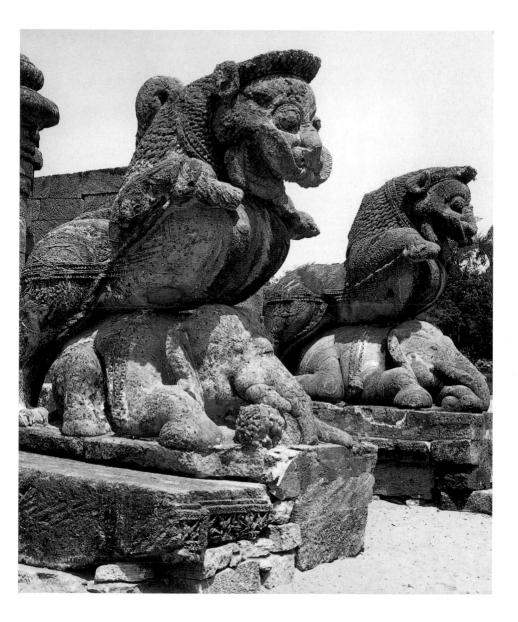

17. Guardian vyalas trampling elephants, in front of the Surya
temple at Konarak in Orissa, mid-thirteenth century; khondalite.

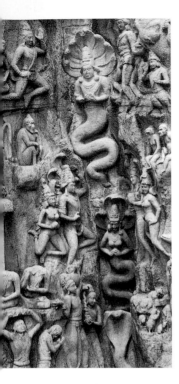

18. Naga king (above) and queen (below). Detail of the aquatic figures in the Ganges river, from a relief at Mamallapuram in Tamil Nadu (see p. 84 and Ill. 65), second half of the seventh century; granite.

Leafy scrollwork constitutes an entire repertory of decoration in Hindu art, much of it derived from the intertwining stalks, tendrils and petals of the lotus. This floral decor is distributed throughout the temple, with petalled garlands and pot-and-foliage designs on columns, friezes of undulating leafy stalks on doorway jambs and thresholds, and full lotuses with concentric rings of deeply cut petals on ceilings.

85

The architectural setting

Whether figural, animal or vegetal, the prolific imagery of Hindu art only gains meaning from the architectural setting which provides it with a ritual and symbolic context. Worship within a temple conforms to a simple pattern that appears relatively unchanged over some fifteen hundred years or so; nor do these rites vary substantially according to the requirements of the different cults. Worshippers approach the temple sanctuary in order to make visual contact with the sculpted image or emblem of the deity placed inside the *garbhagriha*, or 'womb chamber'. This act of seeing, called *darshana*, is central to all forms of veneration in India. The concern with direct visual contact means that sacred monuments are laid out so as to emphasize the progression from the entrance towards the sanctuary doorway. This axial principle is observed in the simplest shrines, which consist of little more than a garbhagriha with a doorway sheltered by a porch, as well as in large and elaborate complexes with sequences of walled enclosures, gateways, columned halls and corridors.

154

Whatever the scale of the Hindu monument, the garbhagriha is inevitably massive, dark and confined. Such qualities give the impression of a cave, reminding devotees of the natural grottoes where gods and goddesses like to manifest themselves. The garbhagriha doorway is of paramount importance since it signifies the threshold of the innermost sacred zone. Its jambs and lintels are adorned with the auspicious figural and vegetal motifs that have already been mentioned.

30

Alignments within the temple are not restricted to the horizontal axis: a symbolic vertical axis connects the image or emblem of the divinity inside the garbhagriha to the summit of the tower that rises above. The finial that crowns the apex of the superstructure is always positioned over the middle of the sanctuary beneath; in northern India, the summit is marked by a ribbed, disc-like element known as an *amalaka*, with a pot-like finial above. If the garbhagriha is reminiscent of a natural cave, then the tower represents a sacred mountain: hence the term *shikhara*, or 'peak',

39

by which this feature is known in northern India. Shikharas present characteristic curved profiles, often multiplied into clusters of secondary components to suggest an actual mountain range. The sacred imagery that crowds the upper stages of the towers affirms that the temple is truly a *devashthanam*, or 'seat of the gods'. Shiva himself resides on the summit of Mount Kailasa in the Himalayas; temples dedicated to him as Kailasanatha, the lord of Kailasa, are intended as replicas of his lofty abode.

The vertical axis of the temple is accompanied by other axes of symbolic relevance. The central points of the sanctuary walls are marked by niches housing accessory icons; these are aligned with the image or emblem that receives worship within. On visiting a temple, devotees circumambulate the garbhagriha in a clockwise direction, an act of homage known as *pradakshina*. Such rites explain the sequence of imagery on the sanctuary walls, sometimes contained within a walled-in passageway, as well as the distribution of subshrines, pavilions, altars and flag-columns in the compounds of larger sacred complexes.

In order to ensure the correct ritual and symbolic functioning of the temple, priestly scribes encoded much of this lore into building manuals known as the *Vastu Shastras*, some examples of which, like the *Manasara*, are traced back to the seventh or eighth century. These works classify information about the selection of the temple site, the laying out of the ground plan of the building, the merits of different materials, the proportional relationship between plan and elevation, and the mouldings of basement, cornice and tower. Temple diagrams, or *mandalas*, are usually squares subdivided into lesser squares, each representing a 'seat' of a god. Some mandalas are occupied by a figure called the *vastu purusha*, or cosmic man, whose limbs regulate the overall layout of the monument. That temple sanctuaries were actually erected on mandala plans described in the *Vastu Shastras* is revealed by their mathematically regular square layouts.

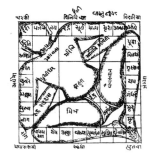

19. Crouching figure of *vastu purusha*, the cosmic man, whose limbs define the squared diagram on which the garbhagriha of the temple is to be built. From a manual on temple construction.

This obsession with numbers permeates all aspects of the sacred building; the garbhagriha in southern Indian temples is even termed *vimana*, 'well measured'. Plans and elevations are geometrically related, with the horizontal and vertical dimensions being derived from the size of the image or emblem that receives worship inside the garbhagriha. This numerical control symbolically links the temple with the mathematically determined structure of the universe.

Royal patrons

If the symbolic basis of Hindu architecture is bound up with seemingly timeless beliefs and practices, the actual construction of sacred monuments is related to historical events and individuals. Inscriptions on buildings and works of art record the pious donations of kings and queens, not to mention courtiers, commanders and merchants. One reason for the close relationship between royal figures and sacred art is the assumption that the ideal Hindu ruler was the upholder of *dharma*, traditional law, and the agent of moral well-being and prosperity. Accordingly, it was his or her duty to erect temples and commission carved and painted depictions of Hindu divinities.

While rulers were expected to assert their military power and display their authority whenever possible, they were also responsible for the spiritual welfare of their people. As chief worshipper, the king or queen generously endowed temples with gifts and grants of income from land so that rituals of devotion would be maintained at all times. He or she was rewarded for these benefactions by blessings from the deity which guaranteed victory for the ruler's troops and prosperity for the people. Only after promoting a particular divinity in this way could monarchs expect to gain sufficient power and influence. Displays of royal sponsorship in temple construction and religious ceremony were a crucial means of achieving legitimacy and maintaining control.

The role of kings and queens as worshippers finds expression throughout Hindu art. Royal figures, generally shown with the palms of their hands joined in the typical attitude of adoration, appear beside temple deities or in front of sanctuary doorways. Such portraits of royal patrons include a pair of sandstone figures 20 from Khajuraho in Madhya Pradesh. The stately costumes and sumptuous jewels of this royal couple are clearly delineated, so too their elegantly arranged hands performing a significant rite. Among the many other examples of royal portraiture in Hindu art is a mural on the linga shrine of the Brihadishvara temple at 107

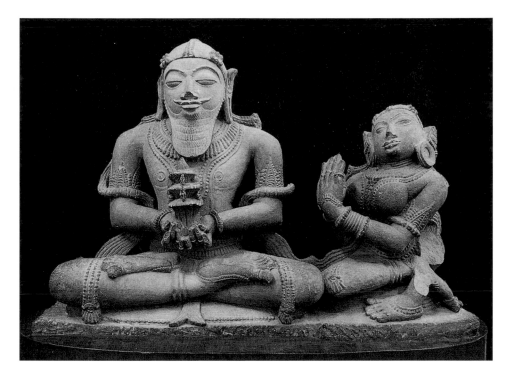

20. A royal couple performing a rite of temple worship. From Khajuraho in Madhya Pradesh, eleventh century; sandstone, H 42 cm.

Tanjavur in Tamil Nadu. This shows Rajaraja I, the eleventh-century Chola patron of the monument, in the company of his spiritual adviser.

Many Hindu dynasties associated themselves with a particular divinity who was considered the guardian of the royal household. As a potent source of power, goddesses were of special importance in this regard. Such protective deities appeared on regal documents and war banners to become a highly visible part of the king's domain. Temples expressly built for them were situated within the palace precinct to serve as private chapels for the king and his household. Where the deity was worshipped in a sanctuary some distance from the capital, a replica image or a schematic representation of the shrine in which it was housed might be painted onto the walls of the royal audience hall or private prayer chamber. Examples are the representation of Vishnu Padmanabha in the king's own shrine room within 173 the eighteenth-century palace at Padmanabhapuram (named after the god), which served as the residence of the kings of southern Kerala, and the view of the Shrinathji shrine at Nathdwara that appears in the murals of about the same period 127

that adorn the fortified headquarters of the Rajput rulers of Bundi in Rajasthan. There were, however, occasions when an auspicious image could actually be brought to the capital itself. Such was the case with an icon of Krishna under the name of Govinda-deva, removed from a temple at Vrindaban on the Jumna in Uttar Pradesh, and accommodated within a newly built shrine in the eighteenth-century palace of Sawai Jai Singh II in Jaipur in Rajasthan.

119

Rulers and their retinues made frequent pilgrimages to their chosen deities at far-off shrines. The twelfth- and thirteenth-century Ganga rulers of Orissa, for example, visited the Jagannatha temple at Puri, while the sixteenth-century Tuluvas of Karnataka were followers of Vishnu under the name of Venkateshvara worshipped in the hilltop shrine at Tirumala, as well as of Shiva in the riverside shrine at Kalahasti, a short distance apart in southern Andhra Pradesh. In fact, Achyutaraya, one of the most powerful of the Tuluvas, celebrated his coronation ceremony at both Tirumala and Kalahasti in 1529. Queens too were ardent devotees of deities at pilgrimage sites, none more so than Ahilyabai, the eighteenth-century Maratha queen who ordered the construction of the Vishvanatha temple at Varanasi, the most important of all Hindu sacred cities, situated on the left bank of the Ganges in Uttar Pradesh.

87

Some Hindu temples fulfilled the needs both of divine worship and of royal commemoration. Two sister queens of Vikramaditya II, the Early Chalukya ruler of Karnataka, commissioned a matching pair of temples at Pattadakal in the early eighth century to celebrate a military victory of their lord. Some three centuries later, the Chola king Rajendra I erected a temple at Gangaikondacholapuram to glorify his successful march northwards as far as the Ganges. A carved panel on the monument possibly depicts the royal founder as a saint receiving a victory garland from Shiva himself. Temples in later times were sometimes built in memory of a deceased king or queen, thereby serving as a funerary monument, though without enshrining any human remains. Known in northern India as *chhatris*, such structures usually accommodated a small linga that represented the deified presence of the royal figure.

108

Royal sponsorship of Hindu shrines in India is now a thing of the past, though the descendants of some royal families continue to participate in temple ceremonies. These acts sustain the crucial relationship between rulers and gods that has underpinned so much of Hindu art and architecture in the past.

21. Column of Heliodorus, at Besnagar near Vidisha in Madhya Pradesh, Shunga period, first century BC; H 6.5 m. The image of Garuda that topped the column, and the associated sanctuary of Vishnu under the name of Vasudeva, have vanished.

Chapter 2: Beginnings: second century BC to second century AD

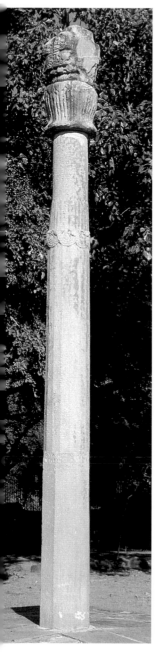

While the sacred scriptures of Hinduism are traced back to the middle of the first millennium BC, if not earlier, the fact remains that Hindu temple architecture and art are comparatively late phenomena. No sanctuary associated with a Hindu cult has yet been discovered that predates the fifth century AD. This does not mean that Hindu shrines did not exist in earlier times, but, rather, that such structures must have been fashioned out of wood and other ephemeral materials, and have simply vanished. What does survive, however, is the occasional relic with Hindu cult associations. The most historically significant of these is a 6.5-metre-high inscribed sandstone column standing at Besnagar, near Vidisha in Madhya Pradesh. A first-century BC record on the shaft mentions that it was set up in honour of the god Vasudeva, an early name of Vishnu. The inscription refers to the column as a Garuda standard, presumably because it originally bore an image of Vishnu's eagle mount on top, of which no trace can now be found. The patron is named as Heliodorus, emissary to the Shunga court at Vidisha from Taxila, capital of the Gandhara kingdom in northern Pakistan.

Heliodorus' column suggests that a cult of Vishnu must once have flourished in this part of northern India during the Shunga period in the second–first centuries BC. However, the stone icons belonging to that era found in and around Vidisha do not depict the gods or goddesses of Hinduism; instead they show human-like spirits implying wealth and abundance known as *yakshas*. These first-century BC sandstone figures depict imposing standing males with ample stomachs, dressed in pleated garments and heavy jewelry, carrying auspicious water pots. Comparable female figures, or *yakshis*, also occur in Shunga art, as in the moulded terracotta plaques found at various sites in West Bengal. One example from Tamluk, an ancient port on the Bay of Bengal, portrays a beautiful maiden with ample hips decked in elaborate ornaments, including a jewelled belt and earrings; her bunched hair is adorned with pins. Yakshas and yakshis are not specifically

21

22

22. A yakshi, on a moulded plaque from Tamluk in West Bengal, Shunga period, second century BC; terracotta. Linked with fertility and prosperity, such female figures are common to both Buddhist and Hindu art.

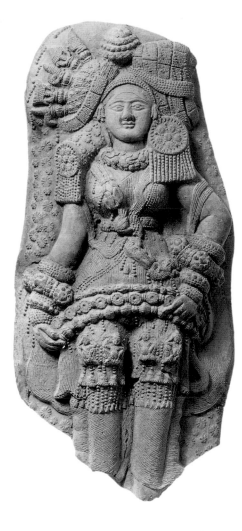

Hindu divinities, but they are manifestations of a sub-stratum of Indian folk beliefs inherited by both Buddhism and Hinduism, and are thus considered here. They represent the origins of the dvarapalas and surasundaris that flank the entrances to later Hindu temples.

30, 48

The Buddhist heritage
The beginnings of Hindu architecture and sculpture are much indebted to the monumental art of Buddhism. Adopted as the official cult by Ashoka (*c.* 272–31 BC) and other rulers of the Maurya kingdom of northern India, Buddhism rapidly became the dominant state religion from the second century BC onwards.

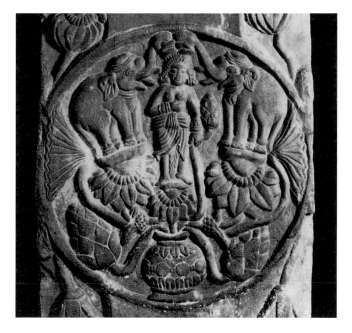

23. Medallion from a railing post of the stupa at Bharhut in Madhya Pradesh, Shunga period, second century BC; sandstone. Lakshmi is shown as the lotus goddess, being bathed by elephants holding upturned pots in their trunks; all stand on lotus flowers emanating from a single pot.

Because of the active policy of propagation by Ashoka and his successors, it was the first religion in India to exploit the possibilities of an official art realized in permanent materials. The principal building forms of Buddhism are the *stupa*, or hemispherical funerary mound identified with the Buddha and his teachings, and the *vihara*, or monastery, with cells for monks arranged around an interior square court.

Stupas and viharas dating from the Shunga period, built of stone or brick, survive in a ruinous condition at several sites in Madhya Pradesh. The stupa at Sanchi, a short distance from Vidisha, for example, is surrounded by a circular railing interrupted at the cardinal directions by limestone portals known as *toranas*. These have posts and lintels covered with carvings that illustrate the life of the Buddha and other popular legends, together with yakshas equipped with spears, and yakshi-like *shalabhanjikas* clutching the branches of trees. The stupa at Bharhut was similarly adorned, but has now been dismantled and its sculpted elements dispersed. Among the subjects depicted in the carved roundels on the railing that surrounded it is Lakshmi: known in later Hindu art as the consort of Vishnu, she appears here as a lotus goddess symbolizing wealth and good luck.

23

Buddhist architecture under the Shungas also developed rock-cut techniques by which cliff faces were laboriously hewn

into elaborate façades, complete with verandahs and doorways, leading to excavated shrines and monasteries. The *chaitya*, the most characteristic rock-cut form, is a semicircular-ended hall divided into triple aisles by rows of columns, with a votive stupa at one end; the entrance is marked by a horseshoe-shaped arch continuing the profile of the vault within. Together with similarly excavated viharas, chaitya halls imitate the arched and vaulted forms of flexible timbers and bamboo. That such a wooden tradition may have co-existed with excavated techniques is suggested by reliefs and murals on these monuments. They depict multi-storeyed buildings with curved eaves and vaulted roofs with projecting arch-like windows, features all to be encountered in later structural Hindu temples.

Buddhist architecture continued to evolve up to the fifth and sixth centuries AD, and is, therefore, contemporary with the earliest Hindu monuments (see Chapter 3). That the two traditions overlapped artistically and technically is obvious from shared features such as columns with capitals fashioned like compressed cushions or adorned with pot-and-foliage motifs, and doorways flanked by armed guardians and surrounded by lotus bands and mithunas. Interchanges also took place between Buddhist and Hindu icons: seated images of the Buddha meditating beneath the multi-hooded canopy of the serpent Muchalinda resemble those of seated Vishnu protected by Ananta; reclining images of the Buddha dying are akin to those showing sleeping Vishnu floating on the cosmic ocean. Some deities make an appearance in both the Buddhist and Hindu pantheons, most notably the goddess Lakshmi, who has already been mentioned, and nagas with human upper bodies sheltered by serpent hoods. Among the minor characters that populate both Buddhist and Hindu art are the river goddesses Ganga and Yamuna, embracing mithunas, and pot-bellied ganas. As for the ubiquitous lotus, the basis of virtually all ornament in India, this has a long and varied career in both Buddhist and Hindu architecture. In the end, none of these themes can be classified as purely Buddhist or Hindu; rather, they belong to the wider visual world of Indian art.

11

24. Linga with a full figure of Shiva carved onto its shaft, under worship in the Parashurameshvara temple at Gudimallam in Andhra Pradesh, Shunga period, first century BC; sandstone, H 1.5 m. This is the earliest depiction of Shiva in Hindu art.

The earliest Hindu images

In addition to this collective artistic heritage of Buddhism and Hinduism, a small number of sculptures representing specifically Hindu emblems and deities are known from the Shunga period, dating back to the second century BC. This modest corpus of images extends up to the second century AD, after which there is

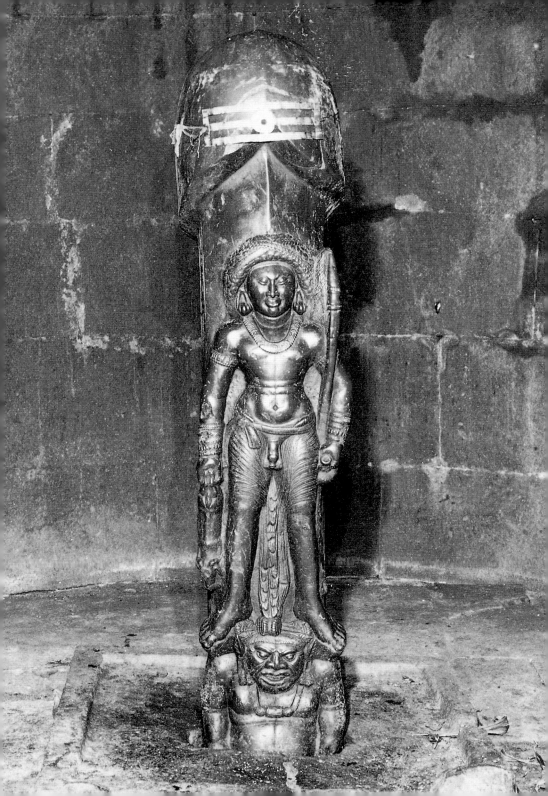

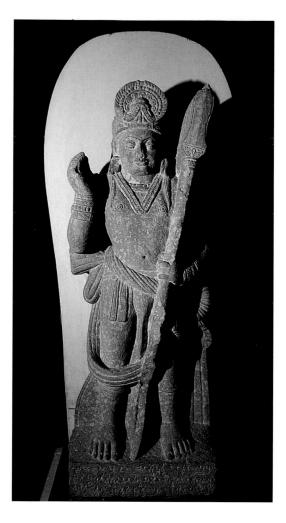

25. The youthful battle god Karttikeya, from Mathura in Uttar Pradesh, Kushana period, second century AD; sandstone. An early example of a Hindu image modelled on the massive male yaksha figures of earlier times.

an inexplicable break in the artistic record. Carved stone icons of Hindu gods and goddesses have been unearthed at various sites throughout India, generally as isolated artefacts devoid of any architectural settings. This overall lack of context suggests that Hindu cults were still in an early stage of formation and had not yet gained widespread acceptance.

By far the finest Shunga period artefact with a definite Hindu cult affiliation is the first-century BC linga still under worship at Gudimallam in southeastern Andhra Pradesh. This 1.5-metre-high emblem is carved as a naturalistic phallus with a figure on the shaft, identified as Shiva himself. The god stands on the shoulders of a dwarf with a grimacing face, and holds an axe in one hand and

24

an antelope body in the other. His scanty dress reveals his sexual organ, his hair is thickly matted, and he wears large earrings. While all these attributes, including the dwarf mount, are encountered in later depictions of Shiva, the coincidence of naturalistic phallus and full standing image is unique. (In later combinations of phallic and anthropomorphic forms, Shiva is generally reduced to one or four faces gazing outwards from the linga.)

37

Sculpted depictions of Hindu deities are also known from the Kushana period in the first and second centuries AD. Mathura in Uttar Pradesh, one of the capitals of the Kushana kings of northern India, is renowned for its varied imagery, both Buddhist and Hindu. One fragmentary relief represents a linga shrine with a simple phallic emblem set up beneath a tree and surrounded by a railing; winged beasts with human torsos and lion bodies are shown worshipping on either side. This scene gives an idea of how the Gudimallam linga might once have appeared; indeed, just such a railing was discovered beneath the floor slabs in which it is now embedded. Other Kushana period sculptures from Mathura include Surya accompanied by two horses, and an image of Karttikeya holding a spear. Fashioned out of the mottled red sandstone common in the Mathura region, the deities are carved in the bulky but imposing manner that is a hallmark of Kushana art.

25

Coins issued by another line of Kushanas ruling over the kingdom of Gandhara add to the known repertory of early Hindu imagery. Gold coins from the first and second centuries AD show a standing god holding a trident accompanied by a massive bull, obviously an early form of Shiva together with Nandi. Such diminutive images offer crucial evidence for the growing importance of Hindu cults and the beginnings of a specifically religious art. It is, however, only after an interval of more than two hundred years, marked by an almost total absence of stone and terracotta sculptures, that Hindu art emerges with a full repertory of icons and styles.

26
59

26. Gold coin showing a god holding a trident and standing in front of a bull, from northern Pakistan or Afghanistan, Kushana period, first century AD; D c. 2 cm. An important item of evidence for the early development of the cult of Shiva.

Chapter 3: Early Maturity: fifth to ninth centuries

After the tentative beginnings outlined in Chapter 2, followed by a somewhat mysterious gap in the third and fourth centuries, Hindu art and architecture come into full being, rapidly attaining maturity of form and style. This sudden development appears to have resulted from the vigorous support of Hindu cults by newly established ruling houses, most notably the Guptas and Pratiharas in northern India and the Early Chalukyas and Pallavas in the south. The achievements of this wave of sponsorship are obvious in the earliest temples and their attendant sculpted imagery.

Hindu sacred architecture in the first five hundred years or so that constitute this phase makes the transition from the rock-cut medium to structural techniques, most characteristically expressed in corbelled sandstone and granite. Major stylistic differences are apparent in the earliest examples, and it is convenient to make a broad distinction between northern and southern Indian modes, best seen in the superstructures rising above the sanctuaries. Temples in the north have *shikhara* towers, 39 characterized by gently curved profiles. They are ornamented with distinctive horseshoe-shaped arches, known as *gavakshas*, 41 and capped with ribbed disc-like elements, or *amalakas*. Such motifs distinguish these temples from their southern Indian counterparts, where superstructures are pyramidal and multi- 68 storeyed, each stage being topped by a parapet composed of model roof forms of different shapes. Sacred monuments in both traditions incorporate a full range of carved images set into wall niches, and have an ornate sculpted decor that invades all parts of the building, from exterior basement mouldings and cornices to interior columns, brackets and ceilings.

Hindu sculpture in this phase is unparalleled for the multiplicity of icons integrated into a single architectural setting; such compositions demonstrate that even the earliest Hindu temples were conceived as 'seats of the gods', with multiple images of different deities. Carved representations are often devised as mythological tableaux that illustrate divine acts of deliverance

and destruction. Crowded compositions present gods and goddesses in the company of their retinues, attendants and animal vehicles. Emotional and dramatic content is expressed through contrasts between gracefully posed figures with otherworldly detached expressions, and those in aggressively active postures with terrifying eyes and tusks. As in architecture, it is convenient to discriminate between developments in the different regions so as to appreciate fully the individuality of local artistic traditions. Such stylistic variations in sculpture are evident from the very beginning of this phase.

Madhya Pradesh and Uttar Pradesh under the Guptas, Mauryas and Pratiharas

The Guptas and their feudatories in northern India sponsored both Buddhist and Hindu cults in the fifth and sixth centuries. The earliest Gupta Hindu shrines for which any historical evidence is available are the cave-temples at Udayagiri in Madhya Pradesh, one of which bears a record of Chandragupta II (ruled *c.* 380–415) with a date that corresponds to AD 401. The exteriors of these monuments are featureless, except for doorways carved into the sandstone cliff face. One example enshrines a linga with a single face of Shiva; the god has a third eye in the middle of his forehead, and is decked with flowing tresses, attributes that will recur in later depictions. The entrance to the dated cave-temple at Udayagiri is flanked by diminutive maidens clutching trees. At either side are relief panels showing guardians leaning on clubs, together with Vishnu and Durga. Vishnu stands stiffly, two of his four hands placed on his hips; he wears a costume with falling tassels and a tapering crown. Twelve-armed Durga appears together with Mahisha into whose buffalo body she plunges her spear, pinning down the animal's head with her foot. A relief of the Saptamatrikas is seen nearby.

By far the most impressive sculpted composition at Udayagiri is a magnificent relief of Vishnu in his incarnation as Varaha. The god is shown stepping out of the cosmic waters, suppressing an aquatic creature with one foot, his boar head affectionately nuzzling the tiny figure of the goddess Bhudevi who clings to his left shoulder. Sages praising this miraculous act are arrayed in rows on either side. The shallow relief of these subsidiary figures contrasts with the full modelling of Varaha, thereby emphasizing the monumentality and bulk of the otherwise human body and limbs of the god. While the scene is an obvious representation of one of the most celebrated Hindu myths of salvation, it is also

27

27. Varaha, the boar incarnation of Vishnu, rescuing the goddess Bhudevi. Rock-cut relief in the cave-temple at Udayagiri in Madhya Pradesh, Gupta period, fifth century; sandstone, H 4 m. This composition has been interpreted as a political allegory of the Gupta kings.

thought to be an allegory of the Gupta kings as universal rescuers and protectors.

Further examples of Varaha in Gupta art include a three-dimensional sculpture from Eran in Madhya Pradesh; dated also to the fifth century, it has the same massive body and assertive posture that characterize the Udayagiri relief. A standing Vishnu at the same site shows the god in a stiff frontal pose accentuated by his crowned head and the large halo. Eran is also of interest for a 13-metre-high column dedicated to Vishnu, dated 484, in the reign of Budhagupta (*c.* 477–500). This has a fluted bell-shaped capital on top of which are back-to-back seated lions, a design that recalls the much earlier ceremonial columns erected by Ashoka. The Eran column, however, is surmounted by double-sided standing images of Vishnu's mount Garuda with unusual human, rather than eagle, heads. The cut-out spokes of the disc placed

28

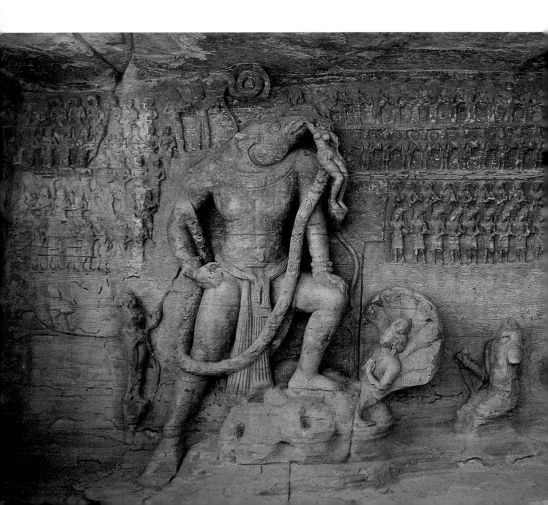

28. Standing Vishnu at Eran in Madhya Pradesh, Gupta period, fifth century; sandstone. The massive stance and bulky modelling are typical features of the Gupta style.

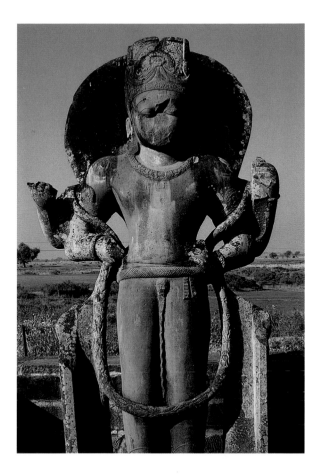

behind the heads suggest that in Gupta times Vishnu may have been considered a solar deity.

The Guptas are also to be credited with initiating the first phase of structural Hindu temple architecture in northern India. The small shrines that they erected generally comprise a square garbhagriha or sanctuary preceded by a columned porch. The fifth-century temple at Tigawa in Madhya Pradesh has plain outer walls topped by a flat roof; porch columns display pot-and-foliage capitals with pairs of back-to-back seated lions above. (An almost identical shrine stands at the Buddhist site of Sanchi in Madhya Pradesh, demonstrating close links with contemporary Buddhist architecture.) By about 600 this architectural type had developed into a more elaborate structure and was elevated on a plinth. The Parvati temple at Nachna in Madhya Pradesh has a podium with rusticated blocks, referring to the rocky mountainous home

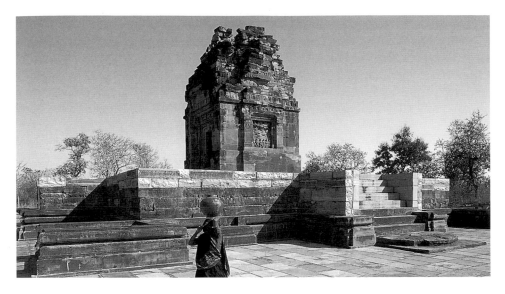

29. Dashavatara temple at
Deogarh in Madhya Pradesh,
Gupta period, sixth century.
The square sanctuary elevated on
a plinth is all that remains of this
important early Hindu monument.

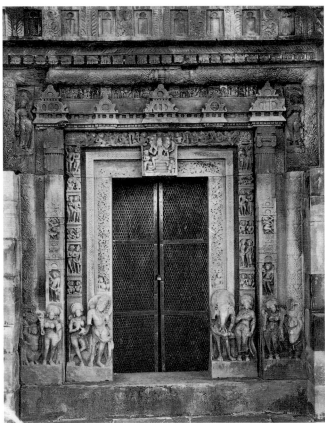

30. The entrance doorway of the
Dashavatara temple is flanked by
mithuna couples, attendant
maidens, and dwarfish ganas;
mithuna couples alternating with
ganas cover the jambs; the block
in the middle of the lintel shows
Vishnu seated on the coils of the
cosmic serpent Ananta, sheltered
by its multiple hoods; in the
outermost corners are the
goddesses Ganga, on the makara
(left), and Yamuna, on the tortoise
(right).

of Shiva. The garbhagriha itself consists of superimposed square chambers, the upper one forming the base of a tower, now lost. The lower chamber is entered through an ornate doorway with decorated pilasters and jambs covered with delicately carved foliate ornament, mithuna couples and river goddesses. It was once surrounded by a walled passageway lit by stone screen windows on three sides, the earliest known example of this feature in Hindu architecture.

A more elaborate version of this scheme is seen in the early sixth century at Deogarh in Madhya Pradesh. The Dashavatara temple is raised on a rectangular terrace, from the corners of which subsidiary shrines, now lost, projected outwards. Only a few courses of the tower over the square garbhagriha survive in situ, but these are decorated with characteristic gavaksha arches. The garbhagriha is entered on the west through a doorway flanked by slender shafts with diminutive pot-and-foliage capitals.

29

30

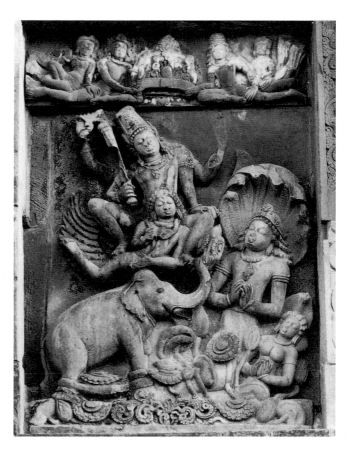

31. A relief on the sanctuary wall of the Dashavatara temple shows Vishnu on Garuda (here human-faced) liberating the elephant Gajendra from the clutches of a naga king and queen, who submit to the god with hands clasped in respect; sandstone.

Carved compositions set into the side walls of the sanctuary show Vishnu in various forms surrounded by fanciful foliate bands. In one panel the god reclines on Ananta in the company of Shiva riding on the bull, Indra on the elephant and four-headed Brahma on the lotus; in another, Vishnu descends to earth on the back of Garuda to deliver Gajendra, an elephant devotee of the god who had been trapped in a lotus pond.

Not all Gupta temples are built of stone: one of the most complete examples from this period is the brick structure at Bhitargaon in Uttar Pradesh. Also assigned to the fifth century, this temple has its outer walls divided into bays by shallow pilasters with decorated capitals framing terracotta panels. Similar panels set in gavaksha-like frames enliven the ascending stages of the pyramidal tower, now ruined. Most of the plaques at Bhitargaon are badly damaged, but other examples survive to give an idea of terracotta art at this time, such as a pair of fully modelled, almost human-size river goddesses removed from a ruined temple at Ahichhatra, also in Uttar Pradesh; dressed in pleated saris and carrying water pots, Ganga and Yamuna stand

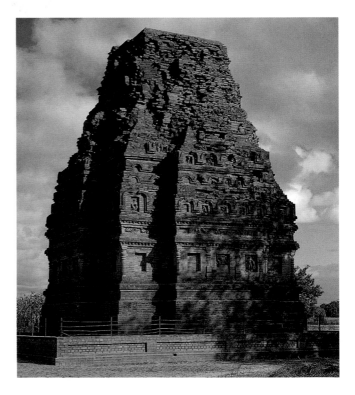

32. Temple at Bhitargaon in Uttar Pradesh, Gupta period, fifth century. A rare example of early Hindu brick architecture, complete with its tapering shikhara tower covered with gavaksha-like niches framing terracotta panels.

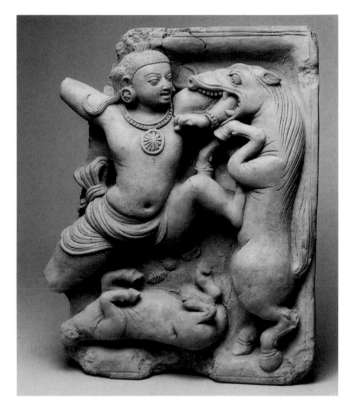

33. Youthful Krishna fighting the horse demon Keshi. Plaque from a ruined temple in Uttar Pradesh, Gupta period, fifth century; terracotta, H 53 cm. Krishna's aggressive kicking posture combined with the tightly framed composition convey the violence of the combat between the god and demon.

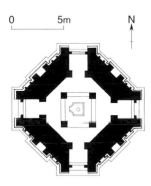

0 5m N

34. Plan of the Shiva temple on Mundeshvari hill in Bihar, 636. Though the outer walls are laid out on an octagonal plan, the garbhagriha is square; in the middle, installed in a pedestal, is a linga carved with faces of Shiva gazing outwards through the doorways on all four sides.

comfortably on a makara and a tortoise respectively. Other terracotta panels concentrate on mythological narratives, such as a plaque showing the youthful Krishna fighting the horse demon Keshi, from an unknown site, again in Uttar Pradesh.

Temple architecture and art in this part of northern India after the sixth century sustain the traditions established by the Guptas. The brick-built Lakshmana temple at Sirpur, founded in the early seventh century by the mother of Mahashivagupta Balarjuna (c. 595–600), ruler of southeastern Madhya Pradesh, is of interest for its fully preserved shikhara. The ascending stages of the curving tower are marked by clearly articulated amalakas at the corners, each of which terminates a subsidiary tier of mould-ings, and prominent gavaksha motifs in the middle. Another post-Gupta period temple is that on Mundeshvari hill in Bihar. Consecrated in 636, the earliest date for a structural Hindu monument in northern India, the sandstone building is laid out not on the usual square plan, with an entrance porch on one side, but as an octagon. Doorways on the cardinal faces are flanked

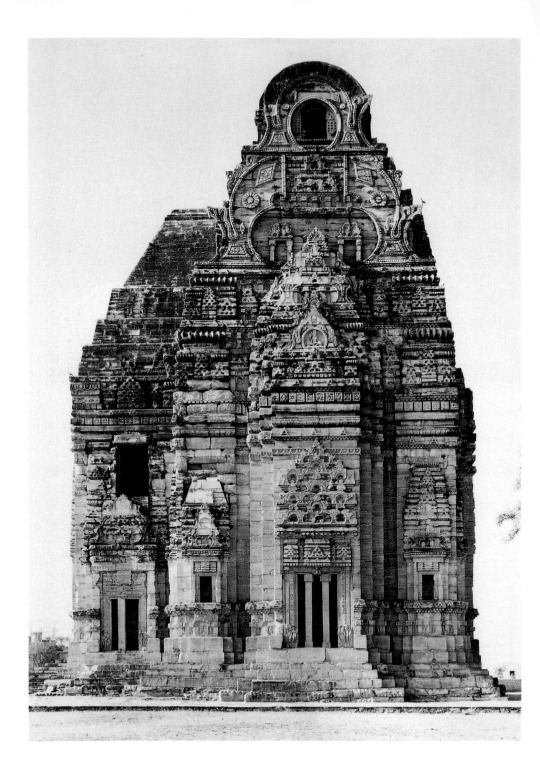

35. (opposite) The Teli-ka Mandir in the fort above Gwalior, Madhya Pradesh, Maurya period, second quarter of the eighth century. The evolution of the northern Indian temple style is expressed through the varied use of the gavaksha arch motif: full and half arches mark the ends of the barrel-vaulted shala roof that crowns the tower, and complex meshes of small arches create the pediments above doorways and niches.

36. (above left) Bust of a maiden, from a temple in Gwalior, Madhya Pradesh, Pratihara period, ninth century; sandstone, H 51 cm.

37. (above right) Linga in the Chaturmukha Mahadeva temple at Nachna in Madhya Pradesh, Pratihara period, ninth century; sandstone. Around the shaft are four faces that express the various natures of Shiva.

by fully evolved basement mouldings, with niches topped by triangular pediments composed of gavaksha elements in between. All that remains of the tower are blocks strewn all about, many with gavaksha and amalaka motifs. The octagonal interior has four slender columns carrying a raised ceiling over a four-faced Shiva linga.

The next phase in the evolution of Hindu art and architecture in this region occurs during the eighth and ninth centuries under the patronage of the Maurya and Pratihara rulers of Kanauj. (The Mauryas referred to here bear no relationship to their namesakes of the third–second century BC.) The Teli-ka Mandir in Gwalior in Madhya Pradesh, associated with the Maurya king Yashovarman (c. 720–50), represents a remarkable stylistic and technological advance. Doorways and niches set into the outer sandstone walls of the rectangular garbhagriha are surmounted by complicated mesh patterns created by interlocking gavakshas. The tower rises almost 30 metres in a series of stages decorated with full and half gavakshas in different planes; the topmost stage is shaped as a barrel vault, or *shala*, with large gavaksha arches at

35

the ends. Figural sculpture is confined to the doorway surrounds, where there is the usual complement of river goddesses, guardians and attendants maidens.

That Hindu sculpture in Madhya Pradesh was also undergoing an iconographic evolution under the Pratiharas is suggested by a ninth-century image of Vishnu in his cosmic form as Vishvarupa, removed from a dismantled temple in Kanauj in Uttar Pradesh. The eight-armed god carries various weapons and is furnished with boar and lion faces at the sides, referring to his Varaha and Narasimha incarnations respectively. Vishnu stands on Ananta, surrounded by lines of miniature warriors and adoring figures in a vision of cosmic grandeur. But Pratihara sculpture could also capture a more intimate spirit, as is demonstrated by a bust of a female figure from an unknown temple in the Gwalior region. The 36 subtle facial expression of this voluptuous maiden is complemented by the richly carved necklace, earrings and headdress. This gentle articulation of female beauty contrasts with the heads of Shiva carved onto the four-face linga still under worship 37 in the Chaturmukha Mahadeva temple at Nachna (not to be confused with the Parvati shrine at the same site). One of these faces is provided with staring eyes and an open mouth that express the violent aspect of Shiva.

Gujarat under the Maitrakas; Rajasthan under the Pratiharas
Following the decline of the Guptas in the sixth century, western India came into prominence under the Maitrakas of Gujarat and a related branch of the Pratiharas in Rajasthan. Both these lines of rulers were actively engaged in temple building, and it is thanks to their patronage that western India developed its own individual art traditions. Among the earliest Hindu temples in Gujarat is the ruined structure at Gop dating from the end of the sixth century. Elevated on an elaborate plinth with deep niches, now empty, is a square-towered garbhagriha topped with double tiers of sloping roofs, punctuated by prominent gavaksha arches. Of the surrounding passageway, only the lower part of the walls remains. While the Gop temple is devoid of carvings, contemporary Hindu monuments at Samalaji on the Gujarat–Rajasthan border have yielded a remarkable series of sculptures. They include a gracefully posed guardian decked with snakes and holding a trident. Sculpted out of grey schist, the figure stands in front of a rocky landscape suggesting the mountainous home of Shiva. Even more remarkable is the sandstone image of Vishvarupa currently under worship in the Nilakantha Mahadeva temple at the same site. Like

38. Mother with child, from Tanesara in Rajasthan, Pratihara period, sixth century; green schist, H 76 cm. The halo behind the head of the mother suggests that she may have been worshipped as one of the Saptamatrikas or Seven Mothers.

the example from Kanauj already referred to, the panel shows multi-armed Vishnu surrounded by attendants, with subsidiary crowned figures emerging from the triple heads of the god. Other sixth-century sculptures from Samalaji focus on more intimate themes, including tender portrayals of mothers cradling children in their arms. Such topics must have been popular in western India at this time because a number of examples of the same subject are also known from the site of Tanesara in Rajasthan.

Seventh- and eighth-century architectural developments in western India are best represented by sandstone temples at Osian in Rajasthan and Roda in Gujarat. While they tend to repeat the earlier Gupta scheme of a small square garbhagriha preceded by a porch, the elevational treatment is much evolved. Outer walls raised on simple sequences of basement mouldings are enlivened by sculptures in the middle of each side, surmounted by triangular pediments with mesh-like designs created from interlocking gavakshas. Similar patterns cover the faceted surfaces of the curving towers, which assume the characteristic northern Indian shikhara form, complete with capping amalakas. Porches remain simple, interest focusing on faceted columns with pot-and-foliage designs at the capitals, and doorways surrounded by figures and lotus ornament. Porches in some of the Roda temples have tiers of sloping roofs punctuated by gavaksha motifs.

The more evolved sanctuaries at Osian are raised on terraces with basement mouldings and shallow niches topped by gavaksha pediments. Harihara temple 1 has subsidiary shrines at the four corners of the terrace, each with a shikhara tower that imitates the superstructure rising over the central sanctuary. Columned halls, or *mandapas*, are added to these larger shrines, providing a roofed space that precedes the garbhagriha doorway. They are generally open, with sloping-backed seating around the sides sheltered by overhanging eaves. Columns with ornate pot-and-foliage motifs support beams and horizontal roof slabs, also adorned with lotus designs.

Temple sculpture in Gujarat and Rajasthan in the eighth and ninth centuries, though continuing the Gupta traditions, does not attempt the large-scale compositions of earlier times. Even so, figures in wall panels preserve an attractive fullness of form and clarity of posture. This is best seen in niche carvings at Osian. Vishnu Trivikrama, for instance, is shown with one leg kicked high in the act of pacing out the universe; he wears a conical crown and carries a clearly sculpted disc and staff. Other popular icons at this site are Harihara, a syncretic form of Vishnu and

39. Harihara temple 1 at Osian in Rajasthan, Pratihara period, eighth century. The complex comprises five shrines marked by shikhara towers, which are covered by tiers of gavaksha arch motifs with subsidiary amalaka elements at the corners.

Shiva united, to whom many of the temples here are dedicated. Surya also appears in the Osian temples, the god being recognized by the lotuses held in his two hands. All these figures are integrated into wall niches framed by pilasters with pot-and-foliage capitals and triangular pediments of interlocking gavakshas.

Further instances of the sculptural art of Rajasthan in the eighth century are the panels set into the terrace of the ruined Harshat Mata temple at Abaneri. Courtiers accompanied by maidens and warriors appear repeatedly on the monument. Their sweet expressions, rounded forms and graceful postures express an undeniable charm. The same is true of the river goddesses, accessory maidens and guardian figures that are arranged in symmetrical compositions flanking the doorways in temples at other contemporary sites in Rajasthan. The smoothly

40

40. The sun god Surya standing in an ornate niche headed by a gavaksha pediment, on the Surya temple at Osian, Pratihara period, eighth century; sandstone. Unlike most other Hindu gods, Surya has only two hands; each holds a full lotus flower.

modelled figures, with clearly delineated facial features and pronounced swaying postures, are an obvious development of Gupta prototypes.

Orissa under the Shailodbhavas and Bhauma Karas
One of the most distinctive regional interpretations of the northern Indian temple style is seen in Orissa, where there is an almost continuous artistic progression from the seventh to the fourteenth centuries. Only the first phase is described here, beginning with the red sandstone monuments of the Shailodbhava kings of Bhubaneshwar. The seventh-century Parashurameshvara temple, 41

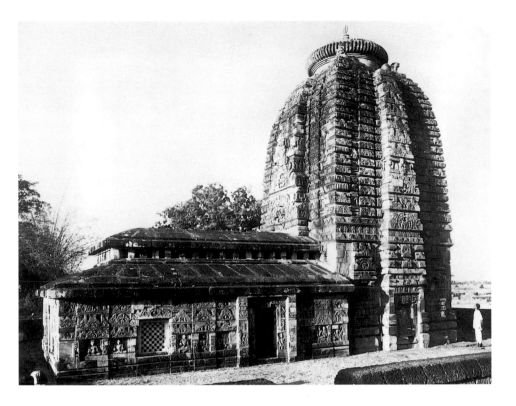

41. Parashurameshvara temple in Bhubaneshwar, Orissa, Shailodbhava period, seventh century. The tower with its vertical lower walls and curving upper portions, and capping large disc-like amalaka, is typical of the rekha deul form of Orissa. The sanctuary is approached through a rectangular hall or jagamohan, which is lit by pierced stone screens in the walls and clerestory windows at roof level.

the finest of the early group, comprises a towered sanctuary of the shikhara type, known in local terminology as a *rekha deul*. This is entered through an elaborate doorway on the west; wall niches on the other three faces accommodate images such as Karttikeya holding a spear and accompanied by a peacock. The niches are raised on basement mouldings marked by carved blocks with animal torsos and miniature figures, and headed by pediments composed of full and split gavakshas. The tower of the rekha deul rises vertically for most of its height, curving inwards only towards the top, where seated lions are placed at the corners. The composition is crowned by a prominent ribbed amalaka and a pot-like finial. The faceted sides of the tower are divided into horizontal layers which combine smaller amalaka motifs with gavakshas, some split into halves. Central panels on each side have large gavaksha frames filled with icons of Shiva Nataraja and Lakulisha, the latter showing Shiva in seated posture holding a club. The rekha deul adjoins a rectangular hall, or *jagamohan*, probably a slightly later addition, with roof slabs raised over the central aisle and sloping over the side aisles. The jagamohan is

42. A detail of the tower of the Vaital Deul temple in Bhubaneshwar, Orissa, Bhauma Kara period, eighth century; sandstone. Above, Shiva Nataraja is set in a circle in a full gavaksha headed by a kirttimukha; below, Surya in his horse-drawn chariot is framed by two lobed half-gavakshas.

entered through doorways flanked by windows filled with pierced stone screens enlivened with dancers and musicians. The animated postures and the shallow relief carving are characteristics of the early Orissa style.

The Vaital Deul in Bhubaneshwar is associated with the Bhauma Kara kings who displaced the Shailodbhavas as masters of Orissa in the eighth century. The temple has an unusual rectangular sanctuary which is consecrated to the fierce goddess Chamunda in the company of subsidiary female divinities. Its outer walls have shallow projections flanked by bands of luxuriant foliage. These frame maidens in alluring poses, their hands held on their hips or raised over their heads, as well as goddesses, including Durga energetically spearing Mahisha. A shala roof with arched ends rises above, its ridge punctuated by prominent pot-like finials. Gavaksha compositions on the long sides of the tower contain icons below kirttimukha masks, that on the front face showing Shiva Nataraja within a large gavaksha flanked by makaras. The exterior of the adjoining jagamohan is of interest for the miniature shrines topped with square shikhara towers; these are incorporated into the four corners of the building.

Similar miniature shrines mark the corners of the hall of the contemporary Madhukheshvara temple at Mukhalingam, also built by the Bhauma Karas, located just across the border of Orissa

42

in the extreme northeastern corner of Andhra Pradesh. Carved icons on the outer walls of the jagamohan are set into niches headed with model rekha deuls in shallow relief. The entrances to the hall are topped by lintels carved with flying warriors and martial processions with elephants and horses; the jambs incorporate tightly composed panels filled with small figures. The gavaksha pediments above are filled with icons of Shiva Nataraja and spearing Andhaka, Durga killing Mahisha, and seated Ganesha.

Kashmir under the Karkotas and Utpalas; Himachal Pradesh

The elevated valleys of Kashmir and Himachal Pradesh cultivated their own distinctive styles of temple architecture and art. Situated in the foothills of the Hindu Kush, the mountainous barrier that divides South Asia from Central Asia, Kashmir was receptive to artistic influences from the Hellenistic world of the eastern Mediterranean arriving in India via Gandhara in the early centuries of the present era. The temple at Martand in the Srinagar valley, founded by the Karkota king Lalitaditya (c. 724–50) and dedicated to the sun god Surya, is the grandest and earliest Hindu monument still standing in Kashmir. Its large square sanctuary is provided with stately portals on four sides, each headed by a trilobed opening cut out of corbelled limestone blocks. The basement and cornice mouldings, pilasters and pediments of the temple all display details of classical inspiration, as do the colonnades that line the rectangular enclosure, which employ fluted shafts and Corinthian-style capitals. The double-gabled

43. Surya temple at Martand in Kashmir, Karkota period, second quarter of the eighth century. The basement and cornice mouldings, pilasters and pediments of the temple, and the fluted columns and Corinthian-type capitals of the surrounding enclosure, all reflect classical inspiration.

43

44. Triple-headed image of
Vishnu Vaikuntha from Kashmir,
Utpala period, ninth century;
bronze inlaid with silver and
copper, H 47 cm. The lion and
boar heads refer to the god's
incarnations as Varaha and
Narasimha.

roofs that rose over the sanctuary and its portals, however, were indigenous features. An idea of how they might have appeared may be had from the better preserved, but much smaller, ninth-century Shiva temple at Pandrethan on the outskirts of Srinagar. Doorways on four sides here are headed by trilobed recesses set within steeply angled gables fashioned out of local limestone.

For examples of stone sculpture from Kashmir, it is necessary to turn to the succeeding Utpala period. Relief panels on the temple at Avantipur built by Avantivarman (c. 855–83), now much ruined, depict a crowned king and a prince, both in worshipful attitudes in the company of courtly retinues, as well as seated

Vishnu with consorts. A series of small stone deities carved in the round, also assigned to the Utpala period, shows multi-headed Vishnu as Vaikuntha, with the crowned head of the god flanked by the boar and lion heads representing his Varaha and Narasimha incarnations. Bronze or brass versions of Vishnu Vaikuntha sometimes show a halo behind the triple heads, with male and female attendants at either side. This multi-headed icon has been linked with the Pancharatra doctrine that was prevalent in Kashmir during this era, in which the different emanations of Vishnu are identified with the process of cosmic creation. Such figures are renowned for their imposing stances, even though they are comparatively small (usually no more than 50 centimetres high). The delicate modelling of the smoothly finished face and chest contrasts with the sharply cut details of the jewelry and headdress. Metal images depicting other Hindu deities are rare, though examples are known of Karttikeya seated on the peacock, and standing Surya wearing flaring tunic and high boots, holding lotuses in his two hands.

While the steep roofs of Kashmir temples are obviously derived from wooden prototypes, only in the sub-Himalayan

44

45. Carved wooden ceiling in the Lakshana Devi temple at Brahmor in Himachal Pradesh, eighth century. The central lotus is surrounded by beams decorated with lotus ornament; flying celestial beings fill the corners.

valleys of Himachal Pradesh do shrines built of deodar, the locally available cedar, still stand. Examples at Brahmor and Chhatradi dating from the seventh and eighth centuries preserve doorways with decorated jambs and lintels, columns with ornate pot-and-foliage capitals, and ceilings with rotated squares adorned with leafy designs and flying celestials. Such carvings are a counterpart to the contemporary traditions in Madhya Pradesh that have already been noticed. The outer walls of the sanctuaries, mostly built of brick and rubble, support tiled gabled roofs on wooden frames that extend outwards to create spacious verandahs.

Apart from their architectural interest, the Himachal Pradesh temples are a repository of some of the finest metal icons in northern India; these too may be assigned to the seventh and eighth centuries. The sanctuary at Brahmor is dedicated to Durga under the name of Lakshana Devi, a brass image of whom is still under veneration. The goddess stares serenely ahead, her face framed by luxuriant tresses, while she transfixes Mahisha with her spear. Vishnu Narasimha in the same temple is also fashioned in brass. The god is shown in an aggressive seated posture, his legs spread wide apart. In an open pavilion outside stands a life-size bull, also executed in brass.

A much smaller bronze icon from an unknown temple shows a five-headed and ten-armed goddess. She is identified as Bhairavi, the most popular Hindu goddess in the region. She and the lesser figures surrounding her are arranged in a complex but dynamic composition which shows the sub-Himalayan style at its best.

Maharashtra under the Mauryas, Kalachuris and Rashtrakutas; Karnataka under the Early Chalukyas

Contemporary artistic developments in southern India in the centuries considered here are also of interest for their variety and sustained vitality. Hindu architecture in this zone also begins in the rock-cut medium and only later makes the transition to structural techniques. This survey begins with the temples and sculptures of Maharashtra and Karnataka before considering the monuments of Tamil Nadu. Cave-temples on Elephanta island on the Arabian Sea coast and at Ellora on the Deccan plateau, both in Maharashtra, are assigned to the sixth century. These monuments may have been executed under the patronage of the local Maurya and Kalachuri rulers respectively, though explicit historical documentation is lacking. (Once again there is a reference to a Maurya dynasty, but these local kings of coastal Maharashtra have no connection with the other lines already mentioned.)

46. Bhairavi from Himachal Pradesh, ninth century; bronze, H 37 cm. Holding a variety of weapons, the multi-headed and multi-armed goddess is surrounded by a prominent trilobed frame. She rides on a seated male who personifies Nandi, the bull mount of Shiva, portrayed in votive posture, his head turned upwards. Small figures of Ganesha and Shiva flank the inscribed pedestal.

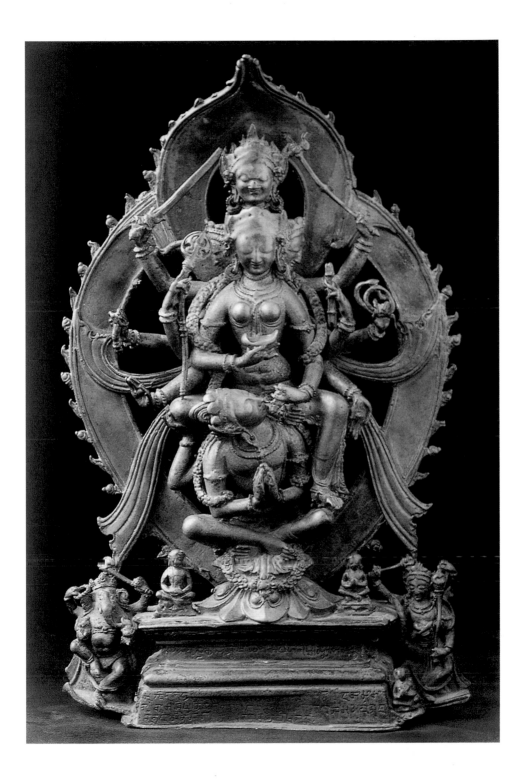

47. Plan of the cave-temple on Elephanta island in Mumbai harbour in Maharashtra, local Maurya dynasty, sixth century. The main hall is flanked by west and east shrines. A main entrance, B linga shrine, C Nataraja, D Lakulisha, E Shiva and Parvati disturbed by Ravana, F Shiva and Parvati playing at dice, G Ardhanarishvara, H Sadashiva, J descent of the Ganges, K marriage of Shiva and Parvati, L Shiva spearing Andhaka.

48. Interior of the cave-temple on Elephanta island, looking towards the linga shrine with its doors guarded by dvarapalas. Though the basalt columns (one broken) with compressed-cushion capitals appear to support the ceiling, all of the elements are carved from the living rock.

The Elephanta shrine has a columned mandapa of twenty-five bays laid out on a symmetrical plan, with triple bays projecting outwards on four sides. Monolithic basalt columns with fluted compressed-cushion capitals replicate those of an actual structure. Entrances are created on three sides through excavated trenches that convey light to the interior. A small linga shrine stands within the cave-temple. Its four doorways are flanked by outsize dvarapalas with ornate headdresses and clubs; sculpted almost in the round, they are arranged in complementary pairs with symmetrically swaying postures. Significantly, the shrine is displaced from the principal axis, which proceeds towards the majestic triple-headed bust of Shiva as Sadashiva (Eternal Shiva) that serves as the dramatic focus of the interior.

This and other mythological panels lining the walls of the Elephanta cave-temple are conceived as large-scale, deeply recessed tableaux illustrating different aspects of Shiva. Considering that these are among the earliest such representations in the Hindu art of the region, their iconographic complexity and compositional assurance are truly impressive. Pairs of panels flank the three entrances: Shiva as Nataraja and as the seated ascetic Lakulisha on the north; complementary scenes of Shiva with Parvati seated on Mount Kailasa on the east; the marriage of Shiva and Parvati, and the god spearing Andhaka on the west. The last panel is a masterpiece of condensed action, with the god fiercely impaling the demon who recoils in violent twisting motion. A further trio of panels is set into the rear wall: to the east, Shiva and Parvati are joined in the composite androgynous figure of Ardhanarishvara; to the west, Shiva assists in the descent of the Ganges, observed somewhat warily by Parvati.

The triple-headed bust of Sadashiva in the middle of the rear wall at Elephanta embodies the complex male-female, husband-wife relationships encompassed by the mythology of Shiva. The god emerges only partly from the mountain: his fourth head is turned unseen into the rock. The faces at the sides depict a feminine aspect and a fierce masculine aspect, a contrast emphasized by their headdresses, with jewels and flowers on one side, and skulls and snakes on the other. The central head is introspective and calm.

Rock-cut traditions in the Deccan also flourished at Ellora in the sixth century, where for a time they coexisted with Buddhist excavations, both series being sponsored by the Kalachuri rulers. The cave-temple known as Dhumar Lena resembles the Elephanta monument in all essential respects, including the basalt

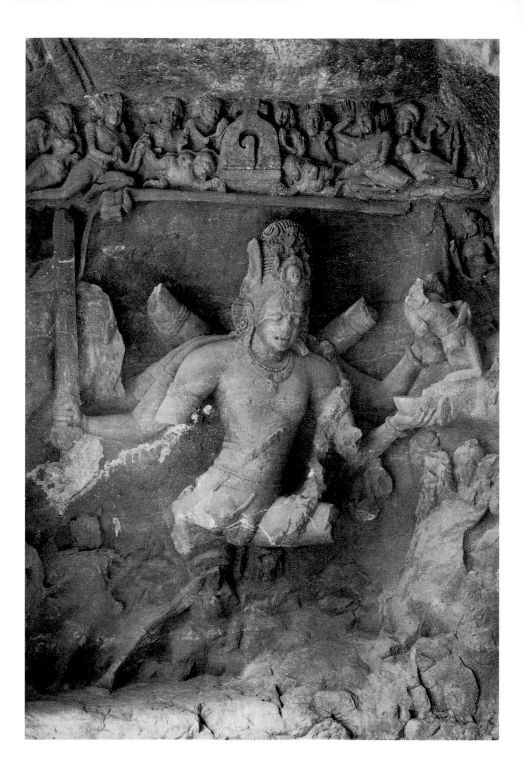

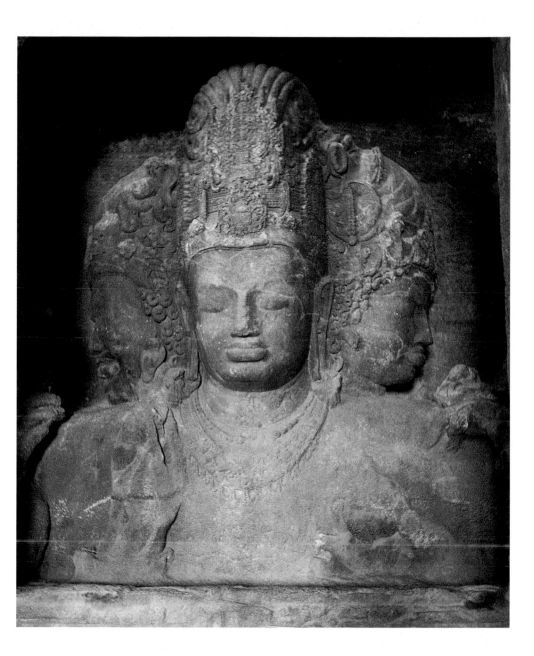

49. (opposite) Shiva impaling the demon Andhaka, in the cave-temple on Elephanta island; basalt. The tusks, protruding eyes and skull headdress of the god indicate his fearsome nature.

50. Colossal triple-headed bust of Shiva as Sadashiva (Eternal Shiva) in the Elephanta cave-temple; basalt. The hair ornaments and the features, especially the broad nose and thick lips, are indebted to Gupta traditions.

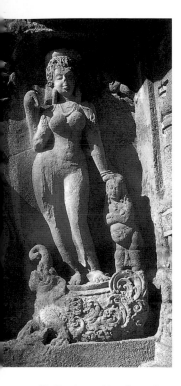

51. The river goddess Ganga, in the Rameshvara cave-temple at Ellora in Maharashtra, Kalachuri period, sixth century; basalt.

material out of which it is quarried; the linga shrine, however, is positioned towards the rear wall, on axis with the principal entrance. Part of the sculptural programme at Elephanta is repeated here, but the triple-headed bust of Shiva is omitted. River goddesses are introduced outside the entrances, a device also found in the Rameshvara, another of the sixth-century cave-temples at Ellora. This monument is more conventional in layout, with a linga shrine flanked by guardians surrounded by a passage-way set into the rear wall of a columned mandapa. Gracefully posed river goddesses and sensuously modelled maidens adorn the verandah walls and brackets. Panels inside the verandah illustrate the marriage of Shiva and Parvati in the presence of the gods, and the Saptamatrikas accompanied by Kali and a skeletal form of Shiva known as Kala. The verandah is approached through a court with a monolithic Nandi in the middle.

For a continuation of this rock-cut phase of Deccan architecture it is necessary to turn to the three Hindu cave-temples cut into the red sandstone cliffs at Badami in Karnataka. The largest of these has a date corresponding to 578, during the reign of Kirttivarman I (566–97), one of the line of Early Chalukya kings who ruled over this part of southern India until the middle of the eighth century. (The Early Chalukyas are to be distinguished from a later dynasty bearing the same name.) The Badami cave-temples have columned verandahs leading to square mandapas with columns arranged around a central hall, and small sanctuaries cut into the rear walls. The outer rows of columns are adorned with jewelled bands and medallions; sculpted figural brackets angling outwards from compressed-cushion capitals show mithuna couples embracing in affectionate poses beneath trees. The ceilings within are enlivened with flying figures, coiled nagas and lotus medallions filled with deities such as Brahma and the Dikpalas. Ganas in mischievous and occasionally obscene poses animate the plinths on which the verandahs are raised.

Major sculptural compositions are carved onto the walls of the verandahs of the Badami cave-temples. The late sixth-century example consecrated to Shiva has a magnificent depiction of Nataraja on the cliff face outside. The god is shown with eighteen arms, one of which is flung diagonally across his body, pacing out the steps of the cosmic dance. The end panels of the verandah are carved with Shiva accompanied by Nandi, and an icon of Harihara. Compositions at either end of the verandah in the dated cave show Vishnu seated on the coils of Ananta, and in his incarnation as Narasimha leaning on a club. Vishnu as

Trivikrama forms the climax of a large scene with subsidiary fig- 52
ures witnessing the miraculous transformation of Vamana the
dwarf into a cosmic giant. A mural showing courtly female figures
inside the eaves of this monument is the earliest surviving paint-
ing in a Hindu temple. Sadly, the composition is too fragmentary
to permit any identification.

Another contemporary cave-temple to be noticed is the
Ravula Phadi at the nearby site of Aihole. This is of interest for
a large composition showing ten-armed Shiva dancing in the
company of the Saptamatrikas, who wear the same pleated gar-
ments as the god himself. Other panels show Durga spearing
Mahisha, and Varaha rescuing Bhudevi.

The seventh century marks a major turning point in the
Hindu architecture of Karnakata, since from this time onwards
the Early Chalukyas began to build structurally. The Upper
Shivalaya at Badami, built out of the local red sandstone, is laid 53
out as a rectangle incorporating a garbhagriha surrounded by a
passageway on three sides, opening off a small mandapa. The
nearby Malegitti Shivalaya is similar in plan, but without any
passageway. Both buildings have their outer walls raised on

52. The Narasimha (man-lion)
incarnation of Vishnu serves as
the focus for the outer colonnade
of the Vishnu cave-temple at
Badami in Karnataka, Early
Chalukya period, 578; sandstone.
The club on which the god leans
is partly broken, but this does
detract from the massive bulk of
the figure.

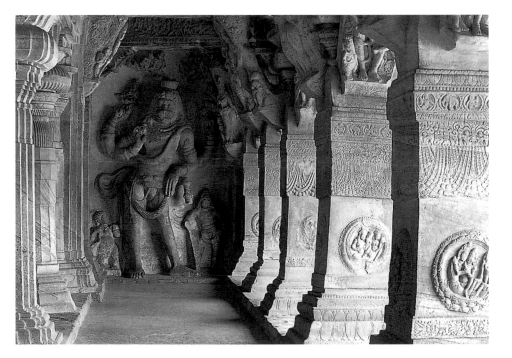

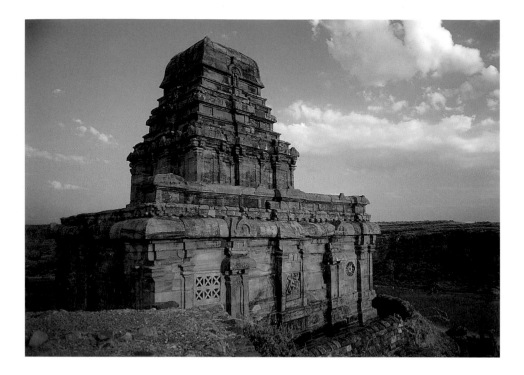

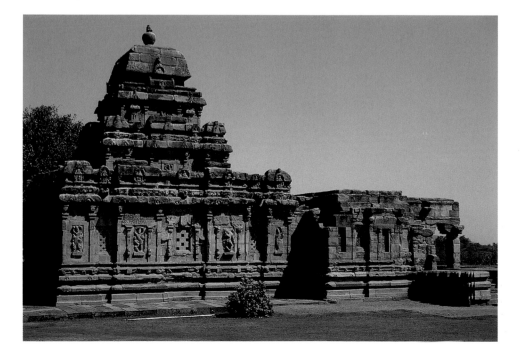

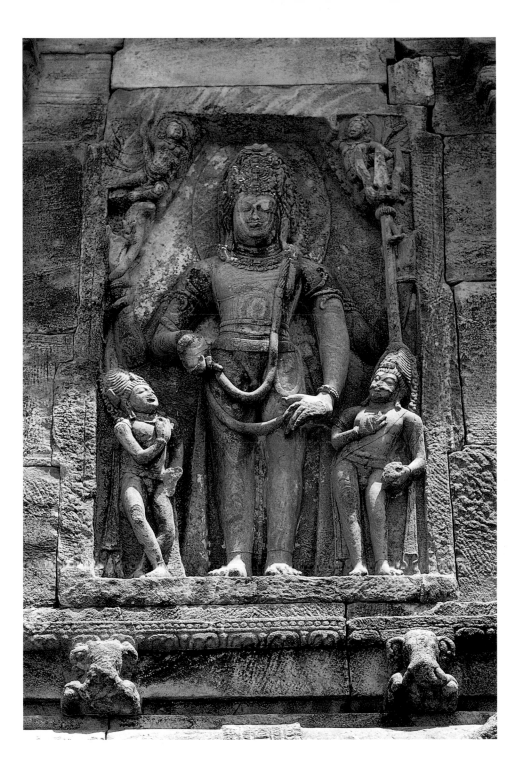

(preceding pages)

53. Upper Shivalaya temple at Badami in Karnataka, Early Chalukya period, seventh century. The storeyed pyramidal superstructure capped by a square-domed roof is one of the earliest examples of a tower of southern Indian type.

54. Sangameshvara temple at Pattadakal in Karnataka, Early Chalukya period, early eighth century. The clear articulation of the elevation emphasizes the pyramidal composition of the towered sanctuary. It is surrounded by a passageway lit by pierced screen windows, and reached from the low mandapa on the right.

55. Shiva holding a trident and a snake, on the Malegitti Shivalaya temple at Badami in Karnataka, Early Chalukya period, seventh century; sandstone. The smooth modelling of the body and the clarity of the facial features recall Gupta prototypes.

basement mouldings, and divided into bays by slender pilasters. In the square towers over the sanctuaries all of these elements are repeated on a reduced scale to create tiered upper storeys rising to square or eight-sided domical roofs. In spite of its name, the Upper Shivalaya is furnished with sculptures showing Krishna lifting up Mount Govardhana and Vishnu Narasimha ripping out the entrails of his victim; they are among the earliest depictions of these mythological events in Hindu art. The Malegitti Shivalaya, on the other hand, has major panels of both Shiva and Vishnu.

55

The development of Early Chalukya architecture reaches its climax in the first half of the eighth century at Pattadakal, a short distance from Badami. The Sangameshvara temple, founded by Vijayaditya (696-733), comprises a garbhagriha and surrounding passageway with a spacious mandapa that has sixteen columns in the middle; projecting porches on three sides were intended but never completed. The outer walls present a clear tripartite arrangement: basement mouldings at the bottom; pilastered projections with sculpture niches alternating with recesses punctuated by pierced stone screens in the middle; and a parapet capped by a line of model roof forms above. The two-storeyed tower is crowned with a large square domical roof. The adjacent Virupaksha and Mallikarjuna temples, erected by two queens of Vikramaditya II (733-44), imitate the layout of the Sangameshvara, but their elevations are more evolved, with double and even triple sets of pilasters to accentuate the wall projections, and windows with flowing foliate designs. The triple-storeyed towers are topped with octagonal and hemispherical domical roofs; their frontal faces are marked by vaulted projections with arched ends, a typical Karnataka feature. Pavilions for seated Nandis stand in front, in the middle of walled compounds with entrance gates.

54

The Pattadakal temples just noted are provided with an elaborate sculptural decor. Porch columns overhung by deeply curved eaves on the Virupaksha temple are carved with a multitude of embracing couples, as well as icons of Vishnu riding on Garuda, and Shiva subduing multi-headed and multi-armed Ravana who is shown in a convoluted twisted posture. Wall panels on either side of the east porch illustrate Shiva appearing out of a fiery linga, and Vishnu as Trivikrama with his leg kicked high. Other wall sculptures include Shiva dancing and the same god in demonic form as Bhairava. Interior columns have their shafts covered with narrative friezes illustrating episodes from both the *Ramayana* and *Mahabharata*. Such compositions firmly establish the full iconographic range of the southern Indian sculptural style.

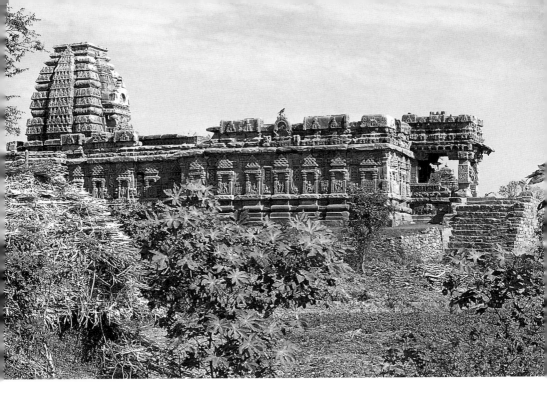

56, 57. Papanatha temple at Pattadakal in Karnataka, Early Chalukya period, eighth century. The pediments of gavaksha motifs topping the wall niches of the long elevation, and the shikhara-type tower over the sanctuary at one end, are typically northern Indian in style. Inside, the sandstone ceiling of the sanctuary is carved with a naga deity holding a garland.

Other Early Chalukya temples are built in a markedly northern Indian style, testifying to the meeting of the different traditions in Karnataka in the seventh and eighth centuries. The Papanatha temple at Pattadakal has its outer walls punctuated by niches headed by pediments with gavaksha designs; the reliefs are devoted to episodes from the *Ramayana* and Krishna stories. The tower over the sanctuary is of the shikhara type, with curved sides enlivened with gavaksha motifs. Voluptuously carved mithunas in entwined motion adorn the interior wall piers, while the ceiling displays a variety of compositions, including a naga deity with a coiled serpent body.

The Durga temple at Aihole typifies these mixed influences. Its unusual semicircular-ended garbhagriha opens off a more conventional rectangular mandapa with entrance porch, all contained within a colonnaded verandah that runs continuously around the building. Sculpture niches on the sanctuary walls within the passageway have pediments with northern Indian gavaksha designs, as well as typically southern Indian model roof forms. The tower over the shrine, though now incomplete, is clearly of the shikhara type, complete with gavaksha motifs and corner

56

57

58

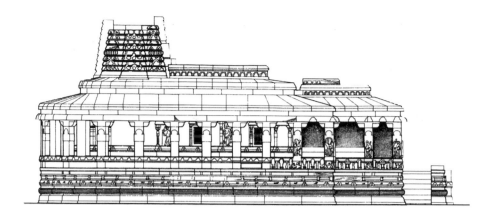

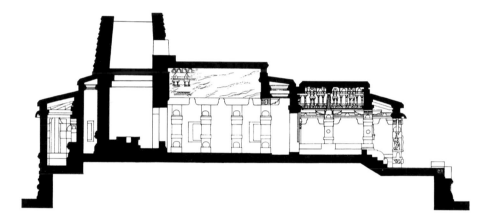

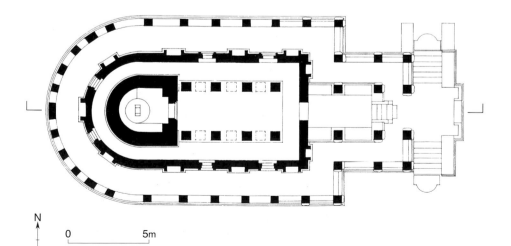

N

0 5m

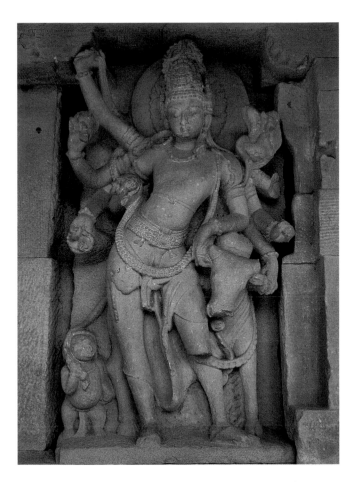

amalakas. The sculptural treatment of the pier shafts at the entrance, especially the brackets with embracing mithunas, however, recalls that of the earlier cave-temples at Badami. The carvings installed in the niches already noted, especially Durga slaying the buffalo demon, and Shiva leaning gently on Nandi, are unsurpassed for their full modelling and expressive postures.

59

A more primitive, but not necessarily earlier, monument at Aihole, the Lad Khan, consists of a large square hall lit by stone screens on four sides, and roofed with double tiers of sloping slabs crowned by a tiny flat-roofed sanctuary. The hall is entered through a rectangular porch, also covered with sloping slabs. The joints between the slabs are protected by log-like strips that recall actual timbers. The temple is of interest for the mithunas carved on the outer columns.

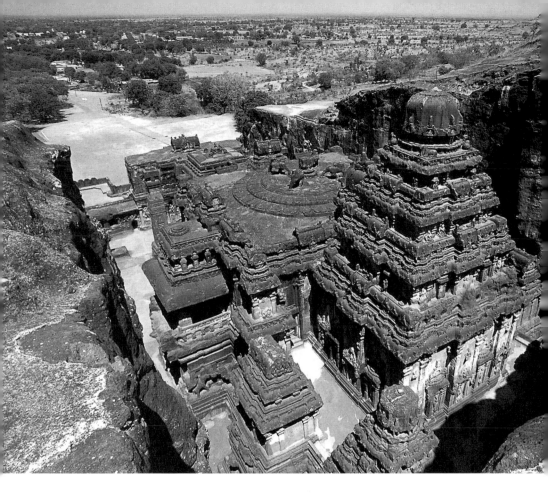

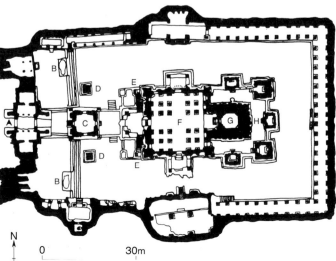

60, 61. View and plan of the Kailasanatha temple at Ellora in Maharashtra, Rashtrakuta period, eighth–ninth centuries. This stupendous rock-cut monument imitates the elevation of a constructed building, with animal plinth and basement mouldings, pilastered walls overhung by a curved cornice, and a pyramidal tower divided into pilastered storeys, each with a parapet of model roof forms, crowned with an octagonal dome-like roof. A entrance gate, B freestanding elephants, C Nandi shrine, D ceremonial columns, E stairs to upper level, F mandapa, G garbagriha, H terrace ringed with subsidiary shrines.

Other smaller temples at Aihole and Pattadakal also employ shikhara towers of the northern Indian type. The superstructure of the eighth-century Galaganatha at Pattadakal is more evolved, with complex gavaksha designs and a prominent amalaka finial. Exactly the same towered scheme is seen a group of contemporary monuments at Alampur in Andhra Pradesh, also assigned to the Early Chalukyas.

A further advance on the southern stylistic schemes of the Early Chalukyas is represented by the Kailasanatha temple at Ellora. This stupendous project was initiated by Krishna I (765–73) of the Rashtrakuta dynasty which succeeded the Chalukyas as the dominant power in this part of southern India. The Kailasanatha is fashioned out of a single block of basalt, some 32 metres high, isolated by trenches cut into the hillside. In spite of its monolithic nature, the monument imitates an actual structure, complete with basement mouldings, pilastered walls, and parapets with model roof forms, as well as interior columns, brackets and beams. The garbhagriha is surrounded by free-standing subshrines on a terrace rather than by a walled passageway as at Pattadakal; however, it adjoins the same sixteen-columned mandapa with triple porches, with a Nandi pavilion and entrance gate in front. All these components are elevated on a high plinth sculpted with three-dimensional elephant torsos, the trunks of the animals gathering up foliage. The sanctuary is provided with a three-storeyed tower topped by an octagonal domical roof; a large lotus surrounded by a quartet of pacing lions crowns the mandapa. The surrounding trenches are transformed into spacious courts with colonnades and lesser shrines. Monolithic elephants and lofty ceremonial columns decorated with panels of lotus ornament stand near the entrance.

The sculptural treatment of the Kailasanatha temple is no less impressive than its architectural conception. Other than the elephant torsos already noted, the base of the monument is supplied with major compositions, including Lakshmi seated in a lotus pond, Shiva dancing triumphant in the outstretched skin of the elephant demon that he has just slain, and Ravana shaking the Kailasa mountain on which Shiva and Parvati are seated. The last scene is much admired for the delicate rendering of Parvati who is shown clinging fearfully to her lord. Comparable expressive qualities are also evident in one of the side shrines, where the Saptamatrikas are shown in the company of male skeletal figures and the bodies of two naked dying men. Crowded strips of narrative reliefs line the access staircases to the main temple. Scenes

60, 61

62

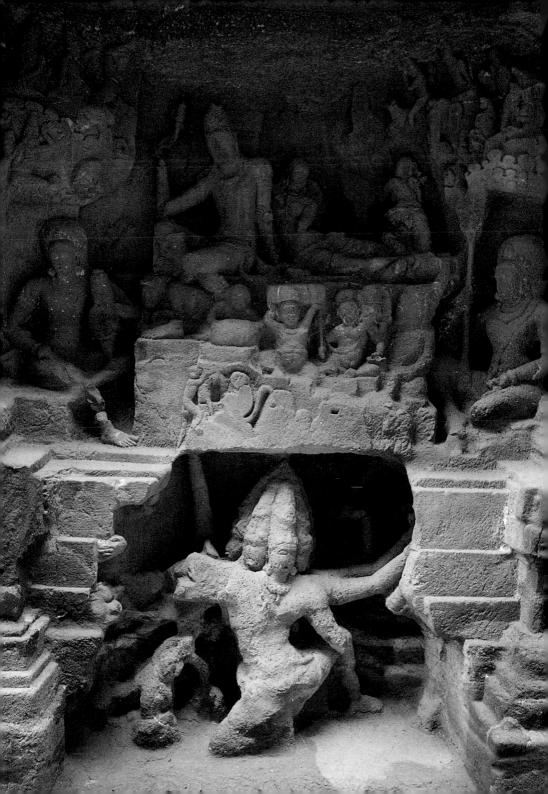

62. Ravana shaking Kailasa, the mountain home of Shiva and Parvati. Rock-cut relief in the Kailasanatha temple at Ellora in Maharashtra, Rashtrakuta period, eighth–ninth centuries; basalt. The composition contrasts the domestic peace of the celestial couple above with the crouching figure of the multi-headed and multi-armed demon below.

63. Shiva receives the river goddess Ganga on an extended strand of his hair. Relief in the cave-temple at Tiruchirappalli in Tamil Nadu, Pallava period, early seventh century; granite. This obviously mythological relief has been interpreted as an allegorical depiction of the Pallava king Mahendravarman.

from the *Ramayana* on the south side include Rama shooting the arrow through the seven palm trees and performing other exploits in the forest, the war between Vali and Sugriva, Hanuman creating havoc in Ravana's palace in Lanka, and the monkeys hauling boulders in the act of building the bridge to Lanka. *Mahabharata* scenes occur on the north side of the staircase.

Tamil Nadu under the Pallavas and Pandyas

A related, though stylistically distinct, southern Indian tradition was initiated in Tamil Nadu under the Pallavas and Pandyas, the respective rulers of the northern and southern parts of the region in the seventh and eighth centuries. As in Karnataka under the Early Chalukyas, Hindu architecture began in the rock-cut medium, specifically in the granite outcrops that characterize this zone. The earliest Pallava cave-temples are those assigned to the reign of Mahendravarman I (*c.* 600–630). They consist of small mandapas with eight columns showing part-octagonal shafts and curved brackets. The example at Mandagappattu has a trio of sanctuaries set into the rear wall; they are now empty, but according to an accompanying inscription they were dedicated

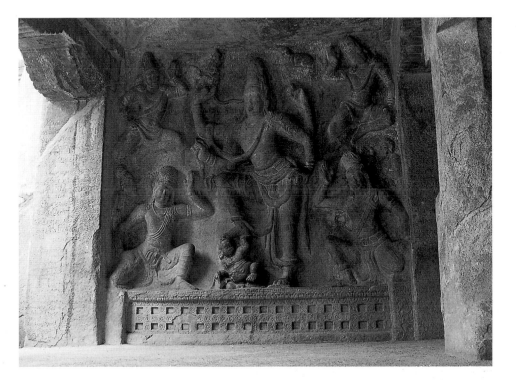

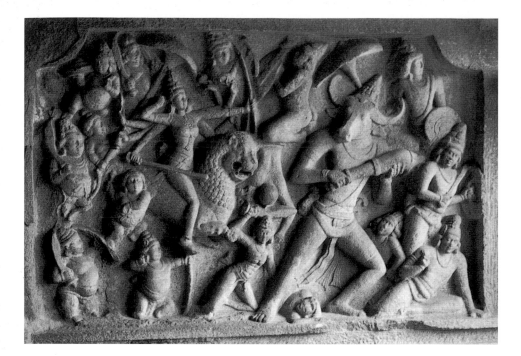

64. Durga riding on her lion, accompanied by her troops, advances on buffalo-headed Mahisha who is shown wielding a club. Relief in the Mahishasuramardini cave-temple at Mamallapuram in Tamil Nadu, Pallava period, second half of the seventh century; granite. The rhythmic groupings of the figures express the superior power of the goddess.

65. An ascetic stands on one leg in front of four-armed Shiva, who is shown holding various weapons. Detail of the large-scale relief carved on a granite boulder at Mamallapuram in Tamil Nadu, Pallava period, second half of the seventh century. The scene represents either the hero Arjuna performing penance to win the magical axe of Shiva, or the sage Bhagiratha performing austerities in order to compel Shiva to command the Ganges to descend to earth.

to Shiva, Vishnu and Brahma. A contemporary monument is the cave-temple at Tiruchirappalli, the outer columns of which employ massive part-octagonal shafts and rolled brackets. The interior of the mandapa has a linga sanctuary to one side, and a large-scale relief composition on the wall opposite depicting Shiva assisting in the descent of the Ganges.

The next group of Pallava rock-cut monuments is associated with Mamalla I (*c.* 659–68); they are found at Mamallapuram, a coastal site that takes its name from this royal patron. The Varaha cave-temple is of interest for its outer columns which have seated yalis at the base, and prominent double capitals with lower cushion-like elements and projecting square elements above. Wall panels inside illustrate a variety of divinities, all executed in the softly modelled technique that typifies Pallava sculpture. As impressive are the carvings in the nearby Mahishasuramardini cave-temple. They show Vishnu sleeping on the coils of Ananta, and Durga riding on the lion, advancing towards the buffalo-headed, human-bodied Mahisha in a dynamic composition imbued with remarkable energy. Another cave-temple at Mamallapuram, the Adivaraha, includes a depiction of two of the Pallava kings. These portraits, which are among the earliest in Hindu art, show

63

64

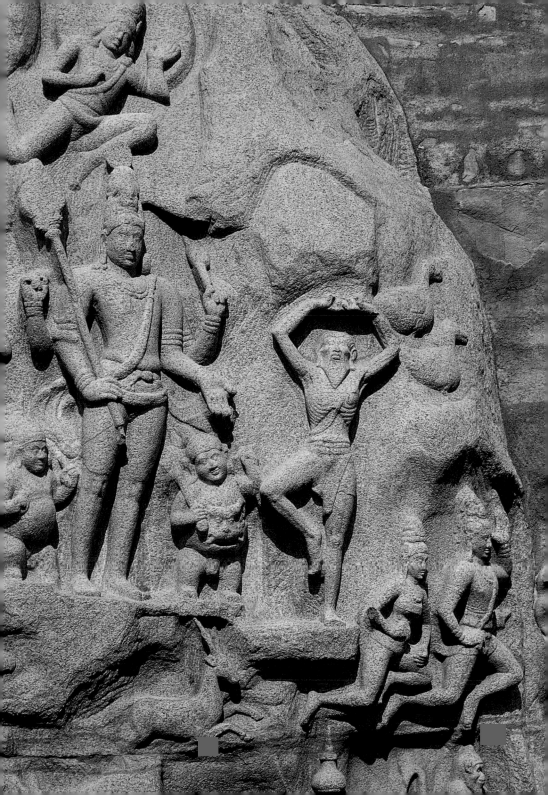

royal personages in the company of their queens, gesticulating towards the sanctuary.

The animated grouping of figures observed in these carvings is sustained in the 30-metre-long relief at Mamallapuram attributed to the reign of Mamalla I. This depicts flying gods and goddesses in the company of elephants, deer and other animals, all converging on a cleft between two huge boulders. The cleft is filled with a slab carved with a naga king and queen, their human hands held together in adoration, over which water once flowed from a tank above. To the left is a man in a yoga-like posture, standing on one foot, in front of whom appears four-armed Shiva; below is a small hermitage shrine with sages, deer and a lion. This scene is sometimes identified as the penance of Arjuna, by which the hero performed physical feats of austerity such as that shown here to win the magic weapon of Shiva; on the other hand, it is also considered to represent the descent of the Ganges, in which the sage Bhagiratha through similar austerities compelled Shiva to command the celestial river to descend to earth so that he could immerse the ashes of his ancestors. According to the latter interpretation, the water flowing over the nagas would represent the Ganges. On a nearby boulder is another large-scale relief, but this presents no difficulty of interpretation. It shows Krishna shielding the herds and gopis from Indra's storm by lifting up Mount Govardhana.

The fluid style of Pallava art is not repeated in the reliefs of the cave-temples of the Pandyas, under whose patronage the rock-cut tradition continued into the eighth century. Two Pandya monuments at Namakkal, for instance, are furnished with impressive figures of Vishnu as Trivikrama and Narasimha. Compared with Pallava sculpture, the modelling seems hard and angular, though it effectively expresses the superhuman energies of Vishnu in his various incarnations.

Structural temple architecture in Tamil Nadu is anticipated by a group of monoliths at Mamallapuram, known misleadingly as *rathas*, or chariots, though they could never have been used in this way. The Pancha (Five) Rathas, which take their names from the five Pandava heroes of the *Mahabharata*, are also linked with Mamalla I, an inscribed portrait of whom is found on the Dharmaraja ratha. The monoliths display the same columnar forms that have already been noticed in the cave-temples; the upper portions are, however, more developed. The square Arjuna and Dharmaraja rathas have multi-storeyed pyramidal towers with parapets of differently shaped model roof forms topped by

18

65

66

67

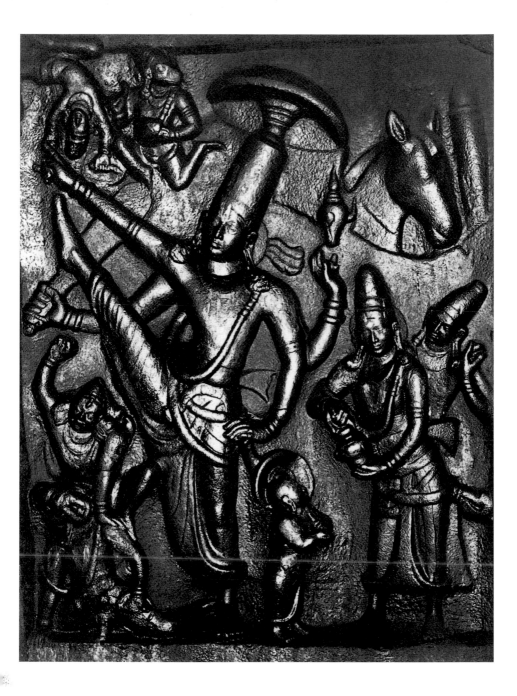

66. Vishnu in his incarnation as Trivikrama, pacing out the universe in gigantic strides. Relief in the Lakshmi Narasimha temple at Namakkal in Tamil Nadu, Pandya period, eighth century; granite.

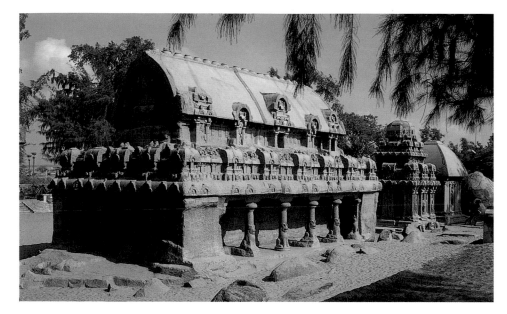

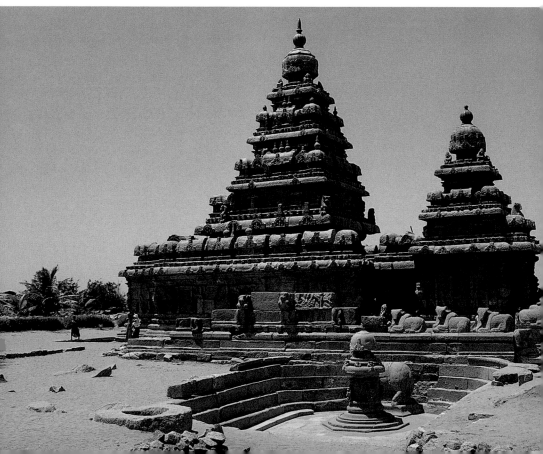

67. The monolithic Bhima ratha (foreground), Arjuna ratha and Draupadi ratha at Mamallapuram in Tamil Nadu, Pallava period, second half of the seventh century.

68. The Shore Temple at Mamallapuram in Tamil Nadu, Pallava period, early eighth century. The two linga shrines, each topped with a steeply pyramidal tower, are arranged back to back. The stepped pool in front was until recently buried in sand.

69. Pilasters rising on rearing yalis flank a niche that shows Shiva appearing out of the linga. Detail of the Kailasanatha temple in Kanchipuram in Tamil Nadu, Pallava period, early eighth century; sandstone.

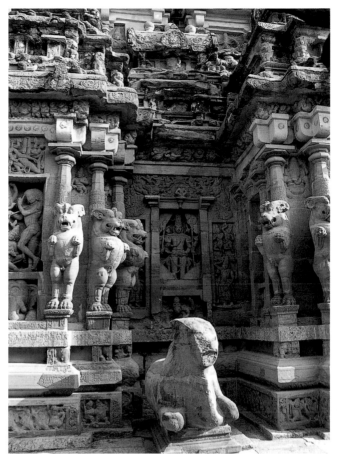

octagonal domical roofs; the rectangular Bhima ratha is distin- 67
guished by its barrel-vaulted shala roof with arched ends. The
adjacent Nakula Sahadeva ratha is similarly vaulted, but on a more
unusual semicircular-ended plan. The sculptural treatment of the
rathas is mostly confined to male and female guardians, the figures
being posed naturalistically as if standing in doorways.

The so-called Shore Temple nearby, erected by the Pallava 68
king Rajasimha (c. 700–728), marks the beginning of structural
architecture in Tamil Nadu. Perched dramatically on the edge of
the Bay of Bengal, hence its name, the temple consists of a pair of
sanctuaries of unequal size, arranged in diagonal formation. Each
is roofed with a pyramidal tower of steep proportions whose
diminishing tiers of storeys are marked by the typical parapet
feature. The larger shrine is surrounded by a passageway open

to the sky, but contained within high walls integrated into the overall elevation. Sculptural adornment is restricted to a panel of Shiva with Uma, another name for Parvati, and their child Skanda carved on the rear wall of the sanctuary; a faceted, polished basalt linga is placed in front.

Later examples of structural architecture, built mostly in softer sandstone, are found in Kanchipuram, the Pallava capital. The Kailasanatha temple, another of Rajasimha's projects, has a square garbhagriha surrounded by a passageway, with minor shrines opening outwards on four sides. The walls are raised on a basement decorated with gana friezes; pilasters with leaping yalis on the shafts frame deeply recessed sculptures. Among the varied icons are Shiva appearing out of the linga, witnessed by Vishnu and Brahma, and Shiva in the chariot shooting arrows. The walls are surmounted by a parapet with the usual array of square domical and shala model roof forms. The same elements recur on the parapets of the three diminishing storeys of the pyramidal tower. In front is a columned mandapa with openings on four sides sheltered by curving eaves; this structure was later linked to the main temple. Both temple and mandapa stand in a rectangular courtyard surrounded by minor shrines housing icons of Shiva with Parvati and Skanda. The inner walls of some shrines pre-serve traces of murals depicting similar scenes, now in an extremely dilapidated condition. The delicate linework and the bright yellow, green and ochre tints offer tantalizing glimpses of a vanished pictorial tradition. A shala-roofed entrance structure at the eastern end of the compound presents a rudimentary form of the towered gateway, or *gopura*, that was to become a standard feature of later southern Indian architecture. An inscription on the mandapa records a raid on Kanchipuram by the Early Chalukya king Vikramaditya II, historically validating the stylis-tic link between the Kailasanatha and the temples built by Vikramaditya's queens at Pattadakal (p. 74).

As with Early Chalukya architecture, however, that of the Pallavas was not to continue beyond the eighth century. One of the latest Pallava projects is the Vaikuntha Perumal in Kanchipuram, erected by Nandivarman II (731–96). This temple is unusual in having within its tower three superimposed sanctu-aries accommodating standing, seated and reclining images of Vishnu.

With this monument the first phase of Hindu temple art in Tamil Nadu comes to an end, not to be resuscitated until the advent of the Cholas at the end of the ninth century.

69

Chapter 4: Culmination: tenth to thirteenth centuries

Hindu art in the four hundred years or so encompassed by this phase of development fulfils many of the tendencies described in Chapter 3. Sacred architecture and sculpture display a technical and stylistic advance on earlier centuries; both find expression in a number of regional styles. Layouts of temples are invariably more complex and larger in scale, with an emphasis on mandapas with ornate columns and brackets supporting corbelled dome-like ceilings, entered through open porches. Shikhara towers in northern Indian temples evolve clustered schemes, with varied and complex arrangements of smaller elements replicating the overall towered form. Pyramidal towers in southern Indian temples become the visual climax of the monument, soaring to previously unattainable heights. By the end of this phase, however, these temples are overshadowed by towered gates or gopuras through which the sacred complex is entered.

80

70

106

111

Temple sculpture noticeably increases in extent and scope: carved figures are no longer confined to wall niches, and are often multiplied both horizontally and vertically so as to cover exterior wall surfaces entirely. Column shafts and angled brackets are similarly transformed by a vivid sculptural imagery that complements the carved decoration of the richly ornamented ceilings. Divinities appear in a seemingly inexhaustible range of aspects and emanations, testifying more to the imaginative potentialities of literary iconographic sources than to the liturgical requirements of worship. Carving tends to be crisp and linear, in an attempt to clarify the innumerable distinctions of attributes, emblems, weapons, costumes, crowns and jewels. Such scrupulously observed details contrast with the smooth modelling and rhythmically swaying postures of the figures, many of which are combined into multiple compositions covering the walls and ceilings.

72, 97

Madhya Pradesh under the Chandellas and Paramaras
Perhaps better than any other group of monuments, the temples at Khajuraho in Madhya Pradesh exemplify the technical and stylistic accomplishments of the era. Erected under the Chandella

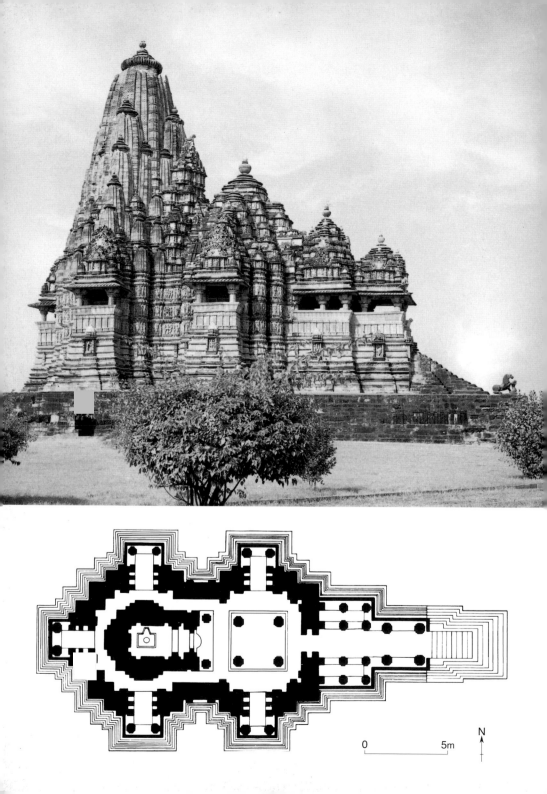

(preceding pages)

70–72. Khandariya Mahadeva temple at Khajuraho in Madhya Pradesh, Chandella period, c. 1030: view, plan, and sculptures depicting deities and attendants. The clustered shikhara tower constructed of corbelled sandstone blocks provides the temple with a dramatic visual climax. The garbhagriha at the western end is surrounded on three sides by a narrow passageway lit by porches. It is reached from the east up a flight of steps that leads to an extended porch, followed by a mandapa with four columns in the middle and porches to the north and south.

rulers in the tenth and eleventh centuries, the Khajuraho monuments represent the high point of the northern Indian style in its central Indian expression. Though dedicated to a variety of Hindu divinities, as well to the Jain saviours, these yellow sandstone temples conform to a fairly standardized scheme. The grandest and most elaborate of the group, the Khandariya Mahadeva erected during the reign of Vidyadhara (1004–35), may be taken as typical. It consists of a garbhagriha surrounded by a passageway with porches projecting outwards on three sides, and a columned mandapa, which is also provided with side porches, as well as an extended frontal porch reached by a steep flight of steps. The outer walls are raised high on a sequence of basement mouldings, and then divided into multiple projections enlivened with superimposed tiers of sculpted figures. These richly textured surfaces are interrupted by the projecting porches where inclined slabs form the backs of balcony seating, sheltered by eaves above.

70–
72

The mandapa of the Khandariya Mahadeva has a pyramidal superstructure employing layers of gavaksha motifs topped with pot-like finials; similar but lesser superstructures rise above the porches. Together, they create an ascending sequence of roofs that reaches its climax in the lofty shikhara rising more than 30 metres above the sanctuary itself. The tower has a central square shaft with a characteristic curved profile and an amalaka finial, surrounded by half- and quarter-shikharas that rise up in the middle of each side. These subordinate elements lend a dramatic vertical thrust to the overall elevation, while at the same time emphasizing its mountain-like mass. The mandapa interior has polygonal columns and figural brackets supporting a corbelled dome over the central bay. The walls of the garbhagriha as viewed within the surrounding passageway have sculpture niches raised on further sequences of basement mouldings.

Other Chandella monuments at Khajuraho conforming more or less to this scheme include the slightly earlier Lakshmana temple, erected in 954 by king Dhanga (950–999). This incorporates subsidiary shrines at the four corners of the terrace, while an open pavilion in front accommodates a sculpted boar representing the Varaha incarnation of Vishnu. A similar pavilion associated with the Vishvanatha temple of 1002 accommodates an image of Nandi. Like the mandapas of the main monuments, these pavilions are roofed with pyramidal superstructures.

Sculptural embellishment proliferates at Khajuraho. The terrace on which the Lakshmana temple is raised has an almost continuous procession of naturalistically carved royal elephants

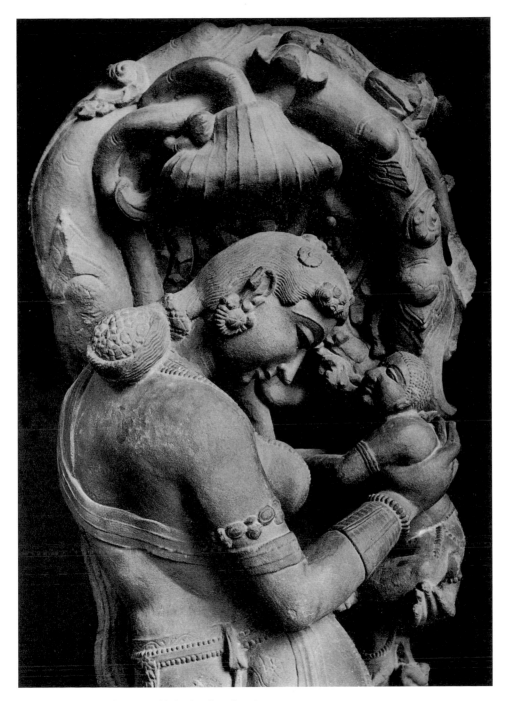

73. A surasundari with a child, from Khajuraho, eleventh century;
sandstone. Such figures appear on the brackets inside the mandapas.

74. Detail of the basement frieze on the Lakshmana temple at Khajuraho in Madhya Pradesh, Chandella period, 954; sandstone. A ruler seated in a pavilion, fanned by female attendants, holds audience with his nobles.

with attendants, mounted warriors bearing swords and shields, foot-soldiers carrying staffs and daggers, wrestlers and musicians, and hunters shooting deer. Royal figures also appear, holding audience with their followers; scenes of copulation and bestiality are confined to the eastern end of the south frieze.

Divine and semi-divine personalities crowd the upper parts of temple walls. Figures arranged in double or triple tiers on both sides of the many corners create a densely textured surface in which the principal deities can barely be made out. However, the emblems held in their multiple hands do permit identification: thus, Shiva as Bhairava, with a skull and small drum, accompanied

75. A magically protective sexual act, on the Khandariya Mahadeva temple at Khajuraho in Madhya Pradesh, Chandella period, c.1030; sandstone. The panel is positioned on the south at the ritually vulnerable junction of the garbhagriha and mandapa.

76. (opposite) Chamunda, one of the yoginis, from Madhya Pradesh, Chandella period, eleventh century; sandstone, H 113 cm. The terrifying nature of the goddess is indicated by her facial expression and wasted body.

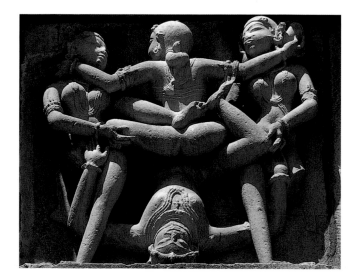

by a dog. The gods are often shown with their consorts in embracing pairs, looking intently into each other's eyes. Beautiful surasundaris abound: playing musical instruments, dancing, juggling balls, combing their hair, gazing into a mirror, removing a thorn from their foot. They are complemented by vyalas in contorted leaping postures.

Some sculptural compositions at Khajuraho depict ritualized sexual acts with such frankness that they have come to enjoy a notoriety that has somewhat obscured their true purpose. As found on the Lakshmana, Vishvanatha and Khandariya Mahadeva temples, such sexual groups are located at the crucial wall junctions of the garbhagriha passageways and mandapas. The groups show mithunas in candid sexual union accompanied by maidens who support the male figure in the more unlikely postures, and who even participate in the erotic activities. 75

A no less complex imagery invades the interiors of the Khajuraho monuments. The Vishnu Vaikuntha image which forms the focal icon of worship in the Lakshmana temple depicts a majestic triple-faced god standing amidst a retinue of divinities and attendants who fill the surrounding frame. An even greater spectrum of celestials occupies the wall niches within the Khandariya Mahadeva, where superimposed figures of Brahma, Shiva and Vishnu appear together in the company of sensually posed surasundaris. Additional surasundaris, carved fully in the round, angle outwards from the column brackets in the mandapas. The maidens stand beneath leafy boughs, often with their backs turned towards the viewer and their heads in profile: they write on a slab, play the flute, attend to their toilette, or cradle a child. 73

The Chandellas were also responsible for a series of shrines consecrated to groups of female divinities known as *yoginis*, the worship of whom formed part of a special Tantric cult associated with Shakti. Yogini temples are conceived quite differently from those already described, being generally unadorned and comparatively crudely constructed. That at Khajuraho consists of sixty-four chambers arranged around four sides of a rectangular compound. At Bheraghat, eighty-one niches open off a colonnade that encircles an open court; they are inhabited by seated goddesses sculpted as voluptuous women, with generous hips and breasts, and elaborate jewelry and headdresses. The most terrifying of all yoginis is Chamunda, whose horrific nature is vividly communicated by her skeletal body with a scorpion on the stomach, by her tusks and bulging eyes, and by the garland of skulls that wraps around her piled-up matted hair. 76

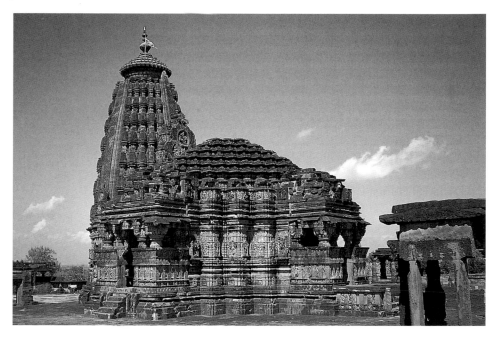

77. Udayeshvara temple at Udayapur in Madhya Pradesh, Paramara period, third quarter of the eleventh century. The vertical bands of gavaksha mesh ornament on the red sandstone tower are a distinctive feature of the bhumija style.

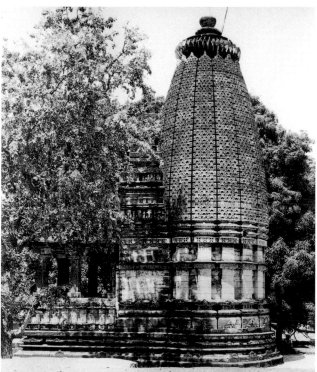

78. Temple at Chandrehi in Madhya Pradesh, tenth century. The circular tower, which has no parallels, is covered with gavaksha motifs. These give it a filigree-like quality that contrasts with the unadorned walls below.

That the Chandellas were not the only active builders in Madhya Pradesh at this time is demonstrated by the Udayeshvara temple at Udayapur, erected during the reign of the Paramara king Udayaditya (1059–80). This building repeats many of the features seen at Khajuraho; the shikhara, however, has tiers of small model towers covering the curving surface of the central shaft, interrupted by vertical bands of gavaksha mesh in the middle of three sides. The fourth side, above the mandapa, has a pediment formed by a large gavaksha arch filled with icons of Shiva and surrounded by deeply etched foliage. The tower is capped with a prominent amalaka and a pot-like finial. Three porches give access to the mandapa, which is roofed with tiers of amalaka motifs organized pyramidally. 77

The distinctive appearance of the Udayeshvara tower has given rise to the term *bhumija*, which is sometimes applied to the Paramara style. In actuality, the bhumija mode extends beyond Madhya Pradesh, and temples in adjacent Maharashtra erected under the patronage of the contemporary Yadava kings display similar shikhara towers with bands of gavaksha mesh. Of the surviving examples from the Yadava period, now mostly dilapidated, the temple at Ambarnath dated 1060 is the most elaborate. However, only the lower portions of its tower survive, and the sculpture niches in the walls below are badly worn.

Other architectural idioms also thrived in Madhya Pradesh at this time, judging from the tenth-century temple at Chandrehi. Here, uniquely, the garbhagriha is contained within a circular tower, covered with bands of gavaksha mesh of exceptional delicacy. A pediment structure composed of similar but larger motifs marks the frontal face. The Sas Bahu temples at Gwalior, dated 1093, though now missing their sanctuaries, illustrate the evolution of the mandapa into a major structural feature. In the larger of this pair of monuments, a pyramidal building with triple tiers of balconied porches projects outwards on three sides. The interior, however, consists of a single lofty space roofed with domical vaults fashioned out of corbelled sandstone blocks. 78

Gujarat under the Solankis; Rajasthan under the later Pratiharas
Parallel developments in temple art during the tenth and eleventh centuries took place in western India, especially under the Solankis of northern Gujarat. The Surya temple at Modhera, completed in about 1025 during the reign of Bhimadeva I (1022–64), is the finest Hindu monument associated with this dynasty, although it survives only incompletely. The temple 79, 80

79, 80. Surya temple complex at Modhera in Gujarat, Solanki period, c. 1025. A free-standing pavilion rises in front of the temple and overlooks a tank (opposite, above), where tiny shrines with shikhara towers are built on the multiple landings and steps that lead down to the water. Inside the pavilion (opposite, below), the polygonal shafts of the columns and the lobed frames suspended between the brackets are covered with stylized figural and foliage carving.

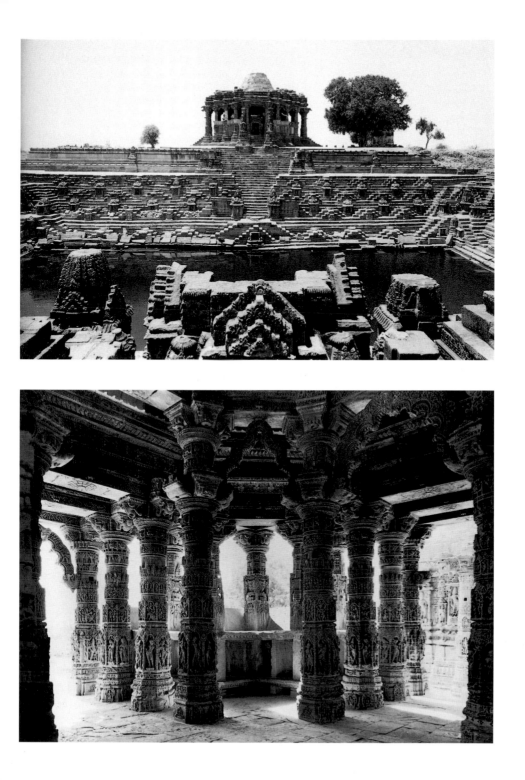

consists of a garbhagriha surrounded by a passageway, which opens off a spacious walled mandapa. Facing the porch of the mandapa is a free-standing open pavilion laid out as a diagonal square, with entrances on four sides. Inside this, the columns are covered with tiers of sculpture; lobed arches between the eight central columns carry the decorated rings of a corbelled dome. Beyond the pavilion, steps lead down to a large rectangular reservoir surrounded by miniature shrines topped with shikhara towers, probably imitating that which rose over the garbhagriha of the main temple, now lost.

A related Solanki project is the Rani-ki Vav, or Queen's Step-well, in Patan, named after its patron, Udayamati, wife of Bhimadeva I. In spite of its obvious utilitarian purpose as a source of drinking water, the circular sandstone well also functioned as a Hindu sanctuary, as is evident from the sculpted imagery set in temple-like niches on the sides of its shaft. A long flight of steps gives access to the water, its stages marked by columns and beams in a way that creates an inverted, subterranean architecture. The monument was filled in with earth at some later date, and has only recently been cleared to reveal sculptures in perfect condition; they give the best possible idea of the refinement of Solanki art. The crispness of the carving, seen both in the figures and in the surrounding frames, transforms the wall surface of the well proper and of the staircase into an almost continuous filigree of light and shade. The iconographic focus is a series of panels depicting Vishnu on Ananta floating on the cosmic ocean, probably intended to be identified with the waters of the well. The god is flanked by panels showing him in other aspects, including Kalki, the apocalyptic rider. But there are also icons of Shiva, among them a multi-armed image of Bhairava, interspersed with surasundaris in bewitching poses, sometimes accompanied by a monkey or even a snake. The sculptural decor extends also to the setting of the panels, which is adorned with friezes of kirttimukhas and petals, extravagant pot-and-foliage capitals, and squatting gana brackets.

For further examples of Solanki art it is necessary to turn to the Jain monuments of the era, especially those on Mount Abu in southern Rajasthan. Though these temples fall outside the scope of this survey, it is worth noting the occasional sculptural theme borrowed from Hindu art incorporated into their interiors, most notably scenes from the Krishna story.

Under a later branch of the Pratihara family that governed southeastern Rajasthan in the tenth century, northern Indian

80

79

81

81. Kalki riding a horse – the last incarnation of Vishnu – attended by maidens, from the Rani-ki Vav in Patan, Solanki period. The white sandstone sculptures on this step-well are the finest examples of eleventh-century Hindu art in Gujarat.

82. Shiva Nataraja on the Ghateshvara temple at Badoli in Rajasthan, Pratihara period, tenth century; sandstone. The refined modelling and elegantly disposed limbs display the fluidity of the Rajasthani sculptural style.

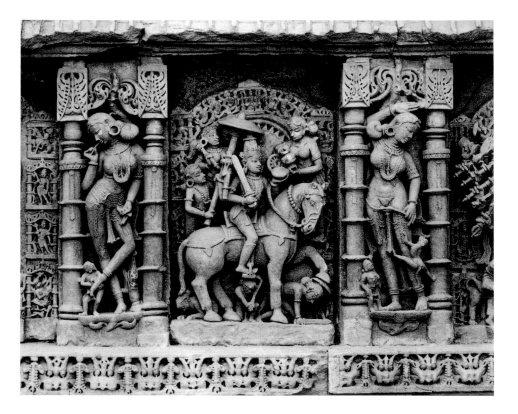

Hindu architecture developed yet another regional variant. The temples at Badoli, of which the Ghateshvara is the largest and finest, combine simple garbhagriha-and-porch schemes with fully evolved shikharas. Niches on the outer walls of the Ghateshvara are surmounted by diminutive angled eaves and shikhara pediments. The icon housed in the rear niche is a splendid Shiva Nataraja carved almost in the round. 82

The Ambika Mata temple completed in 961 at Jagat, also in 84 southeastern Rajasthan, is similar to the Badoli examples, except that here a mandapa with stone screen windows at the sides is added between the garbhagriha and the porch. An unusual feature is the use of model shikharas above the corners of the mandapa, repeating on a reduced scale the tower over the sanctuary. The outer walls have sculptures in varying planes, with attendant females and leaping vyalas assigned to the narrow recesses. Niche projections, distinguished by pairs of circular colonnettes supporting miniature eaves and gavaksha pediments, accommodate diverse icons, especially Durga slaying Mahisha. 83

83, 84. (left and opposite) Ambika Mata temple at Jagat in Rajasthan, Pratihara period, 961. The sanctuary housing an icon of the goddess Durga is approached through a porch with angled overhangs and a mandapa with a pyramidal roof. In a projecting niche the goddess is shown spearing the buffalo demon, surrounded by vyalas with riders, attendant women, flying warriors and seated sages.

85. (opposite, below) Pot and foliage decoration on the columns of the Someshvara temple at Kiradu in Rajasthan, Pratihara period, 1020; sandstone. The sharply delineated fronds and scrollwork are typical of the evolved Rajasthani style.

The richly sculpted elevation contrasts with the somewhat spare interior, which focuses on the image of Ambika under worship in the garbhagriha.

Clustered shikhara-type towers comparable to those in Madhya Pradesh are also known in Rajasthan at this time. The Someshvara temple of 1020 at Kiradu, for example, has tiers of full-, half-size and small towers grouped symmetrically around the central shikhara. The reduction of sculpted detail to cut-out patterns is seen throughout the building, as in the friezes of dancing figures on the basement, and the lush pot-and-foliage 85 motifs on the column shafts.

Orissa under the Somavamshis and Gajapatis

The Mukteshvara temple in Bhubaneshwar, erected under the
Sovamashi rulers in the tenth century, serves as a convenient
marker for the beginning of the second phase of Hindu art in
Orissa. Standing in a walled compound, this exquisitely worked
red sandstone building is approached through a portal with a
sculpted arch. The pair of supporting squat columns have fluted
shafts decorated with jewelled festoons and large cushion capi-
tals. The arch is punctuated by gavaksha motifs filled with staring
faces; two enigmatically smiling surasundaris recline above it, and
makara heads protrude outwards from the sides. The walls of the
sanctuary, or rekha deul, have small niches crowned by delicately
worked gavaksha mesh; the same pattern continues in bands up
the faces of the tower where it frames ornate gavaksha arches
headed by kirttimukhas and flanked by ganas. A large amalaka
and a pot-like finial crown the summit. The adjacent hall, or
jagamohan, has an elaborate entrance doorway topped with an
ornate gavaksha pediment, over which is a seated lion sculpted in

86

86. Mukteshvara temple in Bhubaneshwar, Somavamshi period, tenth century, the finest example of the mature Orissan style. The complex is entered through a portal with an arched lintel, visible at the left. The red sandstone tower of the rekha deul is covered with carved gavaksha motifs, including larger arches framing deities and flanked by ganas in the middle, and topped with a characteristic ribbed amalaka and pot-like finial. The tower contrasts with the lower but no less intricately worked pyramidal roof over the jagamohan. Beyond on the left is the early eleventh-century Siddheshvara temple.

the round. Screen windows at the sides are surrounded by friezes of foliage designs, monkeys and flying couples. The roof of the jagamohan rises in pyramidal fashion in a sequence of deeply modelled horizontal layers. The ceiling within has a central lobed design surrounded by flying figures.

Another project of the Somavamshis in Bhubaneshwar, the Rajarani temple, marks a further evolution of the Orissan style in the eleventh century. Here the tower of the rekha deul is of the clustered type, with reduced versions of itself on the sides and corners of the central shaft creating a complicated multi-faceted silhouette. The wall surfaces below consist of projections framed by bands of delicately worked foliage carved with figures. These include a complete set of the Dikpalas on the corner panels, and numerous surasundaris picking a thorn out of their foot, cradling a child, or clutching a tree. In another complete series of Dikpalas from Bhubaneshwar, now removed from any architectural context, the eight gods are carved in fastidious detail that accentuates the gentle smiles on their faces and the smoothly shining surfaces of their bodies; nowhere are these features better seen than in the image of Agni seated on a ram, his head surrounded by flickering flames.

6

Architectural developments in Bhubaneshwar culminate in the Lingaraja temple, founded by the Ganga kings who succeeded the Somavamshis as rulers of Orissa towards the end of the eleventh century. The Gangas were also responsible for major religious projects at other sites in Orissa, including the Jagannatha temple in Puri, erected in about 1135 by Ananta- 87 varman Chodaganga (1078–1147). Built of red sandstone on a grand scale, the Puri monument is an amplification of the Lingaraja scheme. The walls of its rekha deul are divided by a horizontal tier of mouldings into two storeys, while similar striations mark the superstructure, with inserted shallow model towers in between. Crouching lions are positioned beneath the capping ribbed amalaka which stands more than 56 metres above the ground. The towered sanctuary adjoins a line of square jagamohans, each roofed with a pyramidal mass of masonry, added over the following three hundred years, to create a dramatically ascending profile that accentuates the verticality of the tower.

Undoubtedly the climax of the Orissan series is the temple at Konarak, founded by Narasimha I (1238–58). This ruler took a 88

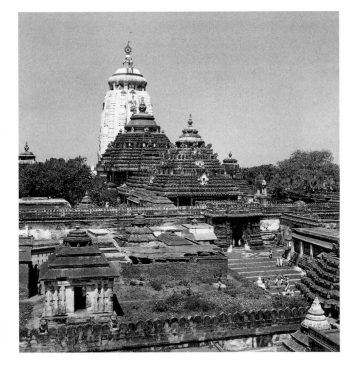

87. Jagannatha temple in Puri, Orissa, Ganga period, c.1135 and later. This is the grandest of the Orissan series, complete with fully expressed rekha deul and a pair of pyramidal-roofed jagamohans. A celebrated pilgrimage temple, it enshrines a trio of crudely fashioned wooden divinities that were tribal in origin, but which came to be identified as Krishna, his brother and his sister, as part of the cult established here by Anantavarman Chodaganga, the royal patron of the monument.

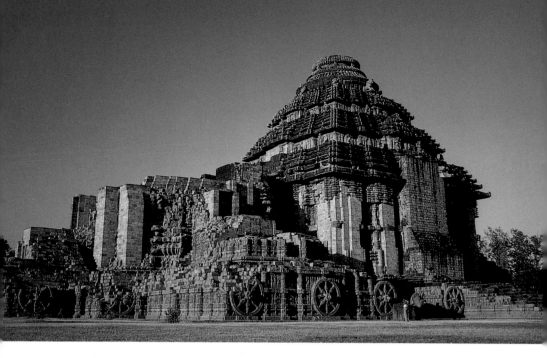

88. Surya temple at Konarak in Orissa, Ganga period, mid-thirteenth century. Only the pyramidal-roofed jagamohan still stands; the towered rekha deul to the left collapsed long ago. Wheels on the plinth are intended to suggest the chariot in which the sun god Surya rides through the heavens; they are ornately treated (see Ill. 1), with miniature animals in creeper motif on the rim, and figures in medallions on the spokes and axles. Running all along the bottom is a procession of elephants, shown both as wild animals in their forested habitat and as royal animals with attendants.

personal interest in the construction of the monument, and in the cult of the god Surya which he established there. Built of coarsely grained khondalite, the temple has now mostly collapsed; even so, its immense proportions and richly applied decoration can still be appreciated. The high walls and triple-tiered pyramidal roof of the jagamohan stand relatively complete. Together with the lower portions of the rekha deul, they are raised on a lofty basement, the sides of which are carved with twelve pairs of wheels. These represent the months of the year, the temple being conceived as the chariot of the sun god riding through the heavens.

To reinforce the astronomical association of the Konarak temple, the east entrance of the jagamohan was given a chloritic schist lintel sculpted with the Navagrahas, the nine planetary deities, each seated in a lobed niche. (The lintel is broken and has been shifted to a shed on the site.) Chloritic schist is also the preferred material for the outsize figures of Surya intended for the side niches of the rekha deul which show the god standing in a rigid formal posture or mounted on his richly bridled horse. He is decked in glorious jewels and wears a conical crown; his expression is subtle and detached.

A related set of smaller panels in the same material, no longer on the building, portrays Narasimha, royal patron of the monu-

ment, meeting with his spiritual advisers, worshipping images of Durga and Jagannatha, seated in a swing in the company of his women, and practising archery. These panels exhibit the smooth modelling and richly applied detail that distinguish the mature Orissan style.

Other large-scale sculptures still to be seen in situ at Konarak include female dancers and players of drums and cymbals placed in the gaps high up on the pyramidal superstructure of the jagamohan. These fully modelled figures are impressive for their bulk and stately movement. More animated are the sexual couples, beautiful maidens and leaping vyalas on the lower walls of the rekha deul, not to mention the countless dancers, musicians and naginis that cover the entire basement and dilapidated wall piers of the detached hall intended for dance performances

89. Standing Surya, from a niche of the Surya temple at Konarak; chloritic schist. The lotuses upheld by the god are still evident, though the two arms have been broken. The charioteer Aruna and seven of the sun-god's horses are seen below.

90. Narasimha, the patron of the Surya temple at Konarak, practicing archery; chloritic schist, H 89 cm. This is one of several scenes depicting royal audience, worship and entertainment.

standing roofless in front. Splendid pairs of three-dimensional animals flank the entrances: kneeling elephants crushing warriors, war horses subduing demons, and ferocious vyalas leaping over prostrate elephants.

Bihar and Bengal under the Palas

During the period covered by these centuries, the territory encompassed by Bihar, West Bengal and Bangladesh was largely under the control of the Palas. These rulers were active patrons of both Buddhist and Hindu cults, but since they built almost exclusively in brick few shrines of either dedication still stand. Fortunately, the principal cult images installed in the temples were fashioned out of black basalt and it is they that survive to give an idea of Pala art.

By far the largest number of Hindu icons associated with the Palas are those of Vishnu dating from the eleventh and twelfth centuries. The most typical shows the four-armed god standing in a formal and symmetrical composition, holding mace and disk in his rear hands. He is dressed in sumptuous jewelry and wears a decorated crown. Diminutive figures of Lakshmi and Sarasvati, the latter holding a vina, are seen below on either side, while flying celestials adorn the frame which has a characteristic pointed-arched top. Fine metal versions of this icon also exist, some no more than 25 centimetres high, which show the deity standing within a high frame with a semicircular top, fringed with flame-like motifs, all superbly executed.

More dynamic are the multi-armed images of Shiva Nataraja, in which the god appears with his head at an angle to the axis of his body, his legs fully bent at the knees. The erect phallus protruding from his costume is a feature typical of Bengali images of this aspect of Shiva. Goddesses too make an appearance in Pala art. One of the most unusual depictions is a twelfth-century relief from Vikrampur in Bangladesh showing Parvati making offerings to a Shiva linga that stands on a high pedestal. She is adorned with jewelry and wears an elaborate crown with side tassels; flying figures and a monster mask fill the edges of the frame.

Karnataka under the Late Chalukyas and Hoysalas; Andhra Pradesh under the Kakatiyas

The temple styles that developed in Karnataka and Andhra Pradesh during the period covered in this chapter are to be distinguished from the main currents of northern and southern Indian architecture, since they incorporate elements derived from

91. Parvati worshipping the linga, from Vikrampur in Bangladesh, Pala period, twelfth century; polished basalt, H 145 cm. This unique composition shows the body of the goddess carved in relief rising over a deeply modelled linga on a circular pedestal.

92. Standing Vishnu from Bangladesh, Pala period, twelfth century; polished basalt, H 163 cm. The smooth modelling of the body of the god contrasts with the crisply executed details of the crown, costume and jewelry, as well as the mace and disc.

17

92

91

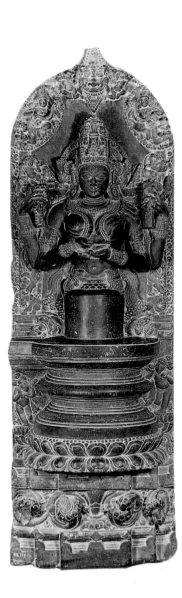

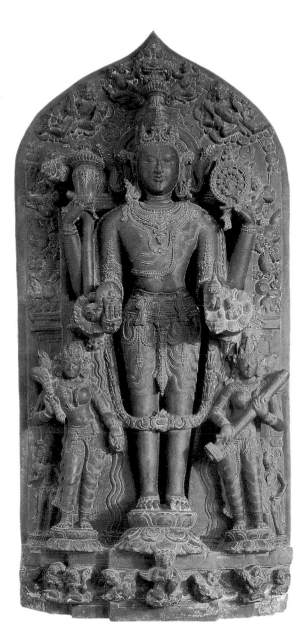

93. A surasundari dancing to the music of a flute-player, on the Mallikarjuna temple at Kuruvatti in Karnataka, Late Chalukya period, eleventh century; chloritic schist. This bracket carries the overhang that shelters the entrance porch.

94. Detail of the Mahadeva temple at Ittagi in Karnataka, Late Chalukya period, 1112. The combination of motifs derived from the northern and southern Indian traditions is a particular feature of Late Chalukya architecture.

both traditions. The typical architectural idiom of this region emerged in the eleventh and twelfth centuries under the Late Chalukyas of northern Karnataka. These rulers were responsible for constructing a series of sandstone monuments with remarkable star-shaped layouts. In the temple at Dambal, for instance, the walls of the garbhagriha and attached mandapa are provided with multiple projections that create a double circle in plan. Wall facets are enlivened with pairs of slender pilasters carrying model shikhara towers in shallow relief derived from northern Indian architecture. Similar shikhara motifs cover the walls of the Mahadeva temple at Ittagi, erected in 1112 by an officer of the Chalukya king Vikramaditya VI (1076–1126), while sharply cut, fanciful foliage animates the upper elements of the multi-storeyed superstructure in southern Indian style. 94

Though the outer walls of Late Chalukya temples tend to be encrusted with architectural motifs, there is an overall absence of figural sculpture. This is amply compensated for, however, by the ornate treatment of the columns with lathe-turned and faceted shafts in the partly open mandapas. Beams carry corbelled ceilings, some with concentric rings of lobed motifs around a central pendant bud. Intricately worked figural brackets of chloritic schist are incorporated into these dome-like compositions, as well as into the porch-like entrances. Among the finest are the surasundaris in swaying postures surrounded by filigree foliage on the eleventh-century Mallikarjuna temple at Kuruvatti. 93

All of these decorative tendencies reach a climax in the exquisitely carved soapstone monuments of the Hoysala kings, the dominant rulers of southern Karnataka in the twelfth and thirteenth centuries. The Chennakeshava temple at Belur, erected in 1117 by Vishnuvardhana (c. 1106–41), has a focal garbhagriha laid out on a star-shaped plan adjoining a large square mandapa with porch projections approached by steps on three sides. The Hoysaleshvara temple at Halebid, begun in 1121 during Vishnuvardhana's reign but not completed for another four decades, has twin garbhagrihas, each with three subshrines projecting outwards. The sanctuaries are linked by a common mandapa, with porches leading to detached columned pavilions, one of which accommodates a naturalistically fashioned seated Nandi. The sanctuary walls in both monuments consist almost entirely of sculpted panels raised on carved friezes. Inclined balcony slabs in the porches have stone screens set between columns with lathe-turned or faceted shafts and prominent double capitals. Similarly fashioned columns with sculpted brackets carry the 97

decorated interior ceilings. All these features are present in the Keshava temple at Somnathpur, founded in 1268 by a general of Narasimha III (1254–91), which represents the architectural culmination of the Hoysala style. Here the temple is expanded to incorporate a trio of shrines, the star-shaped plans of which are echoed in the high plinth on which they stand, as well as the storeyed towers that rise above. The mandapa extends forward as a screened porch, its sides encrusted with rows of northern Indian style shikharas in relief.

95, 96

The basement friezes of Hoysala temples present superimposed lines of elephants, yalis, soldiers, mythological narratives, and makaras and geese with fantastic foliated tails, interspersed with occasional creeper motif containing miniature figures. A wealth of detail is contained in these compositions, especially in the depictions of different aspects of contemporary military life: foot-soldiers carrying shields and pikes; infantry with bows and arrows, swords and daggers; caparisoned war elephants and horses; cavalry officers brandishing lances, sometimes in combat; mounted musicians, some riding on camels and playing kettle-drums; wind bands and drummers; bearers of standards and flags; warriors riding in war chariots shooting arrows. Nor are mythological topics neglected here. The Hoysaleshvara temple, for instance, has a complete cycle of panels narrating the story of Krishna, from his rescue as an infant and episodes of his childhood, such as the killing of the ogress Putana, to the miracle of lifting Mount Govardhana. These are followed by lively battle compositions. Among *Ramayana* episodes illustrated are forest scenes of Rama hunting the golden deer, and Rama and Sita with their monkey allies.

97

The sculptural programmes on the angled facets of the sanctuary walls in Hoysala temples are extensive, with more than three hundred reliefs on the Hoysaleshvara alone. These show deities, attendants and adorers all richly encrusted with tassels, jewels and crowns, often standing in frames with scrollwork and trees at the top; inscriptions below identify the artists. Even though the Hoysaleshvara is dedicated to Shiva, there is a full complement of Vishnu's incarnations, including Narasimha, Varaha and Krishna. Goddesses appear as beautiful women, even when taking terrifying forms such as Bhairavi or the destructive Durga. Subsidiary females are shown grasping a creeper, talking to a parrot, or warding off a monkey, all of which are considered appropriate expressions of female sexuality. One of the most striking compositions in these temples is a fully modelled

95, 96. Keshava temple at Somnathpur in Karnataka, Hoysala period, 1268: view from the entrance, and plan. A pavilion gateway leads into a rectangular compound lined with colonnades and subshrines; this frames a trio of shrines that open off a common mandapa, all raised on a high plinth. The shrines are laid out on star-shaped plans that dictate the angled planes of the walls and the forms of the storeyed towers that rise above.

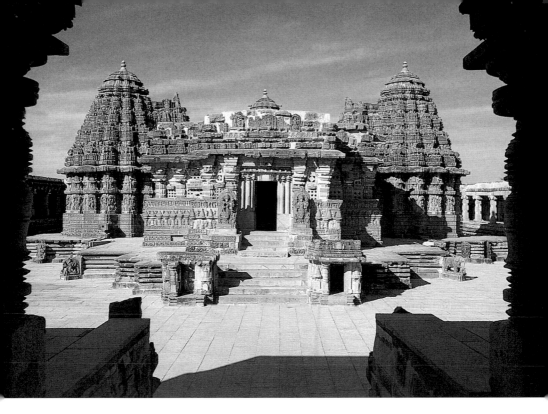

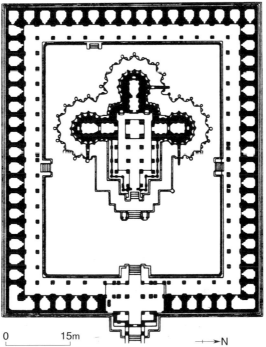

0 15m →N

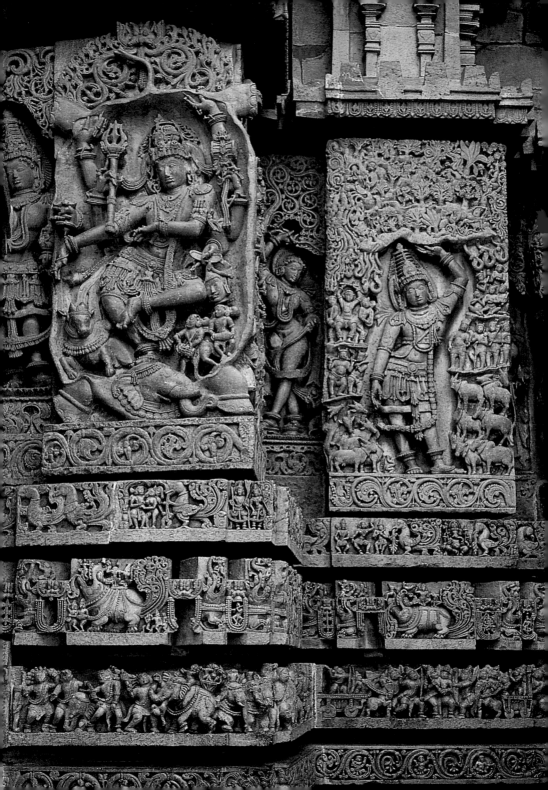

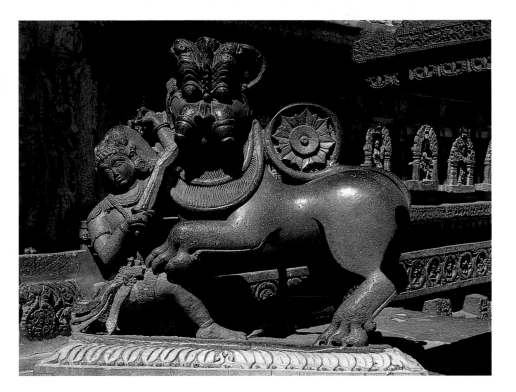

97. (opposite) Shiva dancing in the skin of the elephant demon that he has slain, and Krishna lifting Mount Govardhana, on the walls of the Hoysaleshvara temple at Halebid in Karnataka, Hoysala period, 1121; soapstone. The friezes beneath show lines of animals and fantastic beasts as well as scenes from Hindu epic stories.

98. (above) Warrior fighting a fantastic lion, on the Chennakeshava temple at Belur in Karnataka, 1117; soapstone. This motif served as an emblem of the Hoysala kings who built the temple.

warrior plunging a sword into a fantastic lion who attacks 98 him. This scene is intended as an emblem of the Hoysala kings, emphasizing the heroic and martial aspects of the dynasty.

Among the other sculptures on Hoysala temples are richly decked dvarapalas placed on either side of the doorways leading in to the porches. The filigree costumes and headdresses of these figures are typical of the Hoysala style at its most ornate. Lintels over the doorways have makaras with foliated tails and miniature riders flanking central icons surrounded by looped garlands. Sculptures of surasundaris angle outwards from the column brackets beneath the porch eaves and interior beams of the mandapas. The examples on the temple at Belur are unsurpassed 100 in Hoysala art for their seductive naturalism. The maidens' jewels and tasselled costumes swing freely over their smoothly modelled bodies, as they hold their arms up in attitudes of dance, or play musical instruments. They are surrounded by fantastic foliage, sometimes in the semblance of an overhanging tree. Such animated figures contrast with the more stately icons placed in the garbhagrihas, such as Krishna playing the flute, standing beneath

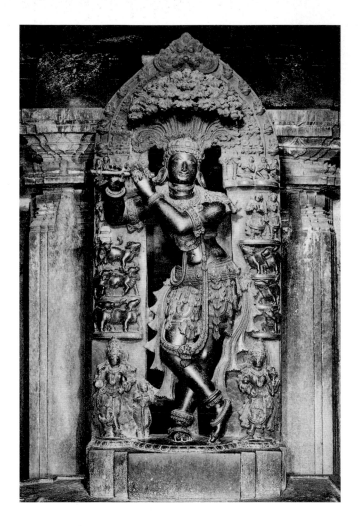

99. Krishna playing the flute, in the southern shrine of the Keshava temple at Somnathpur in Karnataka, Hoysala period, 1268. This soapstone image was intended for worship, and is carved almost in the round.

100. Dancer in a filigree bower, on the Chennakeshava temple at Belur in Karnataka, Hoysala period, 1117; soapstone. This exquisitely carved figure appears on a bracket that supports the eaves of the entrance porch.

a tree surrounded by attendants, gopis and herds, in the southern sanctuary of the Somnathpur temple. In the mandapas, central columns carry ornate domes whose concentric corbelled rings are decorated with scrollwork and lotus buds. Ceilings in the Hoysaleshvara temple incorporate friezes of miniature figures, such as Shiva Nataraja surrounded by the Dikpalas and musicians.

An equally ornate but distinctive temple style developed at the same time in the adjacent region of Andhra Pradesh under the Kakatiya rulers. One of their first monuments is the extensive but now dilapidated temple in Hanamkonda dating from 1163, during the reign of Rudradeva (1158–95). Shrines built of grey-green basalt dedicated to Shiva, Vishnu and Surya lead off a columned

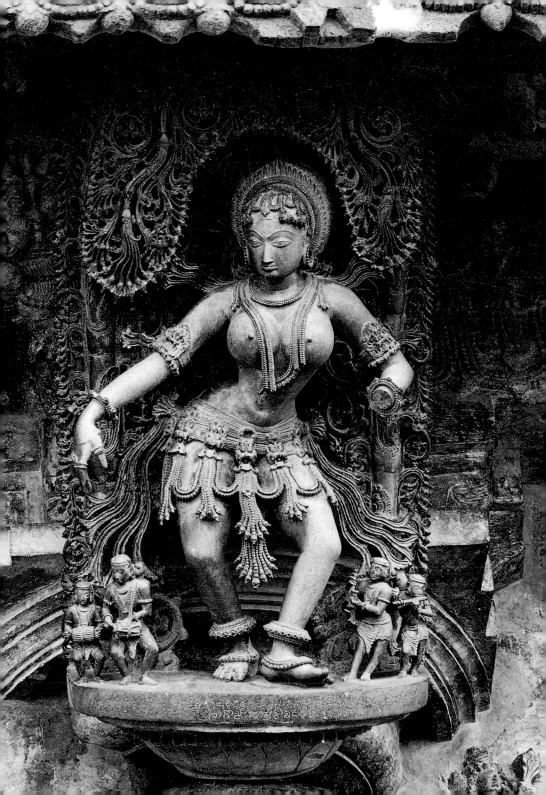

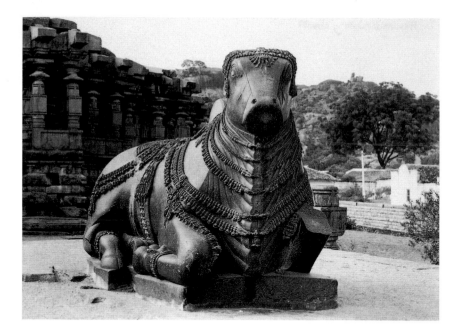

101. Nandi outside the Shiva temple at Hanamkonda in Andhra Pradesh, Kakatiya period, 1163; basalt.

mandapa open to one side. The outer walls of the shrines and hall stand on a deeply moulded basement. No sculptures remain in the wall niches, which have shikhara-like pediments. The balcony slabs in the porch are sheltered by angled eaves. The hall interior is crowded with columns displaying sharply cut, multi-faceted shafts topped by capitals adorned with jewels and petals. The plinth of the temple extends southwards to accommodate a magnificently sculpted Nandi decked with chains and bells. 101

The next important Kakatiya king is Ganapatideva (1199–1262), founder of the new Kakatiya capital of Warangal. Nothing now stands of the Shiva temple that he erected in the middle of his circular city, except for four imposing portals defining a vast square precinct. More than 10 metres high, these gateways consist of pairs of posts carrying massive lintels carved with garlands, lotus buds and other motifs. A more complete idea of Kakatiya architecture may be had from the Ramappa temple at 103 Palampet, founded in 1213 by a general of Ganapatideva. Like its Hoysala counterparts, the Ramappa is raised on a high plinth, and has a garbhagriha with faceted outer walls of reddish sandstone punctuated by superimposed niches in the middle of each side. The tower above is of brick, its outer faces divided into successive pilastered stages. The sanctuary is reached through a mandapa laid out on a stepped plan; balcony slabs are set between columns

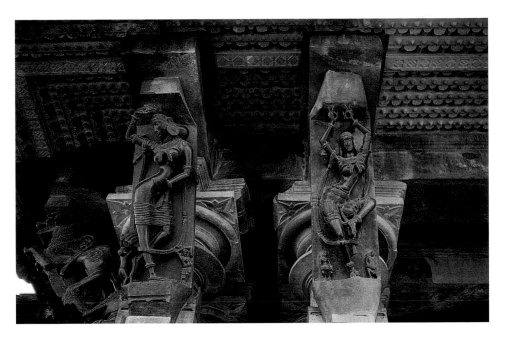

102, 103. The Ramappa temple at Palampet in Andhra Pradesh, 1213, is one of the few Kakatiya monuments to be fully preserved. The lower portions of the building are of sandstone, while the tower is of plaster-covered brick. The female bracket figures on the porch (above) are notable for their unusually elongated proportions, sinuous bodies, and tasselled costumes.

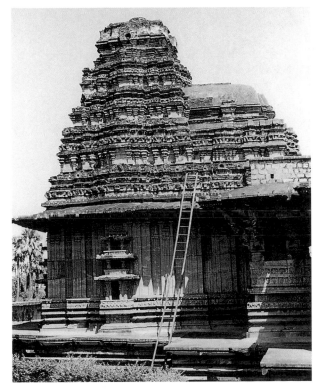

with double capitals overhung by sharply angled eaves. Sculpted surasundaris framed by flowers, bowers and vines angle outwards beneath the eaves. The mandapa interior is dominated by columns with blocks on the shafts carved with mythological topics. The central supports carry a ceiling composed of rotated squares filled with crisply modelled figures, including Shiva in various aspects, and a central pendant lotus surrounded by rings of petals and buds. 102

Tamil Nadu under the Cholas

The supreme rulers of Tamil Nadu during most of this period, the Cholas, began their building careers modestly with small-scale projects inspired by Pallava models. The late ninth-century Nageshvara temple in Kumbakonam, built of fine-grained pinkish granite, consists simply of a square garbhagriha and rectangular mandapa with four interior columns. The outer walls rise from a deeply modelled basement incorporating a frieze of yali torsos and miniature panels illustrating *Ramayana* scenes. Wall niches are framed by pairs of pilasters supporting delicately incised pediments with makaras and fantastic foliage. The curved cornice and parapet of model roof forms above recall similar features in Pallava architecture; so too the large square-domed roof which caps the single-storeyed tower. 68

Sculptures on the Nageshvara temple demonstrate the assured refinement of early Chola art. The major icons are Shiva Dakshinamurti on the south, Ardhanarishvara on the west, and Brahma and Durga on the north. These divinities appear together with enigmatic male and female attendants whose identification remains controversial. The slender figures of celestials and humans are carved with remarkable delicacy, the facial expressions being sweetly detached and serene. Many are fractionally turned in relation to the wall plane, as if to step out of the building. Sculptures on the slightly later Brahmapurishvara temple at Pullamangai are carved with a greater formality that accentuates the grandeur of the deities, while those of the Koranganatha temple at Srinivasanallur are again turned at a slight angle to the viewer, as if they actually inhabited the building. 104

From such unassuming beginnings it seems a tremendous step to the majestic Chola monuments of the early eleventh century. The granite Brihadishvara temple of 1010 in Tanjavur, originally named Rajarajeshvara after its royal founder Rajaraja I (985–1012), is the acknowledged masterpiece of Chola architecture. The temple stands in the middle of a spacious rectangular enclosure, entered on the east through a pair of gateways with 106

104. Sculptures set into niches on the main shrine of the Nageshvara temple in Kumbakonam, Tamil Nadu, Chola period, late ninth century. They include enigmatic female figures, sometimes identified as Sita in the *Ramayana* epic (left) and a courtly maiden, and a male figure who appears to represent a sage. The walls are covered with inscriptions recording gifts made by successive Chola rulers. The cornice is decorated with gavaksha arches, below a row of yali torsos.

105. Squatting gana blowing a conch, supporting the spout for libations that emerges from the sanctuary of the Brihadishvara temple in Tanjavur, Tamil Nadu, Chola period, 1010; granite.

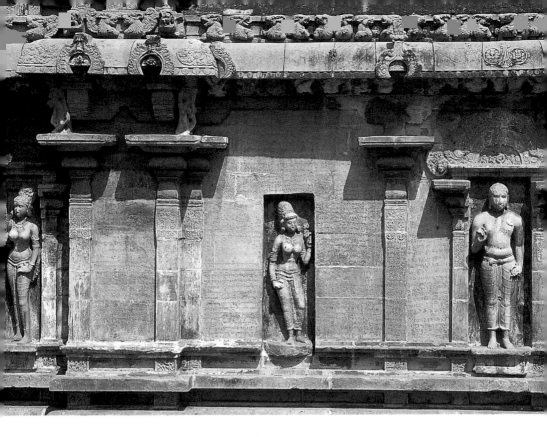

shala roofs rising on tiered superstructures. These are the first
fully mature gopura structures in southern Indian architecture.
The sanctuary itself is approached through two columned
mandapas, one of which was originally partly open, but was filled
in when a front porch was added in later times; they lead to a
transverse gallery with side doorways reached by staircases
flanked by flowing balustrades. The passageway surrounding the
garbhagriha on four sides at the base of the tower is expressed on
the exterior as two storeys, marked by pilastered projections
with window openings in the middle of each side. Sculptures
are placed in niches framed by pilasters and topped by shallow
makara pediments; the intervening recesses are occupied by
shallow pilasters standing in pots with blocked-out foliage, head-
ed by fanciful arched pediments and flanked by flying figures.
A squatting gana blowing a conch supports a waterspout
protruding from the north side of the basement.

Not content with his father's monument, Rajendra I (1012–44),
son of Rajaraja, erected a similarly splendid shrine for himself,

105

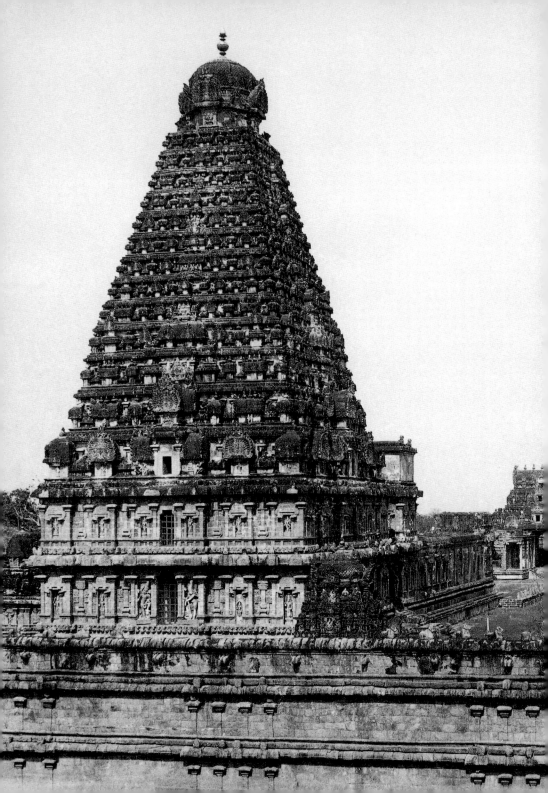

also known as Brihadishvara, at Gangaikondacholapuram. This
repeats the essential features of its predecessor, though without
the window openings in the middle of each side. The treatment of
the tower is noticeably different: the storeys make a gradual tran-
sition from square to octagon and then to circle, thereby creating a
less severe pyramidal scheme with a slightly concave silhouette.
Sculptural programmes in both temples are elaborate, with a full
range of figures distributed in niches on two levels. Icons of
Shiva, Nataraja, and Devi occupy the middle of the garbhagriha
walls in Tanjavur, the deities looking out through window open-
ings in the passageway walls flanked by large guardian figures.
Among the many masterpieces on the outer walls are Shiva as the
naked Bhikshatanamurti, carrying a fly-whisk across his shoulder
and accompanied by a prancing dog, and Nataraja, with his left
foot raised up, to which one of his hands draws attention. The
goddesses Sarasvati and Lakshmi, together with the planetary
deities Surya and Chandra, are positioned beside the doorways to
the transverse gallery. The sculptural scheme at Gangaikonda-
cholapuram is equally extensive, but here icons of Shiva
Dakshinamurti, Vishnu and Brahma occupy the central
panels on three sides of the passageway walls. An unusual
composition depicts Shiva, accompanied by Devi, garlanding 108
the saint Chandesha. Throughout both monuments, the sculp-
tures are carved almost in the round, sometimes projecting
slightly from the recesses in which they are set. Their rounded
and subtle modelling defies the crystalline quality of the granite
out of which they have been fashioned.

The garbhagriha of the Tanjavur temple is dominated by a
colossal polished linga almost 4 metres high. Paintings in two
layers cover the outer walls of the sanctuary, hidden inside the
passageway. The earlier fragments, which are contemporary with
the building, include delicately toned scenes of Shiva seated in the
company of dancers and musicians, a royal visit to the temple at
Chidambaram, and Shiva riding in a chariot shooting as a trio of
demons. One pair of figures portrays Rajaraja himself accom- 107
panied by his spiritual adviser. Further imagery in the temple
includes, in the upper passageway, miniature figures of Shiva in
different dance postures. There are also scenes drawn from the
mythology of Shiva covering the plinth of the inner gopura.
These include the story of the god in disguise as a hunter fighting
Arjuna in the forest.

Later Chola temples make little attempt to rival the scale of
these grandiose projects. The Airavateshvara at Darasuram,

108. Shiva garlanding the saint Chandesha, on the Brihadishvara temple at Gangaikondacholapuram in Tamil Nadu, Chola period, first half of the eleventh century. The saint is sometimes identified with Rajendra I, royal founder of the temple.

assigned to the reign of Rajaraja II (1146–72), is smaller and more detailed than its predecessors, though built of the same granite material. The elevation of the main shrine reverts to a single tier of pilasters containing niches with makara pediments. The tower has fully expressed parapet elements on each stage and a capping hemispherical roof that create a somewhat squat pyramidal profile. Two mandapas precede the shrine, the outer one distinguished by a projecting transverse porch. Sculpted wheels and leaping horses in relief carved on the basement give this a chariot-like appearance. The staircases leading up to it are flanked by kneeling elephants with undulating trunks that serve as balustrades.

109

109. Kneeling elephants flank the steps leading to the entrance porch of the Airavateshvara temple at Darasuram in Tamil Nadu, Chola period, mid-twelfth century.

The basement of the temple at Darasuram is animated by yalis and dancing ganas. The top register has a row of miniature panels framing stories of the sixty-three Tamil saints, including those of Chandesha and Sundarar. An unusual icon on the mandapa walls is that of Sharabha, a form of Shiva as a fantastic beast subduing a demon. Among carvings no longer on the temple is a panel showing Shiva dancing within the outstretched skin of the elephant demon. Another group of sculptures, unusually carved fully in the round, from the same temple, portray Shiva as Bhikshatanamurti, the wandering ascetic, attended by the wives of the forest sages.

The Nataraja temple in Chidambaram received benefactions from many of the Chola kings, who provided gilded copper sheets to clad the twin hut-like chambers that serve as the sanctuary of this sacred complex. The temple consists of three concentric walled enclosures crowded with subsidiary structures. The twelfth-century dance hall in the innermost enclosure is elevated on a double basement adorned with rows of dancers, ganas and yalis; it also has wheels with prancing horses, which recall those at Darasuram and are typical of late Chola art. A much larger mandapa in the second enclosure of the temple may have served as a ceremonial hall for the Cholas.

110. Shiva dancing in the skin of the elephant demon, from the Airavateshvara temple at Darasuram; basalt. The vitality of the twisted posture of the god is unsurpassed in Chola art.

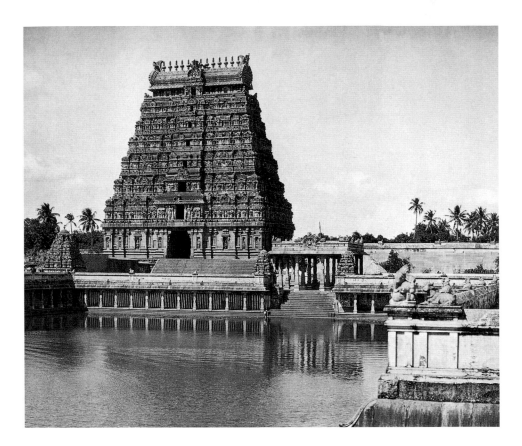

111. Gopura and tank of the
Nataraja temple in Chidambaram,
Tamil Nadu, Chola period, twelfth
century. The gopura type of
entrance structure was to become
the paradigm for all later
architecture in southern India.

111

The Chidambaram complex is entered on four sides through
lofty gopuras, also assigned to the twelfth century. These grand-
est of all Chola towered entryways have rectangular granite
lower storeys subdivided by passageways at ground level. The
treatment of the outer walls resembles that of the sanctuaries
at Tanjavur and Gangaikondacholapuram, with double tiers of 106
basement mouldings and pilastered walls containing sculpture
niches. That these gopuras replaced the sanctuary as the major
artistic features of the complex is borne out by the full range of
icons housed in the wall niches. The jambs flanking the internal
passageways are divided into minute plaques filled with females in
different dance postures. Above this level rise pyramidal storeyed
towers of brick, capped by shala roofs with pot-like finials on their
ridges and ornate decoration on their arched ends. Though much
renovated in later times, these superstructures preserve their
Chola period profiles.

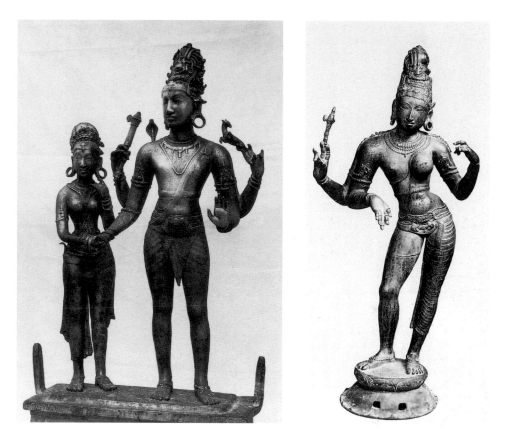

112. Shiva taking the hand
of Parvati, In a group in the
Chidambareshvara temple at
Vadakkalattur in Tamil Nadu,
Chola period, late ninth century;
bronze, H 74 cm and 91 cm. The
refined modelling of these figures
and their gentle expressions are
hallmarks of the early Chola style.

113. Ardhanarishvara from
Tiruvengadu in Tamil Nadu, Chola
period, eleventh century; bronze,
H 100 cm. This figure combines
the male and female bodies,
costumes and head-dresses of
Shiva and Devi to create a
composition of
matchless poise.

No account of Chola art would be complete without a
consideration of the processional bronzes which are among the
greatest masterpieces of Hindu metal sculpture. Produced by the
lost-wax process, these images perfectly complement the granite
figures carved on the temples themselves. The earliest examples,
which go back to the end of the ninth century, are characterized by
soft modelling of the torsos and limbs, delicately worked costumes
and jewelry, and dreamy facial expressions. Figures assigned to
the eleventh century are bolder in relief and more vigorous in pos-
ture. A sharper delineation of facial features and costume details is
noticeable in the later examples of the twelfth century.

Chola bronzes portray all of the major Hindu divinities, in
particular Shiva. The four-armed god appears together with
Parvati as a pair of standing figures, the god affectionately taking
the hand of the goddess, as in an example still under worship in
the Chidambareshvara temple at Vadakkalattur, in the vicinity of

112–
115

112

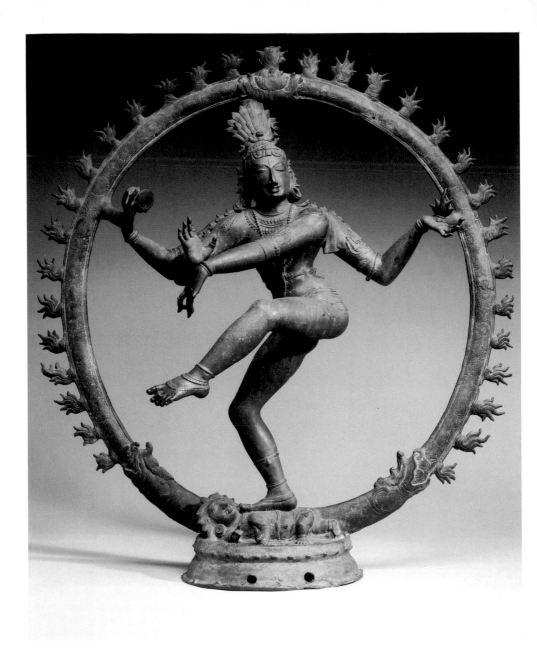

114. Shiva Nataraja from Tamil Nadu, Chola period, eleventh century; bronze, H 111.5 cm. The lifted foot indicates liberation; with the other he crushes ignorance.

115. (opposite) Krishna subduing the naga demon Kaliya by dancing on its serpent hoods, from Tamil Nadu, Chola period, eleventh century; bronze, H 59 cm.

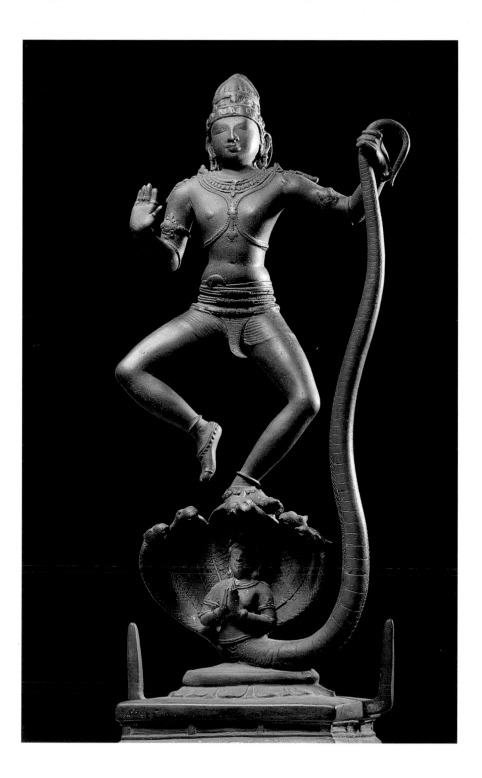

Tanjavur, dating from the late ninth century. The divine couple is sometimes joined by the child Skanda in a seated family group known as Somaskandamurti. Shiva is usually shown with matted hair in which the crescent moon can be seen; he holds a small axe and miniature prancing deer in his rear two hands. The two divinities merge in the image of Ardhanarishvara. Male and female physiognomies and dress are here perfectly blended to create a figure of consummate power and grace. The most celebrated Shiva icon, however, is that of Nataraja, showing the god dancing. His two rear hands hold the fire and the drum, the latter producing the sound which accompanies the cosmic dance; in front, his left hand is flung across his body to point downwards to his lifted foot that indicates liberation, while the other foot crushes a dwarf who represents ignorance. The form of the cosmos is suggested by the flaming aureole that encircles the whole composition. As in other images of Shiva, the headdress of the god is adorned with the crescent moon and snakes.

Krishna too is depicted in Chola bronzes, one of the finest examples showing the youthful god trampling the hoods of Kaliya, holding up the long tail of the serpent demon with one hand. While this eleventh-century composition perfectly captures the paces of Krishna's dance, both god and demon are depicted with peaceful detached expressions. The principal characters from the *Ramayana* also appear in bronzes: Rama and Lakshmana drawing bows, Sita standing demurely to one side, and Hanuman offering his devotion. Among images of saints is a twelfth-century bronze of the naked child Sambandar holding a begging bowl. Many of these figures are remarkable for their human qualities, as expressed in the naturalistic bodies and facial expressions. They represent the most appealing aspect of Chola art, and indeed of all Hindu art during this culminating period of development.

Chapter 5: Revival: fifteenth to eighteenth centuries

At the very end of the twelfth century, northern India was overwhelmed by Muslim invaders arriving from Afghanistan and the farther lands of Central Asia. Just over one hundred years later most of the country was brought under the authority of the newly established sultanate of Delhi, and virtually all temple building came to a halt. Almost no examples of Hindu architecture and sculpture can be assigned to the fourteenth century. It is not until the fifteenth century that these traditions are once again established, and then only in Rajasthan, where the Hindu Rajputs managed to withstand the Muslim assault, and in southern India, where the Hindu kings of Vijayanagara successfully expelled the Muslim intruders. These two regions became the major focus of artistic activity in the sixteenth and seventeenth centuries, during which time much of the remainder of the country came under the sway of the Mughal emperors.

In spite of these somewhat hesitant awakenings, this phase of Hindu art and architecture proved to be a dynamic and inventive period, marked by a proliferation of sacred monuments and associated works of art. In addition to the Rajput and Vijayanagara rulers, Hindu patrons in other parts of India were also able to assert their independence, especially during the eighteenth century when Mughal influence declined.

Most of the temples founded in the period with which this chapter is concerned refer back to earlier traditions, and are thus deliberately revivalist in spirit and style. This is well illustrated in the clustered shikhara towers of northern Indian shrines and the Chola-inspired gopuras of southern India. Such architectural imitations are, however, usually accompanied by a readiness to assimilate new forms and techniques, thereby avoiding any lifeless archaism. Features drawn from contemporary Mughal architecture are integrated into northern Indian temples, while temples in the south develop the mandapa into an architectural showpiece dominated by a full repertory of sculpted imagery that includes Hindu divinities, martial animals, and royal portraits.

147
161
158–59
163

116. The gopis beseeching Krishna to return their clothing, from a dispersed *Bhagavata Purana* in the *Chaurapancha-shika* style, Delhi–Agra region, c.1560; ink and colours on paper, 19.2 × 25.7 cm. The youthful god, seated in the branches of a tree overlooking the river, gestures to the gopis who hold their hands together in devotion.

117. Aerial combat between Krishna and Indra, from a *Mahabharata*, Mughal court in Agra or Lahore, c.1590; watercolour and gold on paper. The violence of the scene is emphasized by the cloudy sky and the agitated draperies worn by the chief protagonists.

The tendency to absorb new idioms is also obvious in miniature painting, which establishes itself as the leading artistic expression of Hindu courtly culture, especially in Rajasthan and Himachal Pradesh. Adapting the narrow horizontal format of earlier Jain texts on palm leaves to sheets of paper as used for contemporary Mughal compositions, miniatures produced at the Rajput courts focused on favoured religious topics, especially the epic stories of Rama and Krishna. Musical-poetical *Ragamalas* were also popular, especially those with scenes showing courtly figures or their divine counterparts, Krishna and Radha, in contemporary palace and garden settings.

The Delhi–Agra region

For the beginnings of miniature painting with Hindu subjects in the first half of the sixteenth century it is necessary to turn to those lands of northern India directly under Muslim rule, notably the kingdom of Delhi. While the Delhi sultans were in no way involved in the commissioning of Hindu works of art, the names of Muslim artists do appear on several Hindu manuscripts. The

patrons of these works seem to have been Hindu nobles and wealthy merchants. It was this mix of backgrounds and cultures that was to have a lasting impact on the development of Hindu art traditions in northern India during these centuries.

The earliest miniature paintings with Hindu themes are executed in opaque watercolours on horizontal paper pages, in imitation of earlier palm-leaf manuscripts. They consist of sets of illustrations with little or no text, and are known collectively as the *Chaurapanchashika* group after the paintings associated with a set of Sanskrit love lyrics by the twelfth-century poet Bilhana. Though the illustrations of the 'Fifty Verses of a Love Thief' are by no means religious in character, they are stylistically akin to those portraying mythological topics. The group is characterized by large areas of strongly juxtaposed bright colours, especially red and dark blue, and a marked flatness and abstraction of form; any overall static effect is avoided by the vigorous rhythms of the compositions and the bold outlines of the figures and architectural details. The most important Hindu paintings of the *Chaurapanchashika* group are a set of depictions of the forest chapter of the *Ramayana* produced in 1516 at Kacchaura, near Agra, and a dispersed *Bhagavata Purana* from the Delhi–Agra region.

From the last series comes a page showing the gopis 116 imploring Krishna to return their clothes. While the execution is perhaps somewhat crude in detail, the boldness of the diagonal composition and the clear separation of the coloured backgrounds to the figures point to a fully evolved pictorial tradition. Other pages thought to come from this *Bhagavata Purana*, showing Krishna seated with the gopis, attacking the fortress of Naraka, or defeating the whirlwind demon, are painted in a 7 similarly vigorous manner. It was this style that was to influence later Rajput painting, especially that which emerged at the courts 123– of Udaipur and Bundi at the end of the sixteenth century. 125

Hindu painting in the Delhi–Agra region underwent a radical transformation after the middle of the sixteenth century due to the rise of the Mughals, who rapidly took control of this area. Under Akbar (1556–1605) courtly miniature painting was thoroughly influenced by Persian traditions, thanks to the presence of im-ported artists at the imperial ateliers set up first in Agra and Fatehpur Sikri, and then in Lahore towards the end of Akbar's reign. Akbar was intensely interested in the people and culture of his rapidly expanding empire, and his curiosity about Hindu mythology led to Persian translations of the major epics

118. Krishna lifting Mount Govardhana, by Miskin, from a *Harivamsha*, Agra or Lahore, 1590s; watercolour on paper. In this example of a Hindu subject produced at the Mughal court in the finest Persian-influenced manner, Krishna is portrayed with the traditional blue skin. A crowd of villagers, city visitors and sages sheltering beneath the mountain witness the miraculous event.

illustrated with full-page vertical paintings in the finest Mughal manner. Among such works is the *Harivamsha*, or Genealogy of Krishna, prepared at Agra or Lahore in the 1590s. A sumptuous page from this work signed by the artist Miskin portrays Krishna lifting up Mount Govardhana. The Persianized style then fashionable at the Mughal court is lavishly displayed in the delicately shaded rocks of the rugged hill that the god effortlessly holds up with his left hand. A page from a contemporary *Mahabharata* executed in a comparable manner depicts Krishna on Garuda flying through the air, battling with Indra who rides on an elephant that plunges earthward. This super-human combat takes place in a sky filled with painterly clouds, under the gaze of the gods arrayed along the top; below is a muted landscape executed in

118

117

a European-influenced manner with fanciful buildings, hills, and a boat in which Europeans are seen travelling. Among the *Ramayana* illustrations produced at the Mughal studio in the last decade of the sixteenth century is one showing Rama and Sita in the forest. The couple sit in a softly toned landscape, empty except for forest sages and a youth climbing a tree.

Akbar's deep interest in Hindu culture was not confined to art: he married princesses from royal families in Rajasthan, and encouraged many of the Rajput princes to attain high posts in his administration, the most notable being Man Singh (1592–1615), heir to the Kacchwaha kingdom of Amber in eastern Rajasthan. A significant moment in Man Singh's rise to power under Akbar was the permission that he received from the emperor to erect a number of temples in Vrindaban, midway between Delhi and Agra. Man Singh's benefactions at this pilgrimage town on the Jumna signify a revival of interest in the area as the heartland of a revitalized Krishna cult. His temples there are built out of red sandstone, the material generally reserved for Mughal official architecture, and they employ Mughal technical features such as

119. Axonometric view of the Govindadeva temple in Vrindaban, Uttar Pradesh, Mughal period, 1591. Though built by a Hindu patron, Man Singh, ruler of the Kachhwaha kingdom of Amber in Rajasthan, the temple employs Mughal-style materials, techniques and forms, including a domed chamber serving as the mandapa.

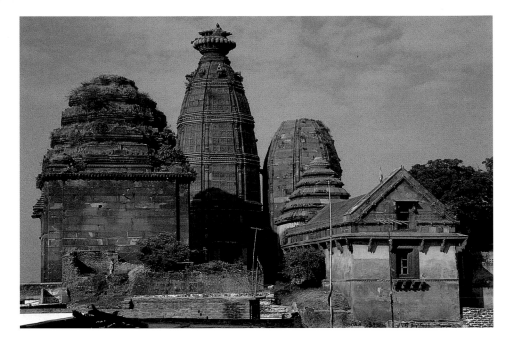

120. Madana Mohana temple in Vrindaban, Uttar Pradesh, Mughal period, end of the sixteenth century. The octagonal tower with curving profile that rises over the sanctuary derives from the deul towers of Orissa and Bengal, as does the pyramidal jagamohan-type roof of the entrance chamber.

truc arches, vaults and domes. The Govindadeva temple of 1591, 119 the largest of Man Singh's projects, has a grandly planned and magnificently constructed mandapa entered on three sides through porches with superimposed colonnades and arcades; the buttresses on either side are enlivened by basement mouldings derived from temple architecture. The spacious interior is roofed with a petalled dome set between two half-domes carried on intersecting arches, a constructional device familiar from contemporary mosques but hitherto unknown in temple architecture. The sanctuary, no longer standing, probably resembled that of the nearby Madana Mohana temple, another of Man Singh's 120 benefactions. This consists of an octagonal tower with curving sides adorned with carved lotus medallions and a prominent amalaka finial, all executed in red sandstone. The shrine is associated with a chamber roofed with a more conventional tiered tower; they stand in a compound entered by a gabled gateway.

While the artistic momentum of Akbar's era continued into the seventeenth century, none of the later Mughal emperors evinced the same interest in or sympathy for Hindu mythology. For the further development of miniature painting with Hindu themes in northern India it is necessary to turn to the Rajput courts of Rajasthan.

121. Jaya Stambha, or Victory Tower, in the fort at Chitor in Rajasthan, c.1448. This unique structure consisting of superimposed chambers linked by an internal staircase is consecrated to Vishnu.

Rajasthan under the Sisodias and other Rajputs

The Sisodias of Mewar in southern Rajasthan, the most powerful of the Rajput lines during these centuries, were the first Hindu kings to resume sponsorship of Hindu architecture and art in northern India. This is partly explained by the fact that temple building traditions in the Mewar region had not completely lapsed during the period of the Muslim conquest. Jain merchants and ministers managed to sponsor large-scale religious projects, such as the temple at Ranakpur built by Dharna Shah in 1439. Under Rana Kumbha (1433–68), damaged Hindu shrines at the Sisodia hilltop citadel at Chitor were repaired and enlarged, and new projects were initiated, such as a monument erected in about 1448 to commemorate a military victory over the combined armies of the sultans of the neighbouring kingdoms of Gujarat and Malwa. Called Jaya Stambha, or Victory Tower, this 40-metre-high structure consists of a raised platform and nine superimposed storeys – seven with deeply moulded walls punctuated by openings, and two at the top with projecting balconies. Multiple images of Vishnu, the god to whom the tower is consecrated, are set into wall niches, each identified by an inscription. Figures of the architects are installed in the fifth storey, a rare instance of such portraiture in Hindu art.

Other Hindu monuments in Mewar are more conventional, consciously harking back to the religious architecture of earlier times. The fifteenth-century Shiva temple at Eklingji, the Sisodia dynastic shrine, for example, presents a revivalist shikhara tower, the sides of which are flanked by lesser half-towers to achieve the desired clustered effect. A more finely finished monument is the contemporary Suryanarayana temple at Ranakpur. Its outer walls are divided into angled projections to such an extent that it almost approaches a circle in plan. The clustered tower is enlivened with half-shikharas that rise on pilastered niches replicating those of the mandapa. The interior is animated with intricately carved arches suspended between columns, as in the finest Solanki monuments of the past. Temples at the later Sisodia capital of Udaipur, such as the Jagadishvara erected by Jagat Singh I (1628–52), are built in the same tradition. In all these examples, figural sculpture is generally reduced to carvings around sanctuary doorways and on porch columns.

That the revivalist approach to religious architecture was not restricted to the kingdom of Mewar is demonstrated by the Jagat Shiromani temple, below the fortress palace at Amber. Erected by Man Singh, the same Kacchwaha prince who has already been

122. Jagat Shiromani temple in Amber, Rajasthan, 1599, erected by the Kacchwaha ruler Man Singh to commemorate the death in battle of his son and heir, Jagat Singh. The revivalist tower that rises over the sanctuary contrasts with the Mughal-style vault that crowns the adjacent mandapa. The temple is entered through a free-standing portal.

mentioned in connection with the shrines in Vrindaban, it has a clustered shikhara of the usual type. This, however, adjoins a double-storeyed mandapa roofed with a curved vault imitating those of contemporary Mughal pavilions. Its interior is adorned with painted panels illustrating episodes from the legend of Krishna, the god to whom the temple is dedicated. In front stands a high entrance portal with pillars topped with shikhara-like finials.

Rajput funerary monuments are sometimes also conceived as traditional temples, as in the cenotaphs, or *dewals*, at Mandor commemorating the Jodhpur rulers. The dewal of Ajit Singh (1678–1724), for instance, has a clustered shikhara enlivened with superimposed balconies rising up in the middle of each side. Other Rajput cenotaphs are closer to Mughal traditions, being little more than open pavilions with domes known as *chhatris*. Groups of such chhatris, often overlooking a stepped tank, are a familiar feature of royal funerary sites in Rajasthan.

Further evidence of Mughal influence is seen in the Shila Devi shrine tucked away beneath the principal gateway of the Kacchwaha palace at Amber. Dating from the period of Sawai Jai Singh II (1699–1743), this royal chapel has a marble courtyard

123. The musical mode *Gauri Ragini*, showing a maiden with peacocks, from Udaipur in Mewar, Rajasthan, *c*.1605; watercolour on paper. The bright colours of the background and the undulating horizon line are typical of the Mewar style.

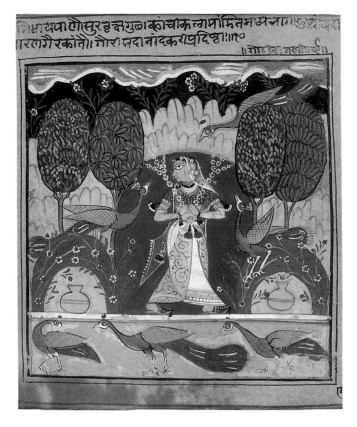

surrounded by Mughal-style cusped arches. The goddess Shila Devi is housed in a small recess, with banana trees carved in shallow relief on panels at either side. Sawai Jai Singh was also responsible for the Govindadeva temple in the garden of his newly founded palace in Jaipur. Walkways and axial channels are laid out in the standard four-square Mughal manner, with a central waterway proceeding northwards to the main shrine. This is conceived as a Mughal garden pavilion, complete with cusped arcades sheltered by angled eaves running around a domed chamber devoid of any tower.

The impact of Mughal architecture on these monuments is hardly surprising considering the close political and cultural ties that were forged between Rajasthan and the Mughal empire under Akbar and his successors. Another striking manifestation of Mughal influence is the painting tradition that grew up at the different Rajput courts in the course of the seventeenth and eighteenth centuries. While works on paper and murals on palace

walls in Rajasthan often imitated favoured Mughal topics such as royal portraiture, reception, entertainment, hunting and war, mythological subjects also make an appearance, testifying to the rise of a genuinely Hindu pictorial tradition.

One of the first Rajput schools of painting to be established is that of Mewar, centred in and around the Sisodia court of Udaipur in the seventeenth and eighteenth centuries. The dependence on the earlier *Chaurapanchashika* tradition is obvious from the use of bright flat colours as backgrounds for the principal figures, and an undulating white horizon to delimit the earth and sky. The contrast between the colours in the backgrounds gives the compositions a strongly marked structure which is characteristic of the Mewar style; this is complemented by the clarity of the linework and the varied postures of the figures. All these features are present in a page dated to about 1605, which depicts the musical mode *Gauri Ragini* as a maiden standing alone in a rocky landscape with trees and peacocks. The same is true of *rasamandala* compositions, in which flute-playing Krishna is surrounded by a ring of dancing gopis holding hands, with female musicians below.

Cycles of *Ramayana* illustrations are also known in Mewar art, the most celebrated being a set of unusually large and horizontal-format pages produced in Udaipur in 1649–53 under the sponsorship of Jagat Singh I. They are remarkable for the bright blues, reds and yellows of the backgrounds, and the

116

123

145

124. Hanuman flying through the air clutching the herb-covered mountain, above a landscape of rocky hills, with streams running down to a river at the bottom, from a *Ramayana* produced at Udaipur in Mewar, Rajasthan, 1649–53; watercolour on paper.

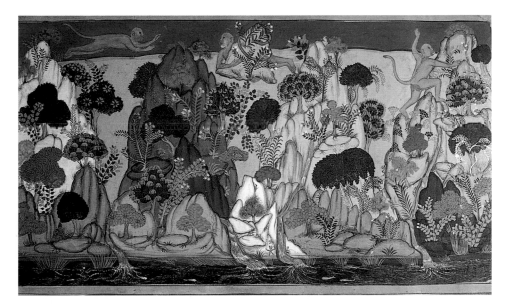

crowded compositions filled with figures, animals and land-scape features. Among the busiest scenes are those depicting the monkeys attacking Ravana's island palace in Lanka, and Rama conferring with his allies in the forest, while tigers drink at a nearby stream and elephants frolic in a lotus pond to the rear. Nowhere is the love of landscape better expressed than in the page depicting Hanuman searching for magical herbs, and then flying through the air clutching the hill on which the herbs are growing, on his way back to Lanka in order to revive Lakshmana.

124

Later Udaipur painting continues the colouristic tradition already noticed, except that there is a concern to produce more lyrical compositions. By the later eighteenth century, it tended to concentrate on large-scale depictions of activities of the Udaipur court, including religious ceremonies.

The kingdoms of Bundi and Kota in southeastern Rajasthan are also of importance for the history of miniature painting. Indeed, one of the earliest *Ragamala* cycles is that associated with the Bundi ruler Bhoj Singh (1585–1607), when he was at Chunar in Uttar Pradesh, in the employ of Akbar. A typical page from this series, the *Malasri Ragini* dated 1591, shows a maiden gazing wistfully at an empty bed within a palace. The composition is remarkable for the clarity of the architectural setting, especially the rooftop chhatris which are shown in quasi perspective against a night sky dotted with stars and the moon.

125

The deep red and dark blue colours typical of early Bundi painting seem to have been inherited by the Kota school. *Shuddhamalara Ragini* from a late seventeenth-century *Ragamala* series painted in Kota takes up the theme of Krishna dancing with the gopis. It is the monsoon season and the artist has taken trouble to portray the swirling clouds and falling drops of rain. Eighteenth-century Bundi painting continues many of these themes, but the colour schemes are gradually modified; while the dark greys and blues of earlier times are still present, pale pinks and greens also appear, especially for landscape features.

126

Painting in Bundi also took the form of murals, such as those in the Chitra Shala or Painted Hall in the palace that rises above the town. Dating mainly from the reign of Vishnu Singh (1773–1821), they include panels with Krishna and Radha in the company of the gopis, coronation scenes of Rama, and the incar-nations of Vishnu. Devotional scenes also appear, with priests standing in front of the Shrinathji image at Nathdwara, a shrine in Mewar much frequented by the Bundi rulers. Some panels even portray the actual shrine itself. Several of these topics recur

127

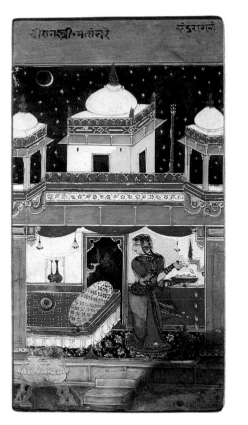

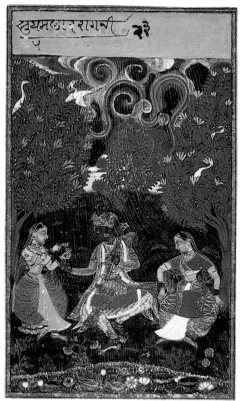

125. The musical mode *Malasri Ragini*, from Bundi in Rajasthan, 1591; watercolour on paper. The strongly architectural composition of the painting is reinforced by bold colours.

126. The musical mode *Shuddhamalara Ragini*, showing Krishna dancing in the monsoon storm attended by two gopis who accompany him on cymbals and a drum; from Kota in Rajasthan, late seventeenth century; watercolour on paper. Kota paintings specialize in dark colours and turbulent skies such as those shown here.

within the Badah Mahal in the private wing of the palace in Kota, where murals are combined with works on paper encased in glass frames set into the walls.

Among the lesser Rajput centres that fostered individual schools of painting is Kishangarh, celebrated for its portraits of noblemen and women with exaggerated profiles and languid eyes. Religious themes are occasionally found. One miniature, for instance, shows the ruler Savant Singh (1747–57) seated before the naked sage Shukadeva and other holy men, while a receding prospect of wooded hills and lakes opens up to the rear. This fascination with landscape is characteristic of the Kishangarh school, as can be seen in a painting showing diminutive figures of Krishna and Radha in a densely planted garden. An unusual aspect of this work is that the painter, Nihal Chand, is supposed to have used the mistress of his patron, Savant Singh, as the model for Radha.

No account of Hindu painting in Rajasthan would be complete without notice of an unusual series of abstract magical diagrams

128

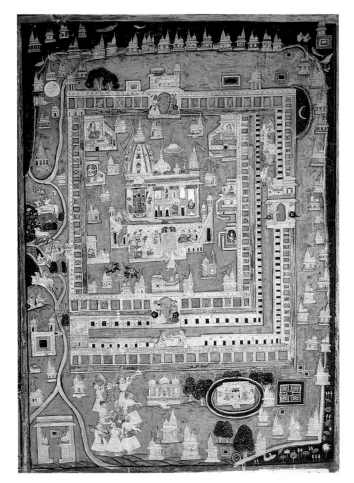

127. Schematic view of the pilgrimage shrine of Shrinathji, a form of Krishna, at Nathdwara. From a mural in the Chitra Shala of the palace in Bundi, Rajasthan, late eighteenth century. The shrine stands at the heart of a complex of colonnaded courts and gates; topped with a shikhara, it is attended by priests and worshippers (cf. III. 175).

known as *yantras* executed in bright colours on tinted paper, many of which were produced at Jaipur in the eighteenth century. Linked with esoteric practices of Tantric Hinduism, such works are intended as meditation aids and are thus essentially utilitarian rather than illustrative. Some consist of a downward-pointing triangle surrounded by a circle of petals, symbolizing the powers of the goddess Kali; others take the form of concentric and interlocking rings, intended to represent the structure of the universe.

Himachal Pradesh
Because of their far-off situation in the sub-Himalayan valleys of Himachal Pradesh, known as the Pahari or 'hill' region, some lesser Rajput states managed to preserve their political autonomy

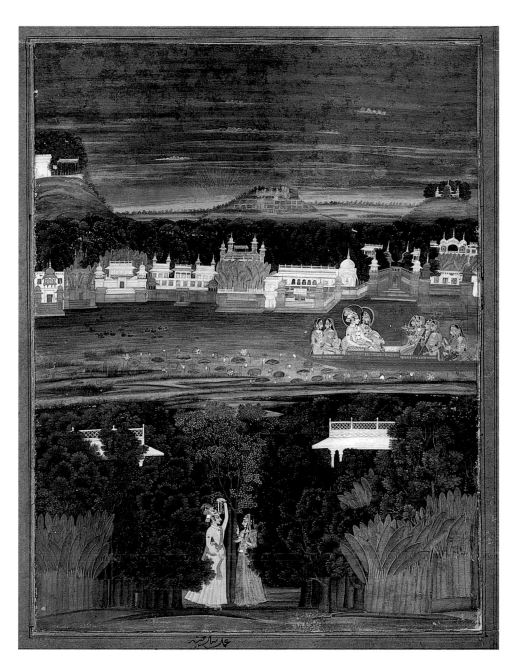

128. Krishna and Radha in a garden (foreground) and riding in a boat (middle distance); from Kishangarh in Rajasthan, by Nihal Chand, mid-eighteenth century; watercolour on paper. The lotus pond where the boating expedition is taking place is overlooked by a waterside palace with pavilions, with a range of wooded hills beyond, all overshadowed by a brooding sunset sky.

129. (below) Page from a Tantric Devi series showing the goddess as a beautiful woman seated on a prostrate body, appearing before a sage; from Basohli in Himachal Pradesh, third quarter of the seventeenth century; watercolour on paper, 21 × 23 cm.

130. (opposite, above) Krishna about to behead the wicked king Kamsa, from a *Bhagavata Purana* produced in Mankot in Jammu, early eighteenth century; watercolour on paper, 21 × 31 cm. The bright yellow background and flat red border are favoured by many of the Pahari schools.

131. (opposite, below) The demon Ravana confronting the hawk Jatayu; from a *Ramayana* produced in Kulu in Himachal Pradesh, eighteenth century; watercolour on paper, 18 × 28 cm. The episode recounts how Jatayu intercepted Ravana's chariot, causing it to fall to earth, killing its driver and horses.

throughout the Mughal period. The Hindu courts of these small kingdoms are of interest for a series of related schools of painting, known collectively as Pahari art, that flourished here during the seventeenth and eighteenth centuries. As in contemporary painting in Rajasthan, Pahari art concentrates on royal portraits and scenes of palace life, mostly executed in a Mughal-influenced manner. Yet there is no shortage of Hindu topics, especially those connected with the life of Krishna and the different aspects of Devi, the most popular divinities in the region. These mythological compositions are executed in a variety of styles associated with the different Rajput courts; they testify to the inventiveness of artists at these somewhat distant centres.

One of the earliest examples of Pahari art is a Tantric Devi series from Basohli assigned to the years just after the middle of the seventeenth century. The pages show different aspects of the goddess, some with fierce expressions brandishing weapons, others seated on a prostrate corpse. An example of the latter type depicts Devi as a beautiful woman, decked in jewels, garlands and lotuses, with a bearded sage seated in a grove gazing intently towards her. The dark greens and greys of the composition are offset by a flat red border.

129

Brighter compositions on empty but intense yellow backgrounds are sometimes preferred by artists working at the court of Mankot in the neighbouring region of Jammu, as may be seen in a page illustrating the final scene from the *Bhagavata Purana*. 130 Here, Krishna is just about to behead Kamsa whom he tugs by the hair, pulling the wicked king off his throne. The violence of Krishna's act is fully expressed by his forceful posture, Kamsa's exaggeratedly crumpled figure, and even the starkly empty throne.

Something of the same energy is present in a *Ramayana* painting from another hill state, Kulu: this shows the multi- 131 headed demon Ravana confronting the hawk Jatayu, which had intercepted his chariot. As in the Mankot page, a yellow background and red frame are employed to draw attention to the clearly delineated protagonists. The *Ramayana* was the occasion for further demonstrations of the expressive range of the Kulu painters, as in heartfelt scenes portraying Rama and Lakshmana taking leave of their father: in one page, Dasharatha lies on a rug, his head turned painfully away from his favourite son.

Another important centre for Pahari art is Mandi, where paintings were produced from the late seventeenth century

132. Krishna drinking in the forest fire to protect the herds; from a *Bhagavata Purana* produced in Mandi in Himachal Pradesh, late seventeenth century; watercolour on paper, 20 × 29 cm. The youthful god appears in the middle of the composition, sucking in a tongue of fire; he is surrounded by herdsmen sheltering their faces from the heat, while their cows rush in from the encircling fire or line up patiently behind them.

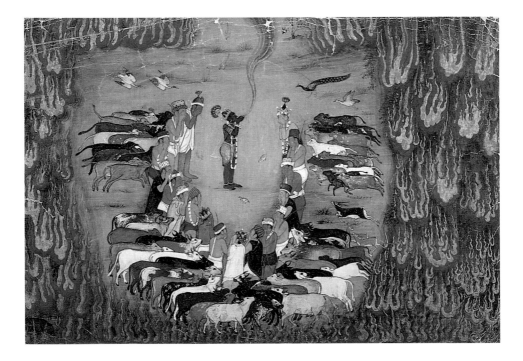

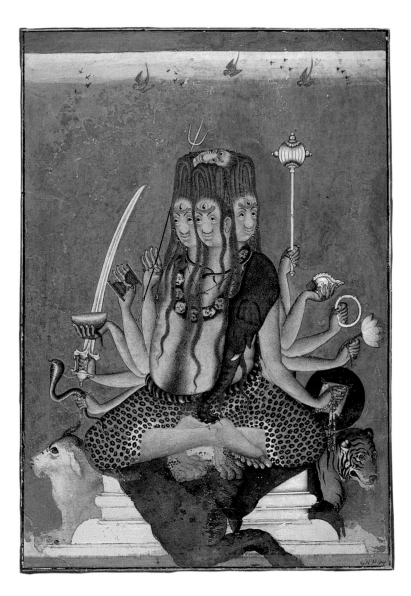

133. Sadashiva, with four of his five heads visible (three at the sides and one at the top), dressed in the skins of a tiger and an elephant and hung with a garland of skulls, from Mandi, mid-eighteenth century; watercolour on paper, 26.5 × 18 cm. A bull and tiger are seated beside the throne of the god.

onwards. An early example of this school is an illustration from the *Bhagavata Purana* of Krishna drinking the forest fire. The naturalism of the figures and animals contrasts with the schematic flames that flicker nervously around the edges of the scene. Unlike other Pahari works considered so far, the tonal range is dominated by green, as it is in another Mandi painting dating from the middle of the eighteenth century. This portrays five-headed Sadashiva, with four heads visible, and with ten hands

132

133

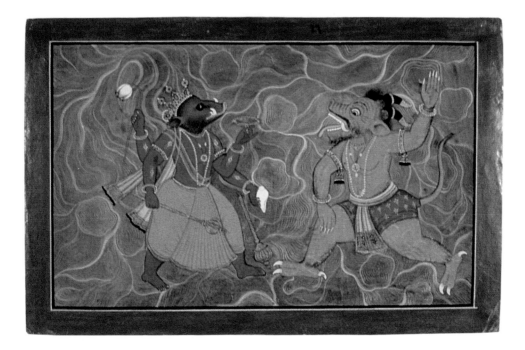

134. Battle between Vishnu and Hiranyakashipu, from Guler in Himachal Pradesh, by Manaku, eighteenth century; watercolour on paper. The god is distinguished by his bright yellow garment, and the disc and conch that he holds in his two left hands; the demon has a contrasting bright green body and red garment, and is more vigorously posed. The dark grey swirls suggest the cosmic ocean in which this contest takes place.

carrying various weapons. The god is dressed in the skins of a leopard and an elephant, and is seated against a blank green background. The expressive power of the figure is heightened by the faces with curiously uplifted eyes flanked by long tresses of hair, and the grey shading of the body and limbs.

Guler was one of the major centres of Pahari art in the eighteenth century, the court painters there producing a broad range of works with mythological topics. The fight between Varaha and Hiranyakashipu, a demon more usually confronted by the Narasimha incarnation of Vishnu, forms the subject of a page signed by the artist Manaku. The protagonists stride towards each other against a background of dark grey swirls intended to suggest the cosmic ocean that preceded all creation. Such dynamic postures are common in Guler art, as may be judged from a series depicting Shiva with Kali. In one painting dating from the end of the eighteenth century the pale-skinned god plays the drum in accompaniment to the emaciated black-bodied goddess who dances frenetically, two of her four hands held above her head. Meanwhile, fiendish female attendants are seen dancing in the grassy hills of the background. Other compositions from Guler further explore the awe-inspiring aspects of Kali, with the

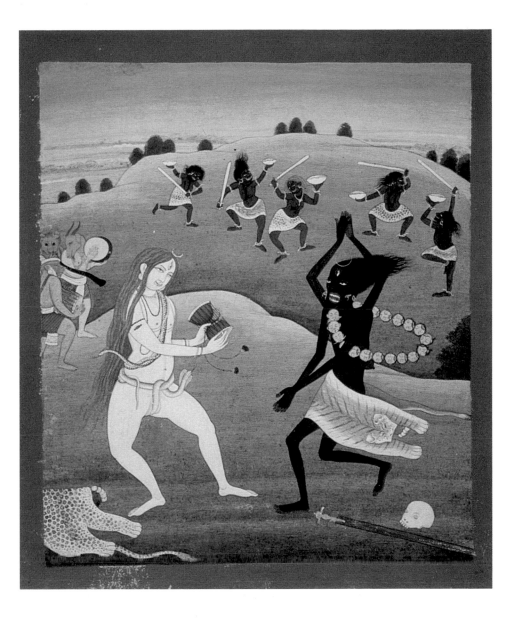

135. Shiva with dancing Kali, from Guler in Himachal Pradesh, late eighteenth century; watercolour on paper, 23 × 20 cm. Kali's savage nature appears from her grimacing face, the flying necklace of skulls, and the tiger skin swinging away from her body.

goddess and her demonic host leading the attack on a battlefield, drinking the blood of her slain opponents, and standing triumphant surrounded by her prostrate victims.

Such ghoulish themes are scrupulously avoided in paintings from the court of Kangra; these signal the final phase of Pahari art extending well into the nineteenth century. Kangra compositions specialize in moody landscapes filled with trees with dense green

136. Radha being persuaded by her handmaiden, and then conversing with Krishna, from Kangra in Himachal Pradesh, late eighteenth century; watercolour on paper. The tenderness of the two scenes is echoed in the delicate hues of the blossoming bushes that surround the couples.

and blue foliage. Such settings dominate the pale-skinned figures who are depicted in languid poses outlined in fluid brush strokes. Krishna scenes prevail, especially those where the hero is alone with Radha in a landscape. Multiple episodes are often incorporated into a single composition, such as Radha being persuaded by her handmaiden to go to Krishna, and then sitting with her lord conversing quietly. Shiva too appears in Kangra art, seated or lying together with Parvati on a tiger skin in a dark-toned forest. Nor are mythological narratives entirely absent: a page from a *Harivamsha* series depicting Parashurama guiding Krishna and Balarama to the hermits who live on Mount Gomanta displays the same attention to flowering trees and other landscape features.

Hindu monuments were also erected in Himachal Pradesh during these centuries. The Hidimba Devi temple at Manali, begun in 1553 under the sponsorship of the local ruler of Kangra, belongs to the same architectural family as the Hindu shrines of nearby Nepal. It has a 24-metre-high tower with three tiers of angled roofs covered with timber shingles, unadorned walls of mud-covered stonework, and a contrasting ornately carved wooden doorway.

137. Parashurama bringing Krishna and Balarama to Mount Gomanta; from a *Harivamsha* produced in Kangra in Himachal Pradesh, beginning of the nineteenth century; watercolour on paper, 35 × 48 cm. The mountain is inhabited by hermits in caves and animal-headed deities with consorts.

Nepal under the Mallas

The antiquity of Hinduism in Nepal is confirmed by stone carvings dating back to the seventh and eighth centuries, which include a remarkable 6-metre-long stone image of Vishnu reclining on Ananta, partly submerged in the waters of a rectangular tank at Budhanilkantha near Kathmandu. Early metal images include a remarkable eleventh-century Ardhanarishvara. However, such icons are isolated from any architectural context and no fully intact Hindu monuments survive before the Malla period, from the sixteenth century onwards. Temples built by various kings of the dynasties ruling concurrently from Kathmandu, Bhaktapur (Bhadgaon) and Patan have brick sanctuaries rising into towers from which multiple roofs angle outwards in diminishing tiers. Such buildings are noteworthy for their intricately carved woodwork, best seen in the ornate doorways, windows and cornices set into the brickwork, as well as in the struts supporting the roof overhangs. Gilded brass panels embossed with divinities, nagas and exaggerated kirttimukhas are often placed over the doorways. The larger buildings are raised on brick podiums with multiple stages, reached by steps flanked by stone animals.

8

138. Taleju temple in Kathmandu, Nepal, Malla period, third quarter of the sixteenth century. This was the first temple in the Kathmandu valley to have more than two storeys.

139. Gilded copper portrait of Bhupatindra, founder of the Nyatapola temple in Bhaktapur, Nepal, Malla period, early eighteenth century.

The Pashupatinatha shrine at Deopatan is one of the holiest in Nepal. Though remodelled on numerous occasions, it maintains the original double-tiered roof system adopted throughout Nepal in the sixteenth century. Triple tiers of roofs, introduced in the Taleju temple in Kathmandu erected by Mahendra Malla (1560–74), also gained in popularity at this time. Four and even five tiers are also known, the Nyatapola temple in Bhaktapur of 1703, a project of Bhupatindra Malla (1694–1722), being one of the highest in the Kathmandu valley. Its sanctuary is further elevated on a five-stage podium. A stone column nearby is crowned with a gilded portrait of the royal founder, who is shown seated in devotional posture beneath a small umbrella.

Not all temples in Nepal conform to this model, and stone-built shikhara towers derived from northern Indian practice were sometimes preferred. The Krishna temple in Patan, erected in 1637 by Lakshminarasimha Malla (1620–41), has a tiered structure enriched by pavilions with diminutive dome-like roofs, culminating in a shikhara at the top. A stone column in front has a gilded metal icon of Garuda in devotional posture.

An unusual aspect of Hindu religious architecture in Nepal is the well intended as a water shrine: an example in the Sundhari Chowk in Patan is lined with carvings of divinities; even the brass water spout is fashioned as an icon of Vishnu on Garuda. Such images are echoed in the carved woodwork incorporated into buildings. Panels over shrine doorways and windows are flanked by makaras with upturned heads, fringed with knotted snakes and foliage; river goddesses and maidens in foliage scrolls emerging out of makara mouths are seen at the sides. These fantastic compositions contrast with the figures carved on struts, especially multi-armed divinities whose extended hands display weapons and emblems, and copulating couples sheltered by trees weighed down with leaves and flowers.

140. Krishna temple in Patan, Nepal, Malla period, 1637. Built entirely of sandstone, this temple employs a northern Indian-style shikhara tower.

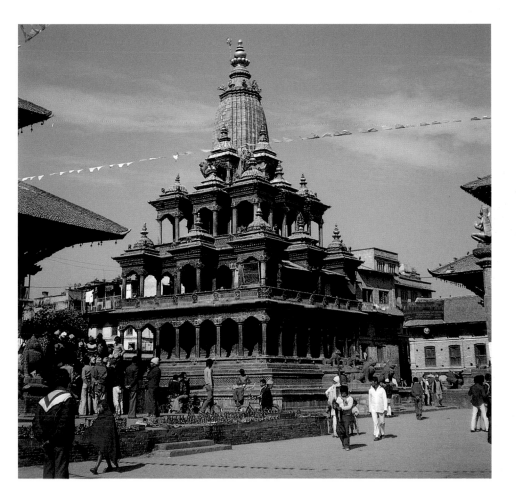

141. Vishnu and Lakshmi on
Garuda, on the gilded brass spout
of the well in the Sundhari Chowk
in Patan, Nepal, Malla period,
seventeenth century.

142. Shiva seated with Parvati,
from Nepal, fifteenth century;
gilded copper inlaid with semi-
precious stones, H 16 cm.
An exceptionally refined evocation
of the celestial couple executed in
a style influenced by that of Tibet,
most noticeable in the crowns of
the figures and the languid limbs.

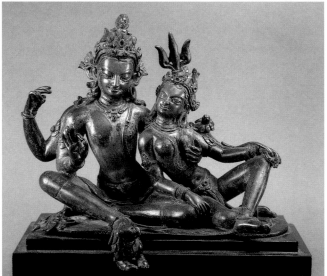

143. A temple with shikhara and multiple chapels housing
divinities related to the cult of Shiva, from Nepal, Malla period,
eighteenth century; watercolour on cloth, 107 × 84 cm.
The shikhara tower and row of chapels recall the Krishna
temple in Patan (Ill. 140).

Gilded copper images dating from the fifteenth and sixteenth centuries reveal the diminutive aspect of Hindu art in Nepal, as in a work set with semi-precious stones portraying Shiva seated 142 with Parvati. The celestial couple is depicted in an affectionate embrace, the goddess nestling comfortably against her lord. Another metal image of about the same date portrays Sarasvati holding a manuscript and a vina. The goddess is seated on a lotus at the centre of an elegant openwork floriate scroll. More horrific goddesses also appear, among them multi-armed Durga surrounded by an aureole of weapons killing the buffalo demon, and skeletal Chamunda garlanded with skulls seated on a prostrate corpse.

Paintings with Hindu subjects executed in Nepal in the seventeenth and eighteenth centuries usually betray the influence of Buddhist traditions from neighbouring Tibet. Such works are executed on cloth, and often depict temples with typical sloping roofs accommodating different gods, framed by lesser deities in the surrounding bands. One of the finest of these shows a shrine 143 with a contrasting curving shikhara tower, within which Bhairava and related multi-armed deities stand in chapels arranged on two levels. Some are more Tibetan in spirit, such as a Devi mandala in which the multi-armed goddess appears in a flaming aura, surrounded by eight petals of different colours accommodating the different Tantric goddesses. All of these cloths are characterized by bright red backgrounds, vivid green and blue tones, and clear black brushwork.

Bengal, Orissa and Assam

Temples built in Bengal during the seventeenth and eighteenth centuries represent a no less distinctive regional tradition than that of Nepal. Because of the lack of stone in this deltaic zone, Bengali temples are invariably of brick. Curiously, they employ arches, vaults and domes, techniques learned from earlier mosque and tomb architecture in the region. Such features are sometimes combined with a curving towered form known as *deul*, borrowed from neighbouring Orissa. The temple at Mathurapur in Bangladesh, for instance, is simply a twelve-sided deul incorporating a small domed sanctuary. Its faceted exterior is covered with horizontal ridges framing terracotta friezes depicting mythological scenes.

The tendency to cloak brick temples with terracotta reliefs is seen in the many temples in Bishnupur in West Bengal, capital of the seventeenth-century Mallas. (These rulers are unrelated to

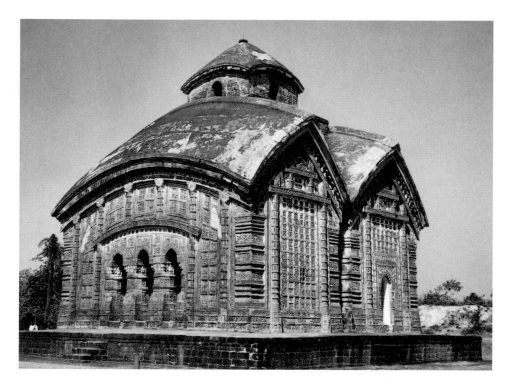

144. Keshta Raya temple in Bishnupur, West Bengal, Malla period, 1655. The brick-built, hut-like chambers with curved ridges and cornices derive from local bamboo and thatch architecture. Inside is a central domed sanctuary surrounded by a passageway.

their contemporary namesakes in Nepal.) The Bishnupur shrines incorporate *bangla* roof forms with curved cornices and ridges that imitate indigenous bamboo and thatch huts. The Keshta Raya temple of 1655 appears from the outside to be a pair of rectangular hut-like chambers with separate entrances topped by a smaller square chamber with a pyramidal roof; inside, however, there is a single domed space surrounded by a vaulted passageway. The Shyama Raya temple of 1643 is laid out in a similar fashion, but the elevation is topped with five diminutive towered chambers, one at each corner and a larger octagonal one in the middle. Some later monuments at Bishnupur, such as the eighteenth-century Shridhara temple, have nine turrets arranged on two ascending levels.

144

Terracotta reliefs cover most if not all of the surfaces of the Bishnupur temples. Basement friezes are dedicated to courtly, hunting and boating scenes, usually in combination with *Ramayana* and *Mahabharata* episodes; panels on the walls above are filled with images of Krishna, alone or with Radha, and other divinities. *Rasamandala* compositions, with fluting Krishna surrounded by rings of dancing gopis, are a particular feature of

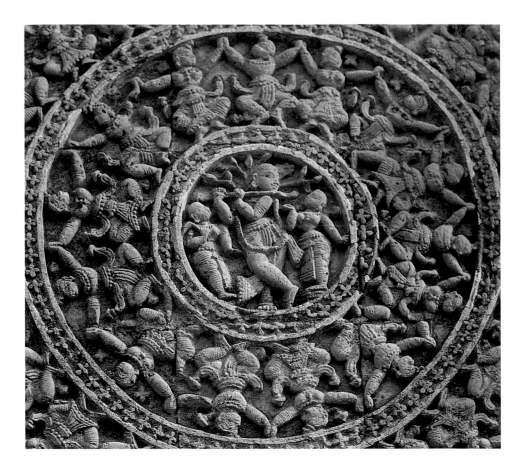

145. A *rasamandala* composition, with Krishna playing the flute surrounded by dancing gopis; terracotta wall panel on the Shyama Raya temple in Bishnupur, West Bengal, Malla period, 1643.

the Shyama Raya temple. Panels over the triple-arched entrances depict *Ramayana* battle episodes, with the protagonists riding in war chariots and firing arrows at each other, or deities such as Kali decked in skulls standing on the prostrate body of her victim, or Devi brandishing weapons mounted on her lion. Entirely modelled in terracotta, these and other figures are crammed together to achieve a nervous imagery that typifies the Bengali style.

Many of these themes spill over into the other arts of the region, such as the wooden book covers intended for palm-leaf manuscripts that are painted with multiple figures of Krishna dancing with the gopis, and the incarnations of Vishnu. Neighbouring Orissa preserves a related pictorial tradition, but this is mostly confined to delicately inscribed palm leaves. Eighteenth-century leaves illustrating the *Bhagavata Purana*

show the exploits of the youthful Krishna, and the myriad phases of his flirtation and love-making with Radha, as the couple dally in a flowery bower, or copulate in the privacy of a bedchamber. The figures are clearly depicted by means of a spidery incised linework, with occasional painterly touches of red, yellow and white. Luxuriant foliage is contained in bands on either side.

A Hindu temple tradition related to that of Bengal is found in regions further east, such as Assam. The Kamakhya temple crowning the hill overlooking the Brahmaputra river at Guwahati was founded by the Koch rulers in the sixteenth century. The sanctuary and line of three halls that constitute this long building are topped with an unusual variety of roofs in the form of octagonal domes, sixteen-sided domes, and hut-like shapes, all of plastered masonry and topped with pot-like finials. Stone carvings inserted into the walls of the outermost, semicircular-ended, hall show vigorously posed musicians and guardians. The interior of the sanctuary is devoid of any goddess image, Kamakhya being represented simply by a yoni.

The Marathas of Maharashtra

A parallel but totally independent phase of Hindu architecture was initiated in the late seventeenth century by the Maratha chiefs of Maharashtra, who challenged the Mughals and eventually expelled them altogether from peninsular India. Once firmly installed as kings in the eighteenth century, the Marathas proved to be prolific builders; so too their prime ministers, or *peshwas*. The Hindu sanctuaries that they erected throughout their realms combine revivalist forms with the arches and domes of late Mughal architecture. The Sundara Narayana temple in Nasik in north-western Maharashtra, begun in 1747 by the peshwa Balaji Bajirao (1740–61), has a domed garbhagriha contained within a clustered shikhara tower, approached through a similarly domed mandapa with projecting porches employing lobed arches. The temple at

146. Stages in the love-making of Krishna and Radha, from Orissa, eighteenth century; incised drawing with watercolour on a palm leaf, 4.5 × 24 cm.

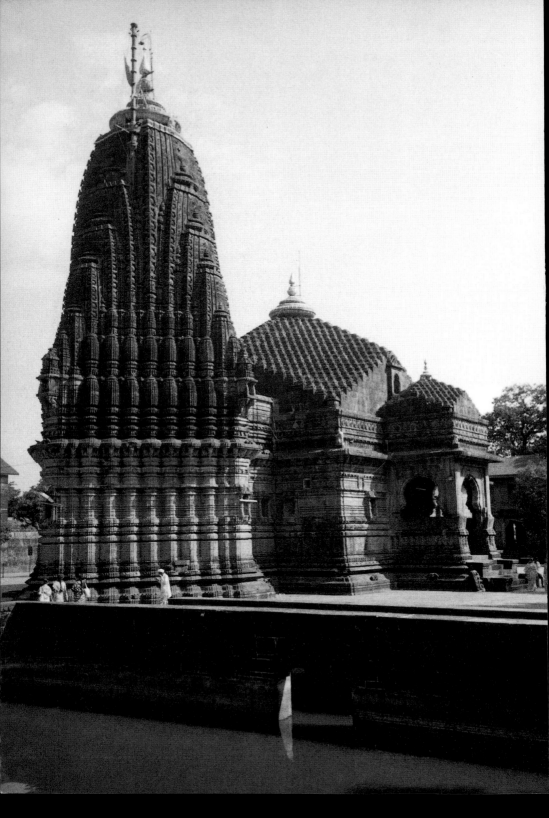

147. Trimbakeshvara temple at Trimbak in Maharashtra, Maratha period, c.1785. The clustered shikhara tower over the sanctuary and the pyramidal roof topping the adjacent mandapa recall past temple forms in Maharashtra and neighbouring Gujarat.

148. Ghrishneshvara temple at Ellora in Maharashtra, late eighteenth century, erected by Ahilyabai, the celebrated Maratha queen.

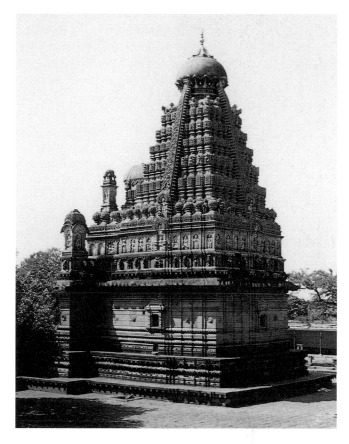

Trimbak, erected in about 1785 by Madhavrao II (1774–96), another peshwa, is built in a revivalist manner that recalls earlier Solanki architecture in Gujarat. The deep red sandstone sanctuary stands in a spacious compound entered through a Mughal-style arched gateway. The garbhagriha is laid out on an almost circular plan, with numerous wall projections carried upwards into the tower; there they are transformed into miniature shikharas clustered around the central shaft. The mandapa is roofed with a bold pyramid of amalaka motifs, interrupted by triangular vertical faces. A trio of porches with balcony slabs give access to the spacious hall; it and the linga chamber are covered with broad domes adorned with ribs and lotus petals.

One of the most celebrated patrons of this era was Ahilyabai (1766–95), queen of the Holkar branch of the Marathas. This family assumed control of much of southern Madhya Pradesh, and its influence even extended as far as the Hindu pilgrimage

147

79,

80

cities of Varanasi in Uttar Pradesh and Gaya in Bihar. Though modest in scale, the Vishvanatha temple of 1777, enshrining one of Shiva's auspicious 'luminous lingas' or *jyotirlingas*, is the most sacred shrine in Varanasi and Ahilyabai's most renowned benefaction. It has a clustered shikhara tower attached to a small pavilion with Mughal-style columns, arches and domes. The same queen was also responsible for the Ahilyabai Ghat, one of the most elaborate in Varanasi, with steps and landings leading down to the Ganges. The Vishnupad temple of 1787 in Gaya also employs a revivalist towered sanctuary; this, however, is accompanied by a multi-storeyed open mandapa roofed with a prominent ribbed dome in accordance with Mughal practice.

Probably the most artistic of Ahilyabai's temples is that standing only a short distance from the much earlier rock-cut monuments at Ellora in Maharashtra, already noticed. Dedicated to another of the jyotirlingas of Shiva under the name of Ghrishneshvara, the monument is notable for its finely modelled details: deeply cut horizontal mouldings define the sandstone plinth and basement; the brick and plaster tower is divided into diminishing tiers of miniature shikhara elements, interrupted by vertical bands on four sides. The tower, which terminates in a fluted dome on petals, has a projection at the front with an encrusted arch framing Shiva and Parvati riding on Nandi; corner finials at rooftop level are conceived as miniature chhatris in the Mughal style. The adjoining mandapa has projecting porches on three sides with balcony slabs. Lively carvings of divinities, horsemen and hunters cover its columns; the brackets are fashioned as crouching ganas.

Of equal interest is Ahilyabai's funerary monument at Maheshwar in Madhya Pradesh, begun in 1799 by her successor Yeshwantrao (1797–1811). The complex is entered through an imposing Mughal-style portal which crowns a flight of steps leading up from the Narmada river. Commemorative chhatris of the Holkar queen and her son Vitthalrao, who predeceased her in 1765, stand opposite each other. Each memorial employs a sanctuary with a revivalist clustered tower and an adjoining mandapa with lobed arches and a lotus dome. A stone portrait of the seated queen is placed next to the linga worshipped inside the domed sanctuary.

Maratha temples in and around the Portuguese possession of Goa on the Arabian Sea coast developed distinctive features because of the impact of locally built European Baroque architecture. A typical example is the Shantadurga temple near Ponda,

148

60–
61

149

149. Shantadurga temple near Ponda in Goa, 1738. The octagonal tower rising above the sanctuary, topped by a balustrade and a small dome with a lantern, derives from Portuguese church architecture, as does the free-standing multi-stage bell tower.

erected in 1738 by Shahu, grandson of Shivaji and ruler of the small state of Satara in Maharashtra. This owes more to the local church style than to any temple tradition.

Karnataka and Andhra Pradesh under the Sangamas and Tuluvas
The disruption of Hindu art traditions caused by the conquests of the Delhi armies was not as long-lasting in southern India as in the north, mainly due to the rise of the Sangama kings who successfully expelled the invaders. By the end of the fourteenth century the Sangamas were busily engaged in building temples at their newly founded capital of Vijayanagara on the Tungabhadra river in central Karnataka. Yet their first projects are modest in scale and relatively plain, with garbhagrihas topped with pyramidal granite towers displaying tiers of eaves-like mouldings.

Hindu art at Vijayanagara in the fifteenth century reveals influences from Tamil Nadu, a region that had come under the control of the Sangamas by this time. The granite Ramachandra

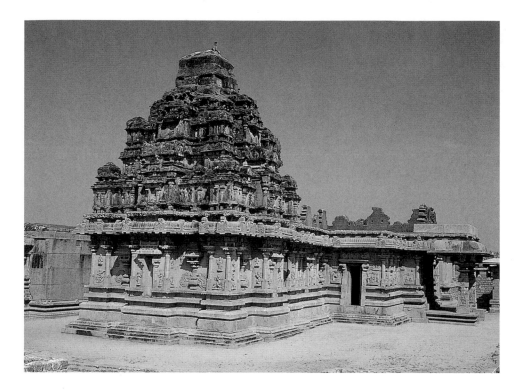

150. Ramachandra temple at Vijayanagara in Karnataka, Sangama period, early fifteenth century. An early example of the Tamil-inspired architecture that was adopted by the Vijayanagara kings.

temple erected by Devaraya I (1406–22) in the middle of the palace area, for instance, has Chola-style basement mouldings and pilastered walls with brackets showing pendant buds at the ends. However, the mandapa with porches on three sides and the pronounced frontal projection on the tower derive from previous local tradition, such as that which flourished under the Early Chalukyas. The outer walls of the temple are covered with carvings that compress the *Ramayana* story into a sequence of panels: thus, Dasharatha standing in front of the fire sacrifice performed by the deer-headed sage Rishyashringa, Rama bending Shiva's bow, Rama and his brothers riding on elephants after their wedding ceremonies, Rama aiming his arrow at the golden deer, Ravana as an ascetic standing outside Sita's hermitage, Rama and Ravana approaching each other in war chariots, and Rama shooting the arrow through the seven palm trees to kill Vali.

The walls of the rectangular compound that contains the Ramachandra temple are also covered with reliefs. Those on the outer face depict the processions of the Mahanavami festival that was developed by the Vijayanagara rulers into a spectacular display of regal powers: rows of elephants grasping trees, richly

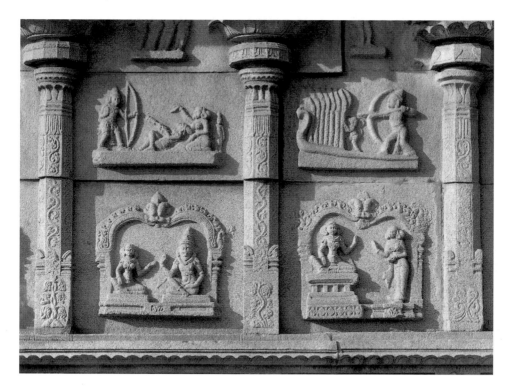

151. Granite reliefs on the Ramachandra temple at Vijayanagara, showing scenes from the *Ramayana*: queen Kaikeyi with her servant (below right), the queen conversing with her husband Dasharatha, persuading him to deprive Rama of his inheritance of the throne of Ayodhya (below left), and then, in later episodes from the story, Rama shooting an arrow through the seven palm trees towards the monkey king Vali (top right), and the death of Vali (top left), after which Sugriva, the rightful monkey king, is crowned.

bridled horses led by attendants in foreign costumes, parades of military contingents inspected by seated royal personalities, and lines of female dancers and musicians. This explicitly royal iconography links the temple with a nearby ceremonial platform, the terraced sides of which are covered with courtly scenes of reception, wrestling, hunting and dancing.

The Tuluvas who displaced the Sangamas as kings of Vijayanagara at the turn of the sixteenth century are credited with a series of magnificent projects. The additions made to the Virupaksha temple by Krishnadevaraya (1509–29) on the occasion of his coronation employ piers enriched with detached colonnettes or rearing yalis. This pier type, deriving ultimately from late Chola practice, is typical of the mature Vijayanagara style. The original gopura entrance is also clearly modelled on Chola prototypes, complete with a granite lower portion and a pyramidal brick and plaster tower topped with a shala roof.

The concept of the religious monument as a planned complex is better expressed in the Krishna temple of 1515, another of Krishnadevaraya's monuments at Vijayanagara. The main shrine consists of a garbhagriha surrounded by a passageway, reached

111

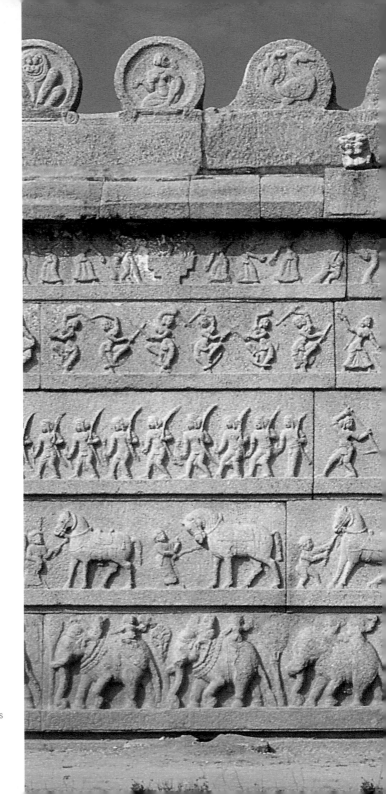

152. Royal reliefs on the compound wall of the Ramachandra temple at Vijayanagara in Karnataka, Sangama period, early fifteenth century; granite. The parades of elephants, horses, military contingents and courtly women are associated with the Mahanavami festival during which the king, his regalia, troops and animals were all blessed by the goddess Durga.

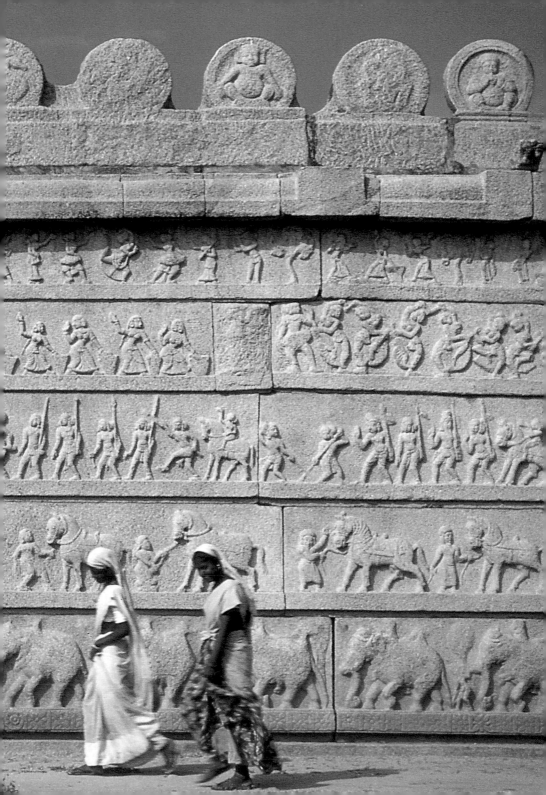

through a pair of mandapas in line, one enclosed, the other open; a separate goddess shrine stands nearby. Both sanctuaries occupy a walled compound entered on the east through a monumental gopura, the outer face of which is furnished with an imposing porch. A broad colonnaded street serving as a bazaar runs eastwards from the temple. Another project at the capital is the Anantashayana temple finished in 1524. This has a large rectangular garbhagriha, intended for a 20-metre-long reclining image of Vishnu probably in plaster-covered brick, of which no trace is preserved. The tower rising above has an unusual curved brick vault with semicircular terminations at both ends.

Krishnadevaraya was also responsible for several important sculptural works. A short distance from the Krishna temple is the largest of these, a 7-metre-high monolithic image of Narasimha, 153 dated 1528. Among the metal sculptures produced during Krishnadevaraya's reign are copper portraits of the king and his two queens in devotional attitudes, installed in an outer corridor of the Venkateshvara shrine at Tirumala in Andhra Pradesh. The faces of the royal trio have long noses and sharply etched eyebrows and eyelids. Krishnadevaraya wears a conical crown with side ribbons, while the queens have their hair folded into elaborate buns.

The most elaborate Hindu temple at Vijayanagara is that dedicated to Vitthala: all of the Tuluva rulers contributed to its building 154 during the first half of the sixteenth century. The outer walls of the main shrine and attached mandapa present an unadorned sequence of basement mouldings and pilastered bays; a brick and plaster tower with a hemispherical roof rises above. This somewhat austere scheme contrasts with the open outer mandapa in front, an addition of 1554, where complex granite piers display leaping yalis and detached colonnettes. These supports define four interior spaces roofed with 10-metre-long granite beams carrying 156 high carved ceilings. The reliefs on the basement of the hall addition show horses being led by attendants, some in Portuguese costume. Other mandapas within the walled compound of the Vitthala temple employ similar columns overhung by double-curved eaves. The interiors are provided with podiums for displaying images of gods and goddesses, especially for ritual betrothal ceremonies between the god and goddess; accordingly, the buildings are known as *kalyana mandapas*, or marriage halls. A small Garuda shrine in front of the main temple is fashioned 155 as a chariot, with stone wheels decorated with lotus ornament.

Hindu temple architecture and art under the Tuluvas also flourished beyond the capital, expecially under local governors at

153. Carved granite monolith of Vishnu Narasimha, seated in an ornate frame, at Vijayanagara in Karnataka, Tuluva period, 1528. The ferocious lion-headed god is shown seated in yogic posture, his legs crossed and bound together with a band; a multi-headed serpent hood rises up above his crown.

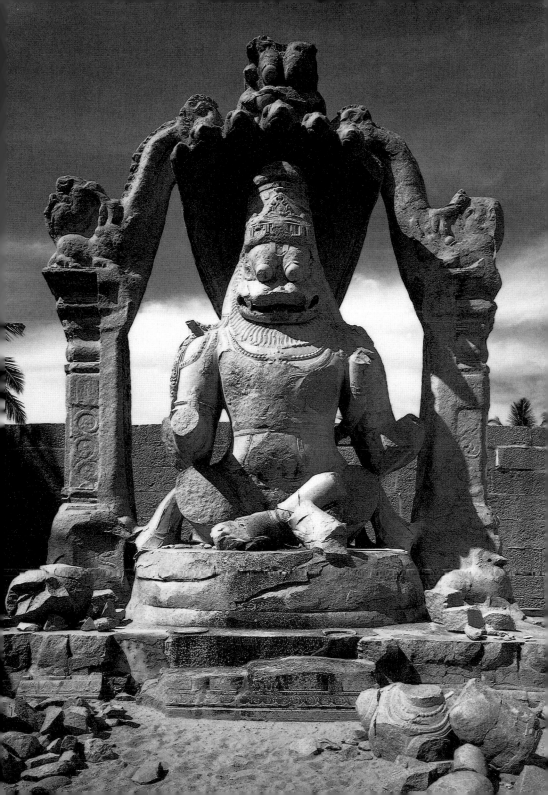

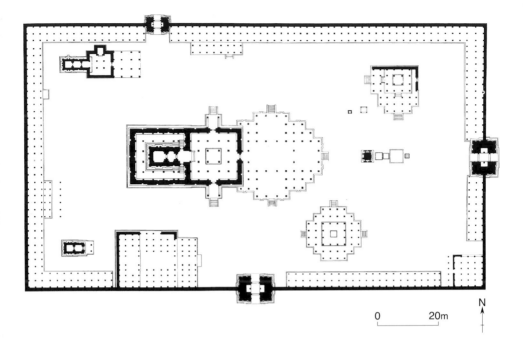

0 20m

N

154. Plan of the Vitthala temple at Vijayanagara in Karnataka, Tuluva period, first half of the sixteenth century. The sanctuary and a number of mandapas stand freely in a walled compound entered through gopuras on three sides.

155. (right) Shrine for Garuda, in the form of a chariot or ratha, in the compound of the Vitthala temple. It was originally topped by a brick tower, since dismantled.

156. (opposite) Mandapa added to the Vitthala temple in 1554. This represents a considerable advance in structural technique and sculptural treatment: granite piers with cut-out colonnettes and rearing yalis support brackets, beams and roof slabs.

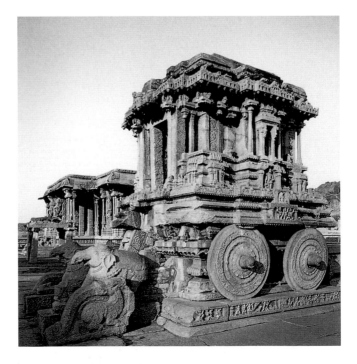

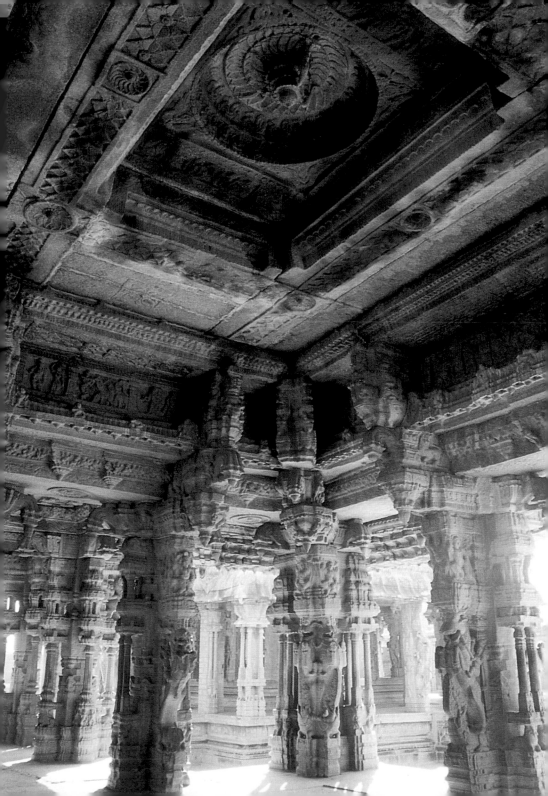

157. Shiva and Parvati disguised as forest hunters pursuing a wild boar; ceiling painting in the Virabhadra temple at Lepakshi in Andhra Pradesh, Tuluva period, mid-sixteenth century. The paintings here constitute the major example of Vijayanagara pictorial art. They depict a broad range of mythological and courtly topics, including this story, which relates the adventures of Shiva mingling with the forest hunters, and his encounter with the hero Arjuna.

various centres in Andhra Pradesh. The Virabhadra temple at Lepakshi, erected by Virupanna during the reign of Achyutaraya (1529–42), incorporates the usual sequence of double mandapas, one open, the other enclosed, both with piers showing leaping yalis or Shiva and Devi in various aspects. The central piers in the outer mandapa are distinguished by major figural compositions. Behind the main sanctuary is an impressive coiled serpent carved out of a solid granite boulder, which rears its multiple hoods over a separate polished granite linga. A short distance away is a monolithic Nandi of massive proportions, almost 8 metres long.

Paintings at Lepakshi are the best preserved from the Vijayanagara era. The ceiling of the inner mandapa is almost entirely covered with a depiction of Virabhadra, the god to whom the temple is consecrated. He appears with ten arms holding different weapons, and with fiercely staring eyes and protruding fangs; on either side are diminutive figures of the donor Virupanna, his wife and daughter. Ceiling compositions over the side aisles of the outer mandapa illustrate a full range of narratives. On the west is the marriage of Shiva and Parvati, the divine couple being flanked by Dikpalas and sages, as well as attendant women dressed in a variety of patterned saris and male courtiers

wearing pointed cloth crowns. One sequence of panels is devoted to the kirata episode, when Shiva disguised himself as a forest hunter. The scenes show Indra appearing before Arjuna, Arjuna doing penance, the sages reporting to Shiva, Shiva and Parvati on Nandi, and finally the divine couple as hunters pursuing a wild boar in a forest. The paintings employ supple linework on an orange-red background, the principal colours being white, green and brown and sepia. The figures are shown in profile, with prominent eyes, sharp noses and pointed chins; the details of costume, jewelry and headdress are clearly indicated by thin brushstrokes.

157

Tamil Nadu under the Aravidus and Nayakas

The Aravidus succeeded the Tuluvas as rulers of the Vijayanagara kingdom after the capital on the Tungabhadra was sacked and abandoned in 1565. Shifting their headquarters further south, they emerged as the major patrons of Hindu art and architecture in Tamil Nadu in the second half of the sixteenth century. The Jalakanteshvara temple in the fort at Vellore is one of the finest of their projects. Its sanctuary is contained within two concentric square enclosures, each entered on the south through a gopura. These matching gateways reiterate the Chola model, being topped with the usual pyramidal towers and shala roofs. The glory of the monument, however, is the granite kalyana mandapa in the outer enclosure, possibly a commission of Venkatapatideva I (1586–1614) at the very end of the sixteenth century. The outer piers of this structure incorporate rearing yalis and horses ridden by fully armed warriors. Elongated colonnettes of slender proportions mark the corner piers as well as those lining the main aisle. The dais at the rear is raised on a tortoise carved in shallow relief on the floor.

158

The vitality and naturalism of the Vellore sculptures are rivalled by similar animal sculptures in the Sheshagiri mandapa in the fourth enclosure of the Ranganatha temple at Srirangam. There, horses with riders rear over warriors who hold up shields for protection; other figures stab tigers and wild beasts, and even Europeans make an appearance, attacking Indian soldiers. The rendering of the costumes and weapons, as well as the trappings of the horses, is precise throughout. Yalis with leafy stalks issuing from their open mouths or with elephant-like snouts are also included in these compositions, while makaras with upturned heads are seen below.

The kalyana mandapa in the outer enclosure of the Varadaraja temple in Kanchipuram is also notable. Dating from the beginning

159

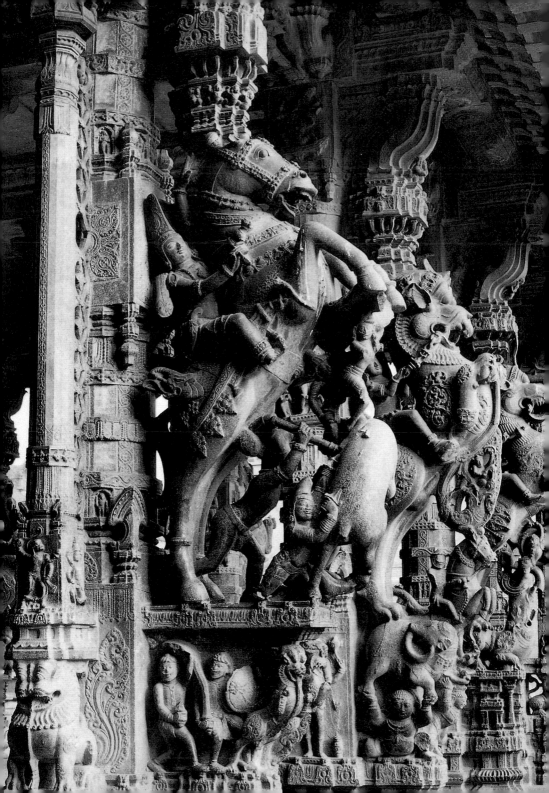

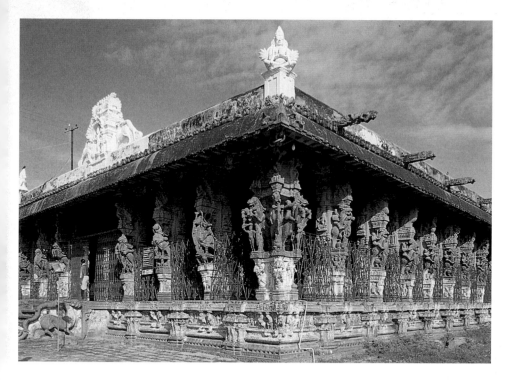

158. (opposite) Leaping horses with warriors on the granite piers of the kalyana mandapa in the Jalakanteshvara temple in Vellore, Tamil Nadu, Aravidu period, late sixteenth century. The martial theme is effectively realized in the finely detailed naturalistic animals and humans.

159. (above) Kalyana mandapa of the Varadaraja temple in Kanchipuram, Tamil Nadu, Aravidu period, early seventeenth century: the granite piers are an example of the transformation of architectural elements into almost three-dimensional sculptural compositions.

of the seventeenth century, it has two aisles forming a cross, each lined with rearing yalis, which meet in the centre at a raised dais. The piers at the corners of the dais have double and triple sets of animals facing outwards. Here, however, the animals with riders are slightly smaller, and the blocks below and above are carved with further beasts, some with bird heads. Other additions to the Varadaraja temple at this time include the eastern gopura of the complex which, with its nine diminishing storeys, exceeds Chola prototypes in height and complexity.

The emphasis on towered gopuras and mandapas with sculpted piers dominates seventeenth-century architecture in Tamil Nadu, as represented by the grandiose projects sponsored by the Nayaka rulers of Gingee, Tanjavur and Madurai who by this time had taken control of the region from the Aravidus. The Ranganatha complex at Srirangam is typical. It consists of seven concentric enclosures, the outermost walls of which measure no less than 950 by 815 metres. Sequences of gopuras are positioned on four sides, on axis with the principal sanctuary in the middle, those nearer the periphery being larger and higher, though not always finished. The inner enclosures at Srirangam incorporate

185

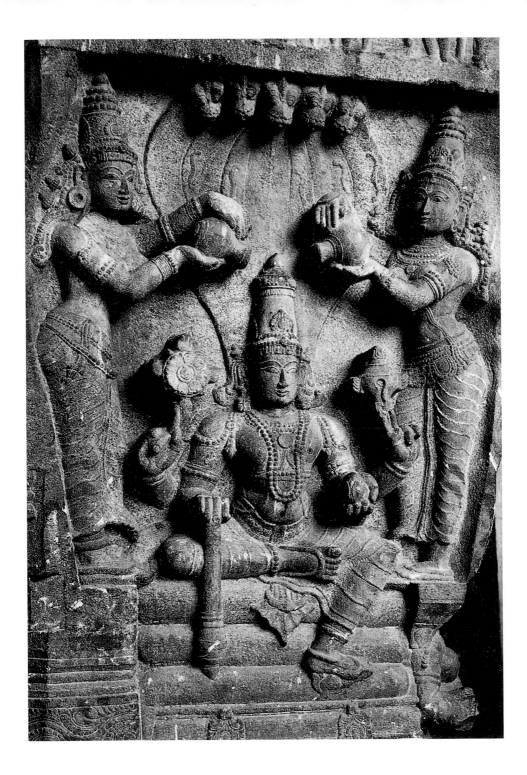

numerous features, including the Sheshagiri mandapa with animal piers already noted, and the Veugopala shrine in the fourth enclosure sponsored by Chokkanatha Nayaka of Madurai (1659–82). This small but finely detailed granite sanctuary employs pilastered projections between which are maidens in graceful poses, holding a vina, a parrot or a mirror.

Larger in scale are the carvings in the Ramasvami temple in Kumbakonam, a project of Govinda Dikshita, minister of Raghunatha (1614–34), one of the Tanjavur Nayakas. This monument consists of a garbhagriha and a pair of enclosed mandapas surrounded by a colonnade in the first enclosure, while in the second enclosure there is a mandapa with two intersecting aisles of spacious proportions lined with sculpted piers. Here appear a variety of attendant women and dancers, a portrait of Raghunatha Nayaka, and diverse mythological tableaux such as Vishnu Trivikrama with one leg kicked up, Rama and Sita with the forest sages, and Vishnu seated on the coils of Ananta, being bathed by attendants holding upturned pots. The smooth bodies of the figures contrast with the sharply cut details of jewels and costumes.

It is, however, in the southernmost part of Tamil Nadu that Hindu art reached its climax. The vast compound of the seventeenth-century Minakshi-Sundareshvara complex in Madurai is entered in the middle of four sides by lofty gopuras. They show distinctive concave profiles, and attain heights of up to 35 metres. The storeyed towers of these gateways are crowded with vividly painted plaster sculptures. The ritual and architectural focus of the temple, however, is the pair of sanctuaries consecrated to the goddess Minakshi and her consort Sundareshvara. Each stands in its own walled compound provided with a towered gateway, and approached through a sequence of columned halls and corridors lined with animal carvings and clustered colonnettes. The eight piers in front of the Sundareshvara shrine are furnished with larger than human-size figures in the round. One composition illustrates the marriage of Sundareshvara and Minakshi in the presence of Vishnu, here considered the brother of the bride, who pours water from a ritual pot. These and other mythological figures surround a flagpole, altar and small Nandi pavilion. Almost free-standing figures of a mounted warrior, a dancing bearded man and a gypsy woman are carved on the outer piers of the thousand-columned hall in the northeast corner of the complex. The temple also incorporates subsidiary shrines to lesser divinities, and a large stepped tank surrounded by colonnades.

160. Vishnu seated on the coils of Ananta, being bathed by attendants; granite column relief in the Ramasvami temple in Kumbakonam, Tamil Nadu, Nayaka period, early seventeenth century.

161. Minakshi-Sundareshvara temple in Madurai, Tamil Nadu, Nayaka period, seventeenth century. The gopuras are covered with exuberantly modelled plaster sculptures painted in bright colours.

162. A granite sculpture in the Pudu Mandapa of the Minakshi-Sundareshvara temple, mid-seventeenth century, depicts the marriage of Minakshi and Sundareshvara, local forms of Devi and Shiva. The groom on the right gestures to his bride in the middle; Vishnu on the left, here considered the brother of Minakshi, holds the ritual water pot while gently propelling the bride forward.

The artistic glory of the Madurai temple is the Pudu Mandapa, which is located outside the walled complex. The hall is surrounded by piers sculpted with large-scale figures and animals; divine subjects include another version of the marriage ceremony of Minakshi and Sundareshvara. Inside, there is a broad central aisle lined by columns with seated lion brackets carrying a raised ceiling. The columns also serve as supports for a set of portraits depicting the Madurai Nayakas down to Tirumala (1623–59), royal sponsor of the mandapa. The ten kings, of ample proportions, with swelling stomachs and buttocks, are all accompanied by diminutive wives and children. Tirumala's bunched hair is gathered up in a cloth, while his predecessors have pyramidal crowns with bulbous tops. Their attire is uniformly ornate, with bountiful jewelry and richly patterned costumes.

Other royal portraits are seen in the Bhuvaraha temple at Srimushnam, much expanded by Krishnappa II (c. 1586–1630) of Gingee in northern Tamil Nadu. The monument incorporates an

162

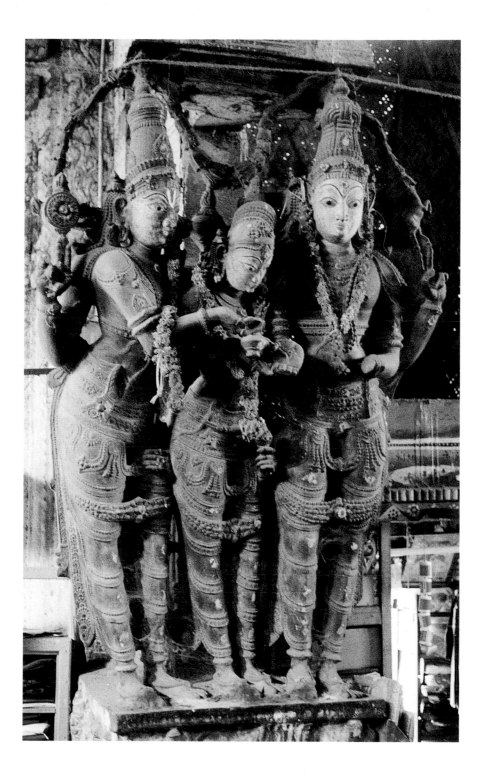

open mandapa with rearing yalis protruding from the central piers, and clusters of colonnettes on the corner piers. The four supports in the middle are distinguished by sculpted representations of the Gingee Nayakas, including one of Krishnappa himself. Like the portraits at Madurai, these figures wear conical caps with overhanging tops, covered with elaborate textile patterns, as well as long earrings and necklaces of pearls; daggers are tucked into their belts. The robust limbs and protruding stomachs are telling attributes of the Nayaka manner.

Temple art under the Nayakas and their contemporaries continued into the early part of the eighteenth century, especially in the southernmost part of Tamil Nadu. Sculptures in the mandapas of the Venkatachala temple at Krishnapuram, for instance, depict the five Pandava heroes of the *Mahabharata* in the company of attendant women, as well as gypsy men bearing maidens on their shoulders. The figures are of interest for their twisting postures, full and smoothly rounded bodies, and sharply cut facial expressions. Yalis maintained their dominance of the interiors of temple corridors and mandapas, becoming ever larger, and their heads increasingly ferocious.

A vigorous tradition of bronze casting coexisted with granite carving throughout the Nayaka period. Metal icons of the major Hindu deities tend to follow earlier practice; indeed, many are copies of Chola models, the only revealing Nayaka features being the sharpness of the modelling and the hardening of the facial expression. Bronzes imitate Chola groupings, such as Shiva and Parvati with Skanda, and Rama with Lakshmana holding bows in the presence of Sita and Hanuman. The figures in such sets are characterized by sharply cast facial features, pleated costumes and diverse weapons. Images of Krishna include the youthful god dancing on Kaliya, a favourite composition drawn from Chola art. A copper sculpture depicting ample-breasted Yashoda suckling the infant Krishna is, however, a unique Nayaka invention. The curvaceous modelling, robust limbs and smoothly worked hair recall the finest granite carvings. A more expressionistic image is that of the emaciated female saint Karaikal Ammaiyar playing small cymbals. Both these examples may be assigned to the late sixteenth century.

Ivories too must be counted among the plastic arts of Tamil Nadu during this time. Unlike bronzes, ivory figures display typical Nayaka characteristics, with fully modelled bodies, fluid postures and precisely incised details of crowns, headdresses, jewels and costumes. All these features are seen in a plaque

163

112–
114

115

164

163. Krishnappa, ruler of Gingee, in the Bhuvaraha temple at Srimushnam in Tamil Nadu, Nayaka period, early seventeenth century; granite. The tall cap, prominent dagger and protruding stomach are typical features of Nayaka portraiture.

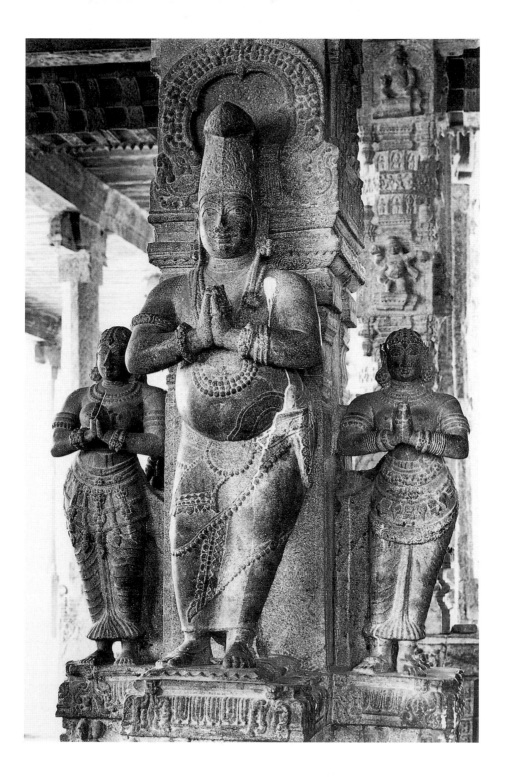

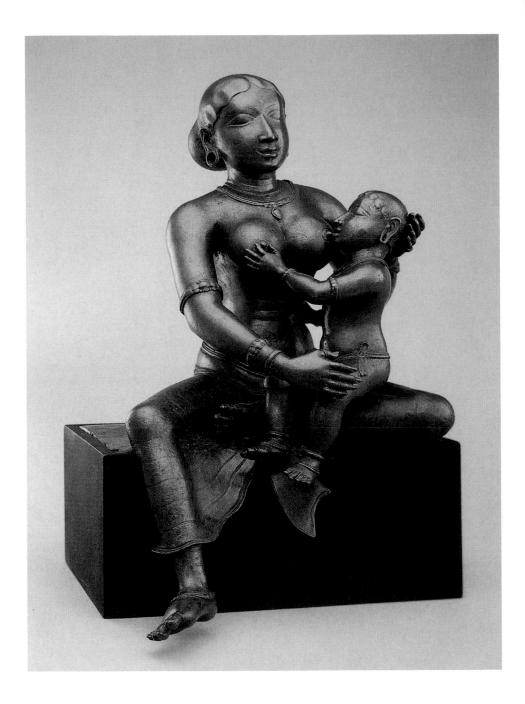

164. (opposite) Yashoda and Krishna, from Tamil Nadu, Aravidu period, late sixteenth century; copper, H 33 cm. The smoothly modelled figures of this unique mother and child composition bear comparison with contemporary granite sculpture.

165. (above) Marriage of Sundareshvara and Minakshi, from Tamil Nadu, Nayaka period, seventeenth century; ivory, H 16 cm. In this miniature version of the subject portrayed in Ill. 162, Sundareshvara/Shiva on the right, the largest of the three figures, takes the hand of Minakshi/Devi on the left. Vishnu also appears here, at the rear, holding up the ritual water pot. The scene is crowded with garlands, tassels, and foliage; a leafy tree rises up over the bride.

showing the marriage of Sundareshvara with Minakshi. Dating 165 from the seventeenth century, this echoes in miniature form and flat relief the carved stone composition already noted at 162 Madurai.

Temple art under the Aravidus and the Nayakas was greatly enriched by wall and ceiling paintings. Their subject-matter 166–168 ranges widely, much of it pertaining to local mythological traditions, but compositional devices and colour schemes tend to be fairly standardized. As at Lepakshi, the painted area is divided 157 into narrow horizontal strips crowded with figures, and borders provided with identifying inscriptions. Flat tones were popular, especially yellow, brown and ochre, with occasional blue, red and green accents; black outlines are added to achieve a strong linear quality. Backgrounds are usually filled with brilliant red or ochre. Faces are often shown in profile, with staring eyes picked out in white.

The ceiling paintings in the Kapardishvara temple at Tiruvalanjuli, a short distance from Kumbakonam, were among the most important of the Aravidu era, judging from photographs taken before they were removed during recent renovation. The cycle dated from the end of the sixteenth century and was devoted to the mythology of Shiva. One scene showed the god together

166. Shiva and Parvati riding on Nandi in the company of gods and sages; detail of a lost ceiling panel formerly in the Kapardishvara temple at Tiruvalanjuli in Tamil Nadu, Aravidu period, late sixteenth century. A darker coloured background filled with flowers emphasizes the importance of the god and goddess.

with Parvati riding on Nandi, in the presence of the forest sages. 166
The rich crowns and costumes were complemented by the foliage-
and flower-strewn backgrounds and borders.

Ceiling paintings in the Shivakamasundari shrine within the
Nataraja temple in Chidambaram typify the Nayaka pictorial
idiom in the seventeenth century. They include the story of
Shiva as the naked beggar Bhikshatanamurti, the god's white body
contrasting with the black background. He is accompanied by a
beautiful, scantily clad woman identified as Mohini, a female form 167
of Vishnu. The long life of Manikkavachakar, a human devotee of
Shiva, is represented in no less than forty ceiling panels in the
same shrine. They are mostly devoted to the childhood of the saint
and his exploits as a youth in the service of the Pandya king.

Further examples of mid-seventeenth-century Nayaka paint-
ing are seen in the passageway surrounding the sanctuary in the
Brihadishvara temple in Tanjavur, substantially renovated by
Vijayaraghava (1634–73); the paintings, which partly obscure the
Chola period compositions noted earlier, include scenes from 107
the lives of Hindu saints. Other paintings of the period in a more

vivid but harder style are found at Srirangam. The ceiling of the corridor that wraps around the focal Ranganatha shrine is covered with legends pertaining to Ranganatha, as well as scenes from the life of Krishna, all organized into compartments. At the end of the cycle is a panel depicting the royal patron Vijayaranga Chokkanatha II of Madurai (1706–32) together with his wives adoring the temple deity.

Kerala

Located on the Arabian Sea coast of southern India, Kerala is notable for its highly individual art traditions. This high-rainfall zone has fostered a wooden architecture with carved timber columns, beams and angled struts carrying sloping roofs clad in copper tiles. (While these buildings strikingly resemble those of Nepal, there is no evidence of any direct influence.) Though temple traditions can be traced back to earlier centuries, the structures that stand today mostly belong to the period covered here.

The triple-shrined Vadakkunnatha temple in Trichur, much patronized in the sixteenth and seventeenth centuries by the kings of Cochin in central Kerala, may be taken as a typical example. The principal linga shrine dedicated to Vadakkunnatha stands within a square of masonry walls with a recessed upper storey, each tier sheltered by a projecting roof sheathed in copper, the upper distinguished by four projecting gables. The entrance porch and open square mandapa that stand in front are capped by similar pyramidal roofs. The circular Shankara Narayana shrine nearby has murals of Shiva Nataraja and Dakshinamurti, Vishnu Padmanabha, and Ganesha covering its walls. Finely carved wooden struts resting on elephant brackets depict divinities, including Garuda with large wings. The conical roof above rises in two stages. The Vadakkunnatha and Shankara Narayana shrines stand together with a third shrine dedicated to Rama in the middle of a spacious rectangular compound bounded by timber screen walls. That is in turn contained within a vast quadrangle of masonry walls, which is entered through imposing gates in the middle of each side topped with sloping tiers of tiles. A detached hall for theatre and dance performances in the outer court is surrounded by timber screens and roofed with a large gable; inside, four stone columns in the middle carry a square wooden ceiling divided into nine compartments filled with deities.

Another Kerala temple of artistic interest is the Mahadeva at Ettumanur, remodelled in 1542. Here the focal linga sanctuary is circular, with doorways in the cardinal directions, the walls in

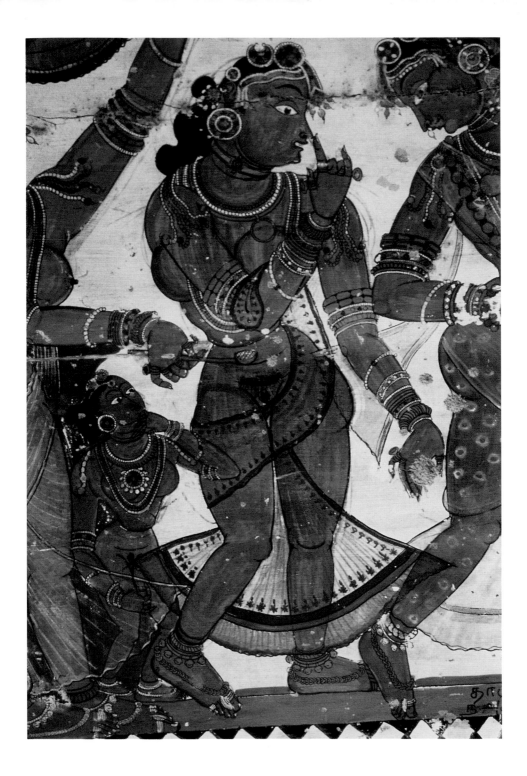

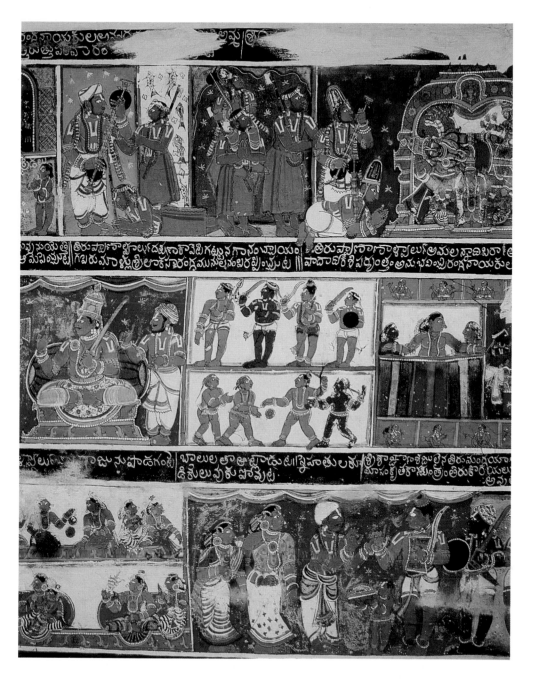

167. Vishnu disguised as Mohini, who seduces the forest sages, from a ceiling painting in the Shivakamasundari shrine in the Nataraja temple in Chidambaram, Tamil Nadu, Nayaka period, seventeenth century.

168. Scenes from local legends, including the worship of Ranganatha by local chiefs (top right), in a ceiling painting in the Ranganatha temple at Srirangam in Tamil Nadu, Nayaka period, early eighteenth century.

between consisting of curved wooden panels and screens framed by friezes of warriors, musicians, sages and animals; in the middle are intricately carved and brightly painted deities. Angled wooden struts supporting the eaves of the conical metal-clad roof are sculpted in three dimensions as female dancers and as characters from the story of Shiva as the hunter appearing before Arjuna. Small stone guardians are placed on either side of the doorways leading to the shrine, where sculpted balustrades line the access steps. Immediately in front is an open square mandapa topped with a pyramidal roof, also covered in metal sheets. Stone columns support wooden brackets and beams; the ceiling within has twenty-five lotus panels surrounded by miniature deities. Sanctuary and mandapa stand at the core of two concentric square compounds. The outer one has a gate with a two-tiered sloping tiled roof and a carving of Vishnu Narasimha as a yogi in the central gable; on the inner walls, large-scale eighteenth-century

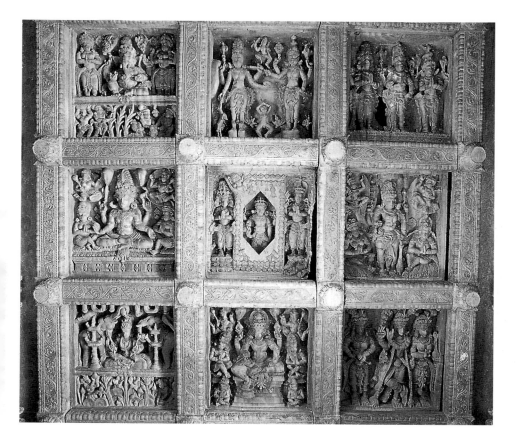

169. (opposite, above) The storeyed principal sanctuary of the Vadakkunnatha temple in Trichur, Kerala, and its detached mandapa, sixteenth century and later. Both have copper-sheathed pyramidal roofs supported on timber frameworks.

170. (opposite, below) Garuda, on an angled wooden strut supporting the roof overhang of the Shankara Narayana shrine in the Vadakkunnatha temple in Trichur, seventeenth century.

171. (above) Wooden ceiling in the Vadakkunnatha temple mandapa in Trichur, eighteenth century. Shiva appears out of the linga in the central panel, surrounded by subsidiary deities.

murals portray Vishnu as Padmanabha reclining on the coils of Ananta, and multi-armed Shiva Nataraja surrounded by celestials. 172

Paintings also cover the masonry walls of the elliptical shrine of the Vaikkathappan temple at Vaikom. Dating back to the seventeenth century, they illustrate Shiva Nataraja in the company of the gods, Vishnu on Garuda, and Rama battling with Ravana; dvarapalas holding clubs and trampling on serpents flank the doorways. The compositions employ a nervous linework that complements the vivid orange, red, green and deep blue tones. Similar paintings also occur in royal buildings. The palace of the Cochin rulers includes a suite of rooms whose walls are covered with murals, some dating back to the building's renovation by the Dutch in 1663. A cycle of *Ramayana* scenes embellishes the king's bedchamber: it begins with the sacrifice of Rishyashringa and the birth of Rama and his three brothers, and ends with the battle between Rama and Ravana, the fire ordeal of Sita, and the return

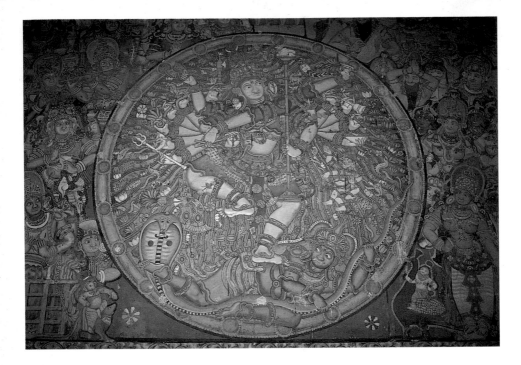

172. Shiva Nataraja, in a mural on the entrance gateway of the Mahadeva temple at Ettumanur in Kerala, eighteenth century. The myriad arms of the god almost fill the circular frame in which he dances; he tramples on a demonic figure clutching a naga.

173. Vishnu as Padmanabha, reclining on the coils of Ananta; mural in the king's private shrine room in the palace at Padmanabhapuram in Tamil Nadu, mid-eighteenth century. The combination of yellow and ochre hues with green and red flourishes is typical of the Kerala pictorial style.

of Rama to Ayodhya. Lakshmi seated on the lotus, Vishnu as Padmanabha, and Shiva seated with Parvati are depicted nearby.

These compositions may be compared with paintings in the palace at Padmanabhapuram, built by Martanda Varma (1729–58), ruler of southern Kerala. Murals in the private shrine room at the top of a tower in the middle of the complex are devoted to a broad range of subjects: Ganesha and Vishnu with their consorts, Krishna playing the flute, Rama together with Sita, and Vishnu Padmanabha on the regularly wrapped coils of Ananta. 173

In addition to carved woodwork and mural painting, Hindu art in Kerala also found expression in metal. Bronzes of major divinities dating from the sixteenth and seventeenth centuries show a preference for sharply delineated features and encrusted costumes and headdresses, as well as an emphasis on curved frames fringed with cut-out tufts of foliage. Among the most popular icons are those of seated Ganesha with his consort, and Ayyappa, the son of Shiva and Mohini, who is shown as a youth with his head surrounded by a halo of hair. Hanging brass lamps are conceived as miniature shrines complete with gabled roofs, accommodating deities such as Padmanabha, and Rama holding the bow, sometimes combined into one design.

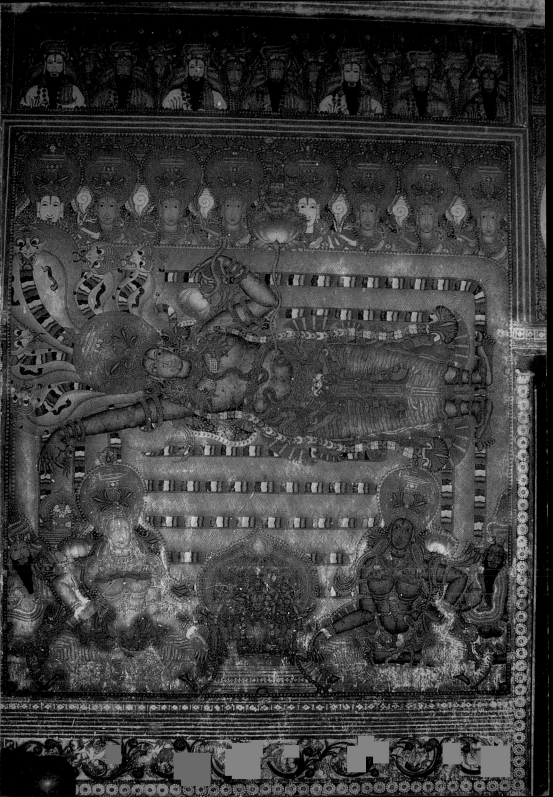

Chapter 6: Lesser Traditions: from the nineteenth century to the present

The most recent phase of Hindu art is of special interest for the multitude of traditions associated with both town and village settings. To begin with, many of the bronzes, wood carvings, terracottas and watercolours considered here reflect the requirements and taste of an emerging middle class, rather than those of powerful individuals, as in the past. Merchants and government officials have been able to commission works of art for the shrines of their communities, and even for their own homes. That during this period Western influence has been strong is evident from the European manner that invades much painting and some sculpture. In parallel with this mainly urban artistic activity, there has also existed a lively rural tradition, often categorized as folk or tribal. Works of art in ephemeral materials produced by village craftsmen give tantalizing hints of India's vanished artistic traditions, whether in wood or clay, painted cloth or paper.

In Hindu temple architecture the revivalist tendencies of earlier times persisted, though with the occasional absorption of elements drawn from European architecture. Mumbai's most important goddess sanctuary, the Mumba Devi temple, was entirely rebuilt in the nineteenth century. It juxtaposes a clustered shikhara-type tower in the finest Gujarati manner with a mandapa in European Neo-classical style. The Lakshmi Narayana temple in New Delhi, erected in 1938 by Raja Baldeo Birla, a prominent industrialist, is an innovative triple-shrined complex designed in a simplified Orissan style, with tall rekha deul-type towers capped by prominent amalakas, all raised up on a double-storeyed base. The exterior facing of white marble and red sandstone refers to the Mughal architecture of the city. Orissa is also the inspiration for the sanctuary of the Birla temple in Hyderabad, Andhra Pradesh, completed in 1976 by another member of this industrial family; the entrance, however, conforms to the gopura scheme favoured in Tamil Nadu, thereby synthesizing the two main regional traditions of Hindu temple architecture in a single complex.

174

Past conventions have also dictated the iconographic pattern of images intended for worship, whether in the temple or in the home. Even so, there is often a spirited quest for aesthetically challenging idioms, especially in marginal zones like Bastar in Bihar and Kanara in Karnataka. Sacred art produced in these somewhat out-of-the-way areas offers insights into the sustained inventiveness of Indian artists. This creativity is perhaps best appreciated in the diverse pictorial traditions that emerged during the course of the nineteenth century. Paintings executed on paper scrolls and hanging cotton cloths attest to the longstanding relationship between public storytelling and visual representation. With their striking colour schemes and compositional devices, they are often the work of itinerant craftsmen. Such artists have also been responsible for the souvenir figurines and plaques of deities sold at pilgrimage shrines. These and other popular images have attracted the attention of several twentieth-century Indian painters and sculptors trained in European influenced academies, contributing to a growing appreciation of the lesser traditions of Hindu art.

178

175–
177

174. Lakshmi Narayana temple, New Delhi, 1938. Its eclectic manner combines a trio of Orissan-style deul sanctuaries (cf. Ill. 87) with Mughal-influenced arcades.

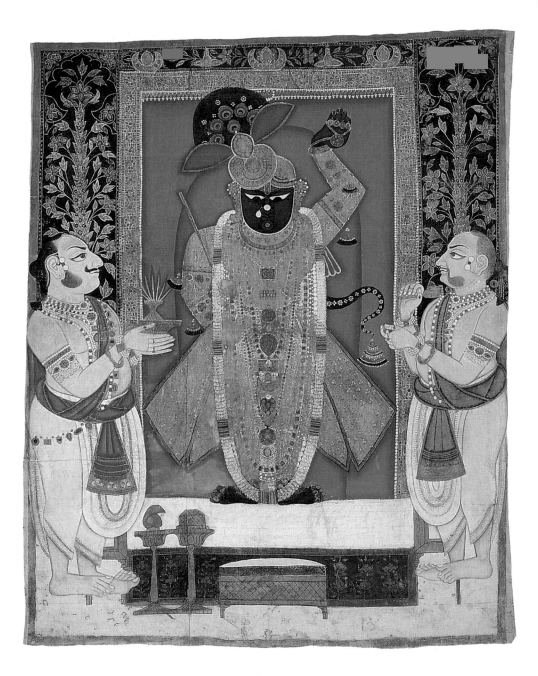

175. Priests worshipping the image of Krishna as Shrinathji;
cloth hanging (picchvai) from Kota in Rajasthan, nineteenth
century; watercolour on cloth, 189 x 145 cm. Such hangings
were unfurled as part of the devotions in the temple at
Nathdwara in Rajasthan (cf. Ill. 127).

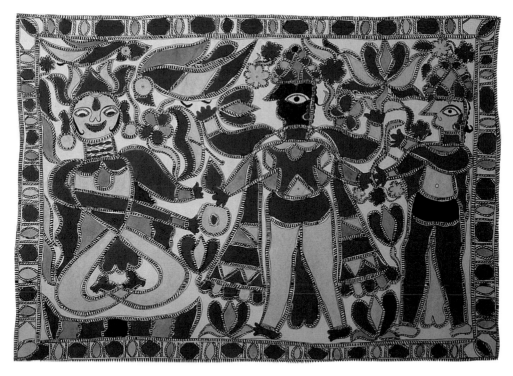

176. Tulsidas, author of the *Ramayana*, with Rama and Lakshmana, by Sunil Kumari, from Jitabandapur in Madhubani, Madhya Pradesh, early 1980s; watercolour.

177. Rama battling with the ogress Taraka; detail from a pata scroll of a *Ramayana* used in live narrations, West Bengal, nineteenth century; watercolour on paper.

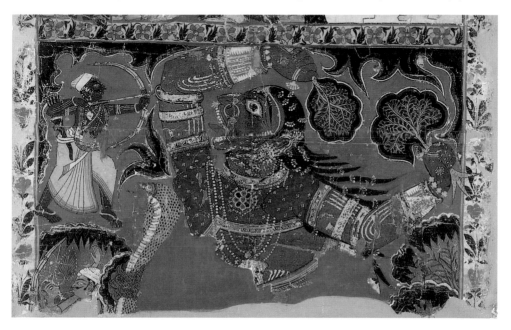

Northern India

Sculptures with Hindu subjects, especially miniature works in metal, are often conventional in form and style. Smoothly modelled bronzes from Orissa of crawling Krishna holding a butter ball and of the standing god playing the flute, or of Radha beckoning to her lord, are cast in a style that recalls earlier temple sculpture in the region; the same is true of figurines from Rajasthan and Gujarat. Such works contrast with bronzes from more remote regions. Those from Bastar in eastern Madhya Pradesh, generally less than 25 centimetres high, are distinguished by the use of applied metal strips and spirals to indicate ornament and facial features. They depict local Hindu divinities riding on an elephant, seated on a swing or embracing beneath a canopy, as well as the more universal Krishna and Radha. Equally distinctive are bronze processional masks from Himachal Pradesh, some of which portray Mujuni, a regional version of Shakti, with a benevolent smiling countenance, wearing elaborate ear ornaments and a crown. Other brass masks are intended as coverings for votive stone lingas, such as those showing the head of Shiva from Madhya Pradesh. Bhairava is also portrayed in this way, his ferocious nature being expressed in the protruding eyes, fanning ears, large moustache and prominent canines. In all these masks the smoothly bulbous forms of the heads are offset by the sharply modelled facial features.

178

Ivory carving represents yet another aspect of the plastic arts in this era, some of the most accomplished examples coming from West Bengal. Typical are miniature shrines showing Durga slaying the buffalo demon, flanked by Ganesha and Karttikeya, set in architectural frames surmounted by semicircular panels filled with shallow figures.

Painting in northern India since the beginning of the nineteenth century offers a broad panorama of techniques and purposes. One group of painted cloths, known as *picchvais*, is associated with the temple at Nathdwara in Rajasthan; they are intended as backdrops for rituals of devotion performed in the temple, but also serve as souvenirs for the home. Picchvais depict Krishna as Shrinathji, richly dressed and decked in garlands, holding up one hand as if to support Mount Govardhana; priests and worshippers stand reverently before the god's shrine. The youthful Krishna is also shown playing the flute in the company of the gopis or the herds, surrounded by plantain leaves and mango trees. Picchvais are characterized by the use of bright blue, green and orange colours which contrast with the pale tones of figures and animals.

127

175

178 Krishna playing the flute, with Radha; from Bastar in Madhya Pradesh, twentieth century; bronze, H 24 cm. Such figurines illustrate the vitality of the lesser traditions of Hindu art that have survived into recent times.

Krishna under the name of Jagannatha is also the principal deity of Puri in Orissa. Paintings on both cloth and paper produced for pilgrims to the temple there show its tower rising over the trio of divinities accommodated in its sanctuary – Jagannatha himself, his brother Balabhadra and his sister Subhadra. The curious staring eyes and primitive shapes of their heads and bodies are particular features of the Puri deities, whose cult images are fashioned out of wood and regularly renewed. Puri paintings are executed with thick strokes of opaque black on flat red, green and yellow backgrounds. They accurately depict the layout of the temple itself, as well as the locations of a host of other shrines in and around the city.

Another much frequented sanctuary is that dedicated to Kali at Kalighat in Calcutta, after which the city takes its name. Paintings on paper, intended as mementos for visitors in the nineteenth century, portray the fierce goddess Kali with huge staring eyes, outstretched tongue, and multiple hands holding weapons and the severed head of a human victim. Krishna also appears, being cradled in the arms of his stepmother Yashoda, dancing on Kaliya, or playing the flute in the company of Radha. The striking appearance of these works is due to the rapidly executed, sweeping brush strokes and transparent washes with shading. A twentieth-century version of this extreme stylization is seen in the watercolours produced in the Madhubani area of neighbouring Bihar. Madhubani art employs clear black inkwork, often with hatching, to define areas of bright pink, green and yellow. In the hands of accomplished village artists, many of them women, it encompasses a broad range of mythological topics, including Durga standing on the lion, and multi-headed, bloodthirsty Kali. A more unusual Madhubani composition, invented by Sunil Kumari of Jitabandapur village, depicts the poet Tulsidas together with the principal heroes of his *Ramayana* epic.

Among other types of painting are the long paper scrolls unrolled vertically before an audience by itinerant storytellers. Known in northern India as *patas*, such works illustrate a full range of legendary tales. Nineteenth-century *Ramayana* patas from West Bengal are up to 8 metres long, and are divided into numerous panels showing the different episodes of the story, beginning with the expulsion of Rama and Sita from Ayodhya, their wanderings in the forest, and Rama shooting the golden deer. The deep red backgrounds provide an effective foil to the figures, which are outlined in black and filled with rich ochre, green and indigo tones. The vitality of pata art is seen to

87

13

176

advantage in a register from a dilapidated scroll showing Rama 177
battling with the ogress Taraka.

Gujarat is also known for its patas. These too are divided into horizontal-format panels. So as to affirm the religious nature of the narrative, they begin with the depiction of a Hindu shrine. This is usually followed by four-armed Ganesha in the company of female attendants and horsemen, with sun and moon emblems above. After this comes a sequence of deities, including Durga spearing Mahisha, and Kali trampling on the corpse of Shiva. *Ramayana* and *Mahabharata* episodes tend to be compressed into one or two panels only. Sketchy linework with thick flourishes of ochre and pink contrasts with bright yellow and white backgrounds. This distinctive style is closely related to that used for block-printed and hand-painted cloths from Gujarat, especially those with thick black outlines on deep maroon, cream or white backgrounds. A typical composition shows Durga riding in a domed chariot drawn by a richly caparisoned horse, surrounded by a myriad of tiny musicians, dancers and other figures.

Southern India

Artistic production in southern India during recent centuries also follows fixed iconographic and stylistic conventions, with a perceptible decline in quality. Smaller bronzes constitute a heritage that has mostly thrived away from the larger centres. Examples from Tamil Nadu include images no more than 30 centimetres high of the guardian divinity Aiyanar, depicted as a mustachioed horseman, armed with sword and shield. Here and in icons of a host of other village divinities, the finely detailed modelling demonstrates the survival of bronze casting techniques in this region down to the present day. Hollow terracotta images of Aiyanar, larger but similar in style, are set up at wayside shrines throughout Tamil Nadu, in the company of similarly fashioned horses and fierce warriors; the animals are equipped with bridle, 179 saddle and other trappings, either modelled in terracotta or applied as thick colour.

Southern India is also of interest for a vibrant legacy of wood carving that survived well into the twentieth century. Processional chariots, or *rathas*, are a particular feature of temple towns in Tamil Nadu where they are pulled by crowds on festival occasions to transport richly decorated temple images around the city streets. The lower portions of the chariots consist of tiers of sculpted panels supported on a timber framework. The example outside the temple at Tirumalapadi, a short distance from

179. Painted horse and attendant at an Aiyanar shrine in rural Tamil Nadu, twentieth century. These almost life-size, hollow terracottas are fired on the spot.

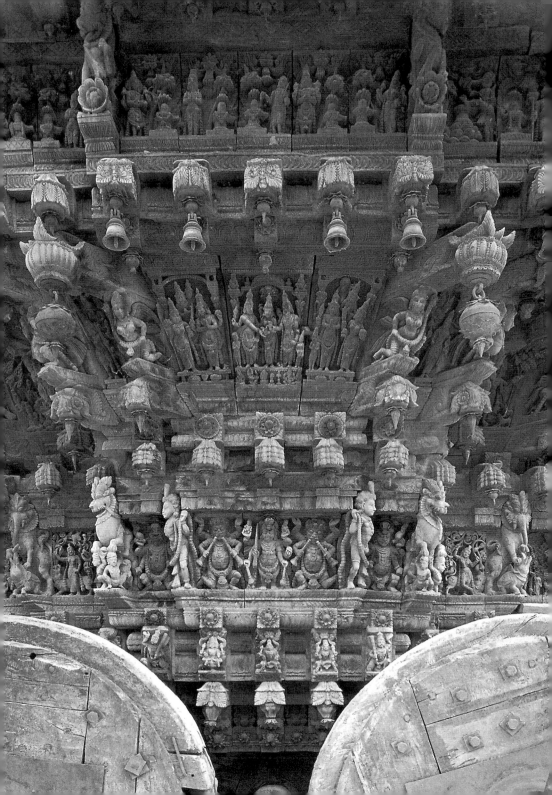

Tanjavur, may be taken as typical: leaping yalis and horses ridden by warriors serve as brackets, while ganas blowing conches and winged celestials mark the corners. The front parts of the chariot often feature the goddess Bhudevi riding a tortoise head, a reference to Vishnu's Kurma incarnation; divinities as well as dancers and sages are placed above. Scenes from the *Ramayana* or the story of Vishnu Narasimha disembowelling the demon Hiranyakashipu are generally reserved for the most prominent central rows.

The finest wood carving in Karnataka is associated with the *bhuta* cults of coastal Kanara. Bhutas are spirits loosely identified with Hindu gods, such as Nandikeshvara, the bull form of Shiva, under worship in the remote village of Mekkekattu. This bhuta is surrounded by fiendish and animal attendants, and accompanied by his consort Parameshvari. The goddess, carved out of separate but interlocking pieces, is represented riding on a celestial bull with a buffalo head and feathered wings. Another striking figure associated with bhuta cults is Jogipurusha, the village fortune teller.

A similar assortment of styles in different media characterizes southern Indian painting during these centuries. Painted pages usually assigned to the town of Paithan in Maharashtra, but possibly produced in northern Karnataka, are notable for their crowded figures and animals in vigorous poses, and their use of bright flat reds, blues and ochres on plain backgrounds. Most depict battle scenes from the *Mahabharata* and *Ramayana*, with the protagonists aiming bows at each other, arrows flying through the air, and fallen victims littering the ground. One composition portrays Lakshmana confronting the demon Kumbhakarna, the giant brother of the demon Ravana, in one of the climactic battles of the *Ramayana*. Among the Hindu divinities who appear in so-called Paithan art are Ganesha with a female fly-whisk-bearer and turbaned trumpeter, and Sarasvati with a peacock. Works in such a style recall contemporary cloth scrolls and transparent leather puppets, also from Andhra Pradesh.

Cotton hangings and canopies from coastal Andhra Pradesh and Tamil Nadu, produced by a complicated process of painting and dying known as *kalamkari*, present another facet of southern Indian pictorial art in these centuries. Using a limited palette of black, ochre and red on a cream background, such cloths are often intended as backdrops for religious ceremonies; indeed, many resemble ceiling paintings in temples. Larger kalamkaris exceed 3×2 metres and are often devoted to the *Ramayana* legend, with a central panel featuring Rama and Sita enthroned in the palace at

181

180. Detail of a wooden temple chariot or ratha at Tirumalapadi in Tamil Nadu, twentieth century. In the lower register are gana attendants with garlands, and yali brackets; in the centre, a relief of the marriage of Shiva and Parvati flanked by gods, between brackets with maidens bearing garlands.

181. Lakshmana facing Kumbhakarna, in a climactic battle
of the *Ramayana*; painting supposedly from Paithan, Maharashtra,
nineteenth century; watercolour on paper.

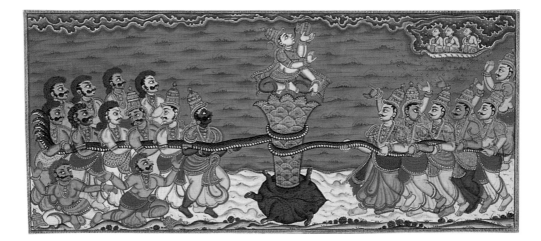

182. The churning of the cosmic ocean, from a *Bhagavata Purana*;
from Mysore in Karnataka, nineteenth century; watercolour on paper.
Vishnu in his tortoise incarnation as Kurma serves as the pivot.

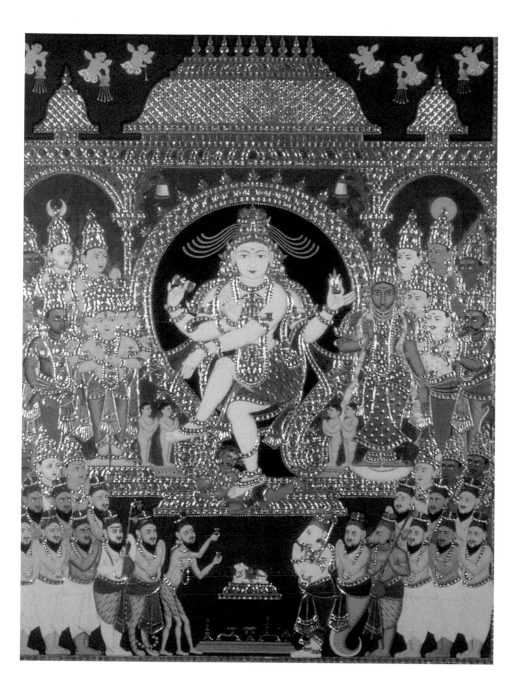

183. Shiva Nataraja in the golden hall at Chidambaram; from
Tanjavur in Tamil Nadu, nineteenth century; painting on wood
encrusted with coloured glass, 74 × 59 cm.

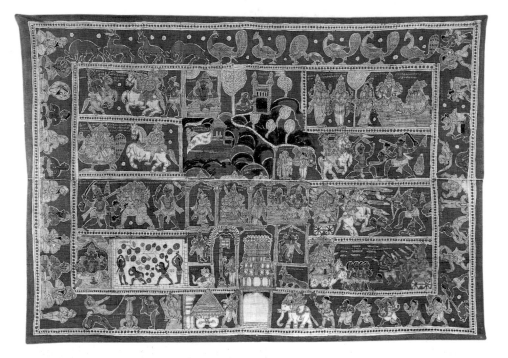

184. Cloth hanging
(kalamkari) depicting the
shrine and associated legends
of the Murugan temple at
Tirupparankunram, from Tamil
Nadu, nineteenth century;
painted and died cotton. The
temple and its wheeled ratha
appear in the centre at the
bottom.

Ayodhya, which is indicated by lobed arches and pyramidal towers. Such panels are surrounded by registers crammed with episodes from the epic; as in ceiling paintings, identification generally relies on inscriptions. Central panels of other kalamkaris depict Vishnu reclining on Ananta, and Shiva seated with Parvati. One fine cloth shows the gods of the hillside Murugan temple at Tirupparankunram near Madurai, within a border filled with lively acrobats and seated sages, peacocks and frolicking deer.

184

 The emergence of a Karnataka school of painting in the nineteenth century was largely due to the patronage of the Mysore court. Among the illustrated books commissioned by the Wodeyar rulers is the *Devimahatmya* of 1799 produced for Krishna Raja III (1799–1868). A nineteenth-century *Bhagavata Purana* has a more conventional horizontal format, recalling palm-leaf manuscripts. One of its illustrations shows the churning of the cosmic ocean, the process that leads to all creation: gods and demons are lined up on either side of Mount Mandara, the world axis, and are twirling it by means of the long serpentine body of Ananta. The figures are disposed on a brilliant orange background, with a narrow slit of deep blue sky at the top filled with curly white clouds. Mysore painting also features single deities seated on thrones

182

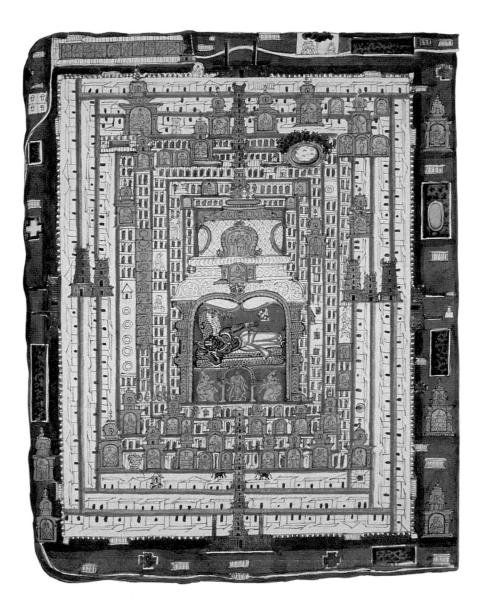

185. Schematic view of the Ranganatha temple at Srirangam with its concentric walled enclosures; from Tamil Nadu, nineteenth century; watercolour on paper. The image of sleeping Vishnu is shown in the central shrine; sequences of gopuras in the middle of each side mark the routes leading to it.

within palace-like interiors, complete with columns, arches, towers, and even European-inspired angels. The fresh linework and preference for yellow, green and red tones are characteristic.

Such works closely resemble contemporary paintings in Tanjavur in Tamil Nadu, which are executed on wood or sometimes on the reverse of glass panels. Tanjavur art focuses on formal arrangements of deities, such as Vishnu with Shridevi and Bhudevi, or Shiva dancing in the golden hall at Chidambaram, a

183

celebrated performance that took place as part of a contest between Shiva and Parvati, which was won by the god. Other scenes are more informal and sentimental, such as the infant Krishna crawling on the floor clutching a butter bowl, or languishing on a couch. The pale skin and staring eyes of the figures contrast with the semi-precious gems and pieces of coloured glass or mica which highlight their costumes, crowns and jewels.

A quite different pictorial genre that gained currency in the course of the nineteenth century is the album of watercolour illustrations of Hindu deities produced for European clients. While the images in such books tend to repeat the conventions of earlier times, the fresh, rapidly executed brushwork expresses a new spirit. Gods appear full-face with staring eyes, even when shown walking across the page. Scenes of religious life include processions with images of temple deities carried on palanquins and sheltered by parasols, or transported in wooden chariots. Actual temples, such as the pilgrimage shrine of Ranganatha at Srirangam, are sometimes also represented.

185

New currents

Towards the end of the nineteenth century some Indian artists came under the sway of Western painting and attempted in different ways to reconcile Hindu themes with imported oil-on-canvas techniques. Ravi Varma (1848–1906) and Abanindranath Tagore (1871–1951), working in Kerala and Bengal respectively, are among the most celebrated exponents of this partly Europeanized manner. Several of their paintings express a moody introversion previously unknown in Indian art, even when portraying newly imagined icons, like Bharat Mata, Mother India. Artists working in the first half of the twentieth century sometimes developed a fascination for indigenous pictorial idioms which they attempted to adapt and develop. The paintings of Jamini Roy (1887–1972) in Calcutta, for example, exploit the same sweeping curves as those found in Kalighat art. His compositions include many distinctly Hindu topics, such as Yashoda with the infant Krishna.

13

While artists today are exploring novel forms and styles, occasionally incorporating religious themes, popular Hindu iconography continues to proliferate. Mass-produced prints, posters and calendars are pasted onto the walls of hotels, shops, and offices, not to mention the metal frames of trucks, buses and rickshaws, to become an integral part of the everyday environment. This ubiquitous imagery presents the broadest possible

186

186. Kali, from Tamil Nadu, late twentieth century, 33 x 23.3 cm. The goddess, depicted with multiple heads, arms and legs, is necklaced with heads and brandishes a severed head (cf. Ill. 13), as a battle rages in the background; she tramples the prostrate figure of Shiva. Such prints, luridly coloured (this scene takes place in ghoulish blue light), are the most popular form of Hindu art today.

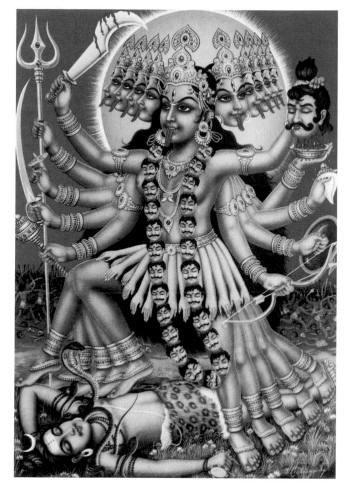

range of gods and goddesses, including newly fashionable pilgrimage deities such as Ayyappa, who is worshipped in a remote forest shrine at Sabarimalai in Kerala. Saintly figures like Sai Baba of Shirdi in Maharashtra, whose life spanned the nineteenth–twentieth centuries, also have a presence in this art. That the brilliant tones and naturalism recall film posters more than temple art only contributes to their universal appeal. Perhaps more than any other sacred images produced in India today, it is these prints that affirm the irrepressible spirit of the Hindu artistic legacy.

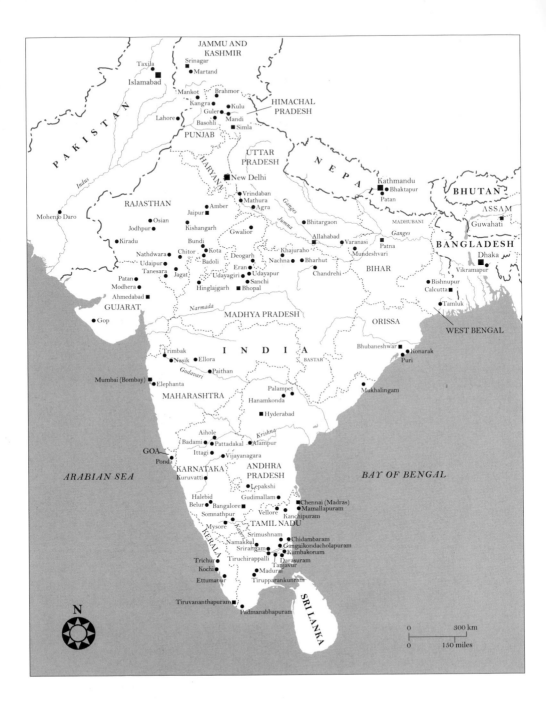

The Indian subcontinent, showing chief sites mentioned
in the text, and international and state capitals
(indicated by black squares).

Bibliography

Hinduism

Bhattacharyya, N. N., *Indian Mother Goddesses*, Calcutta, 1971

Biardeau, M., *Hinduism: The Anthropology of a Civilization*, New Delhi, 1997

Brockington, J. L., *The Sacred Thread: A Short History of Hinduism*, New Delhi, 1997

Daniélou, A., *Hindu Polytheism*, New York, 1964

Dehejia, V., *Slaves of the Lord. The Path of the Tamil Saints*, New Delhi, 1988

Dowson, J., *A Classical Dictionary of Hindu Mythology*, repr., Calcutta, 1982

Dye, J., *Ways to Shiva: Life and Ritual in Hindu India*, Philadelphia, 1980

Eschmann, A., H. Kule and G. C. Tripathi, *The Cult of Jagannatha and the Regional Tradition of Orissa*, New Delhi, 1978

Flood, G., *An Introduction to Hinduism*, Cambridge, 1996

Fuller, C. J., *The Camphor Flame: Popular Hinduism and Society in India*, Princeton, 1993

Harman, W. P., *The Sacred Marriage of a Hindu Goddess*, Delhi, 1992

Huyler, S. P., *Meeting God: Elements of Hindu Devotion*, New Haven/London, 1999

Kinsley, D., *Hindu Goddesses: Visions of the Divine Feminine in the Hindu Religious Tradition*, Delhi, 1986

O'Flaherty, W. D., *Hindu Myths*, Harmondsworth, Middx, 1975

Pintchman, T., *The Rise of the Goddess in the Hindu Tradition*, Albany, N.Y., 1994

Singer, M., ed., *Krishna: Myths, Rites, and Attitudes*, Chicago/London, 1966

Stutley, M. and J., *A Dictionary of Hinduism, Its Mythology, Folklore and Development 1500 B.C.–A.D. 1500*, New Delhi, 1986

Ziegenbalg, B., *Genealogy of the South Indian Gods*, repr., New Delhi, 1984

Zimmer, H., *Myths and Symbols in Indian Art and Civilization*, repr., Princeton, 1972

Hindu art

Arts Council of Great Britain, *In the Image of Man*, London: Hayward Gallery, 1982

Banerjea, J. N., *The Development of Hindu Iconography*, Calcutta, 1956

Banerjee, P., *The Life of Krishna in Indian Art*, New Delhi, 1978

Blurton, T. R., *Hindu Art*, London, 1992

Bosch, F. D. K., *The Golden Germ: An Introduction to Indian Symbolism*, The Hague, 1960

Davis, R., *Lives of Indian Images*, Princeton, 1997

Dehejia, V., *Yogini Cult and Temples: A Tantric Tradition*, New Delhi, 1986

----, ed., *Royal Patrons and Great Temple Art*, Bombay, 1988

----, ed., *The Legend of Rama: Artistic Visions*, Bombay, 1994

---- *Indian Art*, London, 1998

----, ed., *Devi the Great Goddess*, Washington, D.C.: Arthur M. Sackler Gallery, 1999

Eck, D., *Darshan: Seeing the Divine Image in India*, 2nd edn, Chambersburg, 1985

Elliot, J. and D., *Gods of the Byways*, Oxford, 1982

Gopinatha Rao, T. A., *Elements of Hindu Iconography*, 2 vols, repr., Delhi, 1968

Goswamy, B. N., *Essence of Indian Art*, San Francisco: Asian Art Museum of San Francisco, 1986

Harle, J. C., *The Art and Architecture of the Indian Subcontinent*, Harmondsworth, Middx, 1986

Huntington, S., *The Art of Ancient India: Buddhist, Hindu, Jain*, New York/Tokyo, 1985

Isacco, E., ed., *Krishna the Divine Lover: Myth and Legend through Indian Art*, New Delhi, 1982

Kramrisch, S., *Unknown India: Ritual Art in Tribe and Village*, Philadelphia: Philadelphia Museum of Art, 1968

---- *Manifestations of Shiva*, Philadelphia: Philadelphia Museum of Art, 1986

Martin-Dubost, P., *Ganesa: The Enchanter of the Three Worlds*, Mumbai, 1997

Maxwell, T. S., 'Art in the Cults of Hinduism', in *The Gods of Asia: Image, Text and Meaning*, Delhi, 1997

Michell, G., *The New Cambridge History of India I.6: Architecture and Art of Southern India, Vijayanagara and the successor states*, Cambridge, 1995

Mitchell, A. G., *Hindu Gods and Goddesses*, London, 1982

Pal, P., *The Art of Nepal*, 2 vols, Leiden, 1974

Rawson, P., *The Art of Tantra*, London: Hayward Gallery, 1973

Rowland, B., *The Art and Architecture of India. Buddhist, Hindu, Jain*, 3rd edn, Harmondsworth, Middx, 1967

Sastri, H. K., *South Indian Images of Gods and Goddesses*, Madras, 1916

Shearer, A., *The Hindu Vision: Forms of the Formless*, London, 1993

Sivaramamurti, C., *Nataraja in Literature, Art and Thought*, New Delhi, 1974

Stutley, M., *The Illustrated Dictionary of Hindu Iconography*, London, 1985

Temple architecture

Acharya, P. K., *An Encyclopaedia of Hindu Architecture*, repr., Bhopal, 1978

Banerjee, N. R., *Nepalese Architecture*, Delhi, 1980

Boner, A., and S. R. Sarma, *Silpa Prakasa: Medieval Orissan Sanskrit Text on Temple Architecture by Ramacandra Kalacara*, Leiden, 1966

---- *New Light on the Sun Temple of Konarka*, Varanasi, 1972

Brown, P., *Indian Architecture: Buddhist and Hindu Periods*, repr., Bombay, 1965

Case, M., ed., *Govindadeva: A Dialogue in Stone*, New Delhi, 1996

Chandra, P., ed., *Studies in Indian Temple Architecture*, New Delhi, 1975

Chetwode, P., 'Western Himalayan Hindu Architecture and Sculpture', in B. Gray, ed., *The Arts of India*, Oxford, 1981

Dagens, B., *Mayamata. An Indian Treatise on Housing, Architecture and Iconography*, New Delhi, 1985

Dhaky, M. A. [and M. Meister], eds, *Encyclopaedia of Indian Temple Architecture*, 6 vols, New Delhi, 1983–98

Fritz, J. M., and G. Michell, *Vijayanagara: The Medieval Hindu Capital of Southern India*, New York, 1991

Krishna Deva, *Temples of Khajuraho*, 2 vols, New Delhi, 1990

Kramrisch, S., *The Hindu Temple*, 2 vols, repr., New Delhi, 1976

Michell, G., *Brick Temples of Bengal*, Princeton, 1983

---- *The Hindu Temple: An Introduction to Its Meaning and Forms*, repr., Chicago, 1988

---- *The Penguin Guide to the Monuments of India: Buddhist, Jain, Hindu*, London, 1989

----, ed., *Temple Towns of Tamil Nadu*, Bombay, 1993

Pichard, P., *Tanjavur Brhadisvara: An Architectural Study*, New Delhi/Pondicherry, 1995

Postel, M., A. Neven and K. Mankodi, *Antiquities of Himachal*, Bombay, 1985

Sarkar, H., *An Architectural Survey of Temples of Kerala*, New Delhi, 1978

Starza, O. M., *The Jagannatha Temple at Puri: its Architecture, Art and Cult*, Leiden, 1993

Soundara Raja, K. V., *Indian Temple Styles*, New Delhi, 1972

Srinivasan, K. R., *Cave-Temples of the Pallavas*, New Delhi, 1964

Tadgell, C., *The History of Architecture in India*, London, 1990

Trivedi, R. D., *Temples of the Pratihara Period in Central India*, New Delhi, 1990

Viennot, O., *Temples de l'Inde centrale et occidentale*, Paris, 1976

Wiesner, U., *Nepalese Temple Architecture*, Leiden, 1978

Sculpture

Arayan, K. C., *Indian Folk Bronzes*, New Delhi, 1991

Asher, F. M., *The Art of Eastern India, 300–800*, Minneapolis, 1980

Atherton, P., *The Sculpture of Medieval Rajasthan*, Leiden, 1997

Barrett, D., *Early Chola Architecture and Sculpture*, London, 1974

Berkson, C., *Ellora: Concept and Style*, New Delhi, 1992

Boner, A., *Principles of Composition in Hindu Sculpture: Cave Temple Period*, Leiden, 1962

Chandra, P., *The Sculpture of India, 3000 B.C.–1300 A.D.*, Washington, D.C.: National Gallery of Art, 1985

Dallapiccola, A. L., and A. Verghese, *Sculpture at Vijayanagara: Iconography and Style*, Delhi, 1968

De Lippe, A., *Indian Mediaeval Sculpture*, Amsterdam, 1978

Desai, D., *Erotic Sculpture of India: A Socio-Cultural Study*, New Delhi, 1975

---- *The Religious Imagery of Khajuraho*, Mumbai, 1996

Desai, V., and D. Mason, eds, *Gods, Guardians and Lovers: Temple Sculptures from North India A.D. 700–1200*, New York: Asia Society Galleries, 1993

Donaldson, T. E., *Hindu Temple Art of Orissa*, 3 vols, Leiden, 1985–87

Evans, K., *Epic Narratives in the Hoysala Temples: The Ramayana, Mahabharata and Bhagavata Purana in Halebid, Belur and Amrtapura*, Leiden, 1997

Harle, J. C., *Gupta Sculpture*, Oxford, 1974

Huntington, S. L., *The Pala-Sena Schools of Sculpture*, Leiden, 1994

Huyler, S. P., *Gifts of Earth: Terracottas and Clay Sculptures of India*, Middletown, Conn., 1996

L'Hernault, F., P. R. Sririvasan and J. Dumarçay, *Darasuram: Epigraphical Study, Étude architecturale, Étude iconographique*, Paris, 1987

Mallebrein, C., *Die Anderen Götter: Volks- und Stammesbronzen aus Indien*, Cologne, 1993

Mankodi, K., *The Queen's Stepwell at Patan*, Bombay, 1991

Michell, G., ed., *Living Wood: Sculptural Traditions of Southern India*, London, 1992

Mode, H., and S. Chandra, *L'Art populaire de l'Inde*, Paris, 1985

Nagaswamy, R., *Masterpieces of Early South Indian Bronzes*, New Delhi: National Museum, 1983

Randhawa, M. S. and D. S., *Indian Sculpture: The Scene, Themes and Legends*, Bombay, 1985

Snead, S., W. Doniger and G. Michell, *Animals in Four Worlds: Sculptures from India*, Chicago, 1989

Thomas, J., *Tiruvengadu Bronzes*, Madras, 1986

Painting with Hindu themes

Andhare, S., *Chronology of Mewar Painting*, Delhi, 1987

Ambal, A., *Krishna as Shrinathji: Rajasthani Paintings from Nathdvara*, Ahmedabad, 1987

Appasamy, J., *Tanjavur Painting of the Maratha Period*, New Delhi, 1980

Archer, W. G., *Indian Paintings from the Punjab Hills: A Survey and History of Pahari Miniature Painting*, 2 vols, London, 1973

Archer, M., *Indian Popular Painting in the India Office Library*, London, 1977

Barrett, D., and D. Gray, *Indian Painting*, repr., Geneva, 1978

Beach, M. C., *Rajput Painting at Bundi and Kotah*, Ascona, 1974

Binney, E., and W. G. Archer, *Rajput Miniatures from the Collection of Edwin Binney 3rd*, Portland, 1968

Craven, R., *Ramayana Pahari Paintings*, Bombay, 1990

Das, J. P., *Puri Painting*, New Delhi, 1982

Ebeling, K., *Ragamala Painting*, Basel, 1973

Ehnbom, D. J., *Indian Miniatures: The Ehrenfeld Collection*, New York, 1985

Goswamy, B. N., and U. Bhatia, *Painted Visions: The Goenka Collection of Indian Paintings*, New Delhi, 1999

Goswamy, B. N., and E. Fischer, *Pahari Rulers: Court Painters of Northern India*, Zurich: Rietberg Museum, 1992

Jain, J., ed., *Picture Showmen: Insights into the Narrative Tradition of Indian Art*, Mumbai, 1998

Kramrisch, S., *Painted Delight*, Philadelphia: Philadelphia Museum of Art, 1986

Krishna, N., *Painted Manuscripts of the Sarasvati Mahal Library*, Thanjavur, 1994

Pal, P., *Ragamala Paintings in the Museum of Fine Arts, Boston*, 1967

Patnaik, D. B., *Palm Leaf Etchings of Orissa*, New Delhi, 1989

Pratap, R., *The Panorama of Jaipur Painting*, New Delhi, 1996

Randhawa, M. S., *Basohli Painting*, New Delhi, 1959

Rao, S. R., and V. K. Sastry, *Traditional Paintings of Karnataka*, Bangalore, 1980

Shiveshwarkar, L., *The Pictures of the Chaurapanchasika: A Sanskrit Love Lyric*, New Delhi, 1967

Singh, C., *The Paintings of Siva in Indian Art*, 2 vols, Delhi, 1990

Sivaramamurti, C., *South Indian Painting*, New Delhi, 1968

Skelton, R., 'Mughal Paintings from Harivamsa Manuscript', in *Victoria and Albert Museum Year Book*, 2, London, 1970

Spink, W., *Krishnamandala*, Ann Arbor, Mich., 1971

Varadarajan, L., *South Indian Traditions of Kalamkari*, Ahmedabad, 1982

Acknowledgments for Illustrations

The author and publishers wish to express particular thanks to Anna Dallapiccola and Robert Skelton for their help with the illustrations.

1 Photo George Michell. 2 Archaeological Museum, Khajuraho. Photo American Institute of Indian Studies, Gurgaon, Haryana, India. 3 National Museum, New Delhi. 4 National Museum of Pakistan, Karachi. 5 Sven Gahlin Collection, London. Photo courtesy Sven Gahlin. 6 State Museum, Bhubaneshwar. Photo American Institute of Indian Studies, Gurgaon, Haryana, India. 7 Freer Gallery of Art, Smithsonian Institution, Washington, D.C. 8 Los Angeles County Museum of Art, from the Nasli and Alice Heeramaneck Collection, Museum Associates Purchase. 9 Asian Art Museum, San Francisco. 10 Central Museum, Indore. Photo American Institute of Indian Studies, Gurgaon, Haryana, India. 11 Photo John Freeman. 12 Alampur Museum, Hyderabad State. 13 Victoria & Albert Museum, London. 14 Photo American Institute of Indian Studies, Gurgaon, Haryana, India. 15 National Museum, New Delhi. Photo courtesy Robert Skelton. 16 Photo Richard Lannoy. 17, 18 Photo Josephine Powell. 19 Drawing courtesy George Michell. 20 Archaeological Museum, Khajuraho. Photo Ross Feller. 21 Photo Ilay Cooper. 22 Ashmolean Museum, Oxford. 23 Indian Museum, Calcutta. 24 Photo American Institute of Indian Studies, Gurgaon, Haryana, India. 25 Government Museum, Mathura. Photo courtesy Robert Skelton. 26 © British Museum, London. 27 Photo Ilay Cooper. 28 Photo courtesy Robert Skelton. 29 Photo © Roberto Meazza. 30, 31 Photo American Institute of Indian Studies, Gurgaon, Haryana, India. 32 Photo David McCutchion. 33 The Metropolitan Museum of Art, New York. Purchase, Florence and Herbert Irving Gift. 1991. 34 Courtesy George Michell. 35 Photo American Institute of Indian Studies, Gurgaon, Haryana, India. 36 National Museum of India, New Delhi. Photo AKG London/ Jean-Louis Nou. 37 Photo David McCutchion. 38 Los Angeles County Museum of Art, from the Nasli and Alice Heeramaneck Collection, Museum Associates Purchase. 39 Photo David McCutchion. 40 Photo George Michell. 41 From *The Art and Architecture of India. Buddhist, Hindu, Jain*, by Professor Benjamin Rowland, Jr. 42 Photo American Institute of Indian Studies, Gurgaon, Haryana, India. 43 Photo Archaeological Survey of India. 44 Los Angeles County Museum of Art. Photo courtesy Robert Skelton. 45 Photo American Institute of Indian Studies, Gurgaon, Haryana, India. 46 National Museum, New Delhi, Photo courtesy Robert Skelton. 47 From *The Art and Architecture of India. Buddhist, Hindu, Jain*, by Professor Benjamin Rowland, Jr. 48 Photo India Office Library and Records. 49 Photo American Institute of Indian Studies, Gurgaon, Haryana, India. 50, 51 Photo © Ann & Bury Peerless – Picture Library. 52 Photo © Roberto Meazza. 53, 54 Photo Ilay Cooper. 55– 57 Photo Jeffrey Gorbeck. 58 Courtesy George Michell. 59 Photo © Ann & Bury Peerless – Picture Library. 60 Photo Bharath Ramamrutham. 61 © Thames & Hudson Ltd. 62 Photo © Ann & Bury Peerless – Picture Library. 63 Photo Crispin Branfoot. 64 Photo Martin Hürlimann. 65, 67 Photo Gary Williams. 68, 69 Photo Crispin Branfoot. 70 Photo Barbara Wace. 71 Photo Archaeological Survey of India. 72 Photo Henry Wilson. 73 Indian Museum, Calcutta. 74 Photo Crispin Branfoot. 75 Photo Henry Wilson. 76 The Metropolitan Museum of Art, New York. Purchase. Anonymous Gift and Rogers Fund, 1989 (1989.121). 77 Photo George Michell. 78–83 Photo American Institute of Indian Studies, Gurgaon, Haryana, India. 84 Photo © Ann & Bury Peerless – Picture Library. 85 Photo David McCutchion. 86 Photo Ilay Cooper. 87 Photo Josephine Powell. 88 Photo Henry Wilson. 89 National Museum, New Delhi. Photo Martin Hürlimann. 90 National Museum, New Delhi. Photo American Institute of Indian Studies, Gurgaon, Haryana, India. 91 Bangladesh National Museum, Dhaka. Photo courtesy of Enamul Haque. 92 National Gallery of Australia, Canberra. 93 Photo David McCutchion. 94 Photo American Institute of Indian Studies, Gurgaon, Haryana, India. 95 Photo © Ann & Bury Peerless – Picture Library. 97 Photo Crispin Branfoot. 98 Photo Ilay Cooper. 99–101 Photo American Institute of Indian Studies, Gurgaon, Haryana, India. 102 Photo George Michell. 103 Photo David McCutchion. 104 Photo Gary Williams. 105 Photo Ilay Cooper. 106 Photo Archaeological Survey of India. 107 Photo © Dr. V. Nanda. 108 Photo George Michell. 109 Photo Gary Williams. 110 Art Gallery, Tanjavur. Photo Clare Arni. 111 Photo Martin Hürlimann. 113 Government Museum, Madras. 114 Cleveland Museum of Art. Purchase from the J. H. Wade Fund 1930.331. 115 National Museum, New Delhi. Photo © Angelo Hornak Library. 116 The Metropolitan Museum of Art, New York. Gift of H. Rubin Foundation Inc. 117 Victoria & Albert Museum, London. 118 The Metropolitan Museum of Art, New York. 119 From *Govindadeva, a Dialogue in Stone*, published by Vikas for the Indira Gandhi National Centre for the Arts. Courtesy Nalini Thakur and team. 120 Photo Ilay Cooper. 121 Photo © Ann & Bury Peerless – Picture Library. 122 Photo Karoki Lewis. 123 Kanoria Collection, Calcutta. 124 British Library, London, Add. MS 15297(1), f. 100r. Photo courtesy Robert Skelton. 125 Kanoria Collection, Calcutta. 126 San Diego Museum of Art. 127 Photo Ilay Cooper. 128 National Museum, New Delhi. Photo courtesy Robert Skelton. 129 Freer Gallery of Art, Washington, D.C. 130 Government Museum and Art Gallery, Chandigarh. 131, 132 National Museum, New Delhi. Photo courtesy Robert

Skelton. **133** Victoria & Albert Museum, London. **134** Government Museum and Art Gallery, Chandigarh. **135** Virginia Museum of Fine Arts, Richmond. **136** National Museum, New Delhi. Photo courtesy Robert Skelton. **137** Government Museum and Art Gallery, Chandigarh. Photo courtesy Robert Skelton. **138** Link Picture Library. Photo © Ashvin Mehta/Dinodia. **139** Photo courtesy Robert Skelton. **140** Photo George Michell. **141** Photo Crispin Branfoot. **142** Robert Hatfield Elsworth Personal Collection, New York. **143** Los Angeles County Museum of Art. **144** Photo David McCutchion. **145** Photo © Ann & Bury Peerless – Picture Library. **146** British Library, London. **147** Photo George Michell. **148** Photo David McCutchion. **149, 150** Photo Ann & Bury Peerless – Picture Library. **151** Photo John Gollings. **152** Photo Karoki Lewis. **153** Photo John Gollings. **154** By permission of Pierre-Sylvain Filliozat. **155** Photo John Gollings. **156** Photo Karoki Lewis. **157** Photo Crispin Branfoot. **158** Photo American Institute of Indian Studies, Gurgaon, Haryana, India. **159** Photo Bharath Ramamrutham. **160** Photo American Institute of Indian Studies, Gurgaon, Haryana, India. **161** Photo © Ann & Bury Peerless – Picture Library. **162** Photo Bharath Ramamrutham. **163** Photo American Institute of Indian Studies, Gurgaon, Haryana, India. **164** The Metropolitan Museum of Art, New York. Purchase, Lita Annenberg Hazen Charitable Trust Gift, in honour of Cynthia Hazen and Leon Bernard Polsky, 1982 (1982.220.8). **165** Victoria & Albert Museum, London. **166** Photo Archaeological Survey of India, Madras. **167** Ninda Davidson Gwatkin. **168** Photo V. K. Rajamani. **169–171** Photo Bharath Ramamrutham. **172, 173** Photo Crispin Branfoot. **174** Photo A. F. Kersting. **175** Australian National Gallery, Canberra. **176** Victoria & Albert Museum, London. Photo courtesy Robert Skelton. **177** © British Museum, London. **178** Arthur M. Sackler Gallery, Leo S. Figiel Collection. **179** Photo Clare Arni. **180** Photo Bharath Ramamrutham. **181** Courtesy Jagdish Mittal Collection. **182** Asian Art Museum, San Francisco. **183** Enrico Isacco Collection. **184** Victoria & Albert Museum, London. **185** © British Museum, London. **186** Collection Emily Lane.

Glossary-Index

Explanations of Indian terms, names and literary works are given in square brackets.

Locations of cities, towns and sites appear in round brackets.

References to illustration numbers and captions are indicated in *italic* type.